tAtt
oo

Visionaries of Tattoo

By Joseph Ari Aloi aka JK5
Introduction by Carlo McCormick

UNIVERSE

BOOK

First Published in the United States of America in 2011 by
Universe Publishing
A Division of Rizzoli International Publications, Inc.
300 Park Avenue South
New York, NY 10010
www.rizzoliusa.com

2011 2012 2013 2014 / 10 9 8 7 6 5 4 3 2 1

Printed in China

Editors: Joseph Ari Aloi aka JK5 & Julie Schumacher
Production: Jessica O'Neil
Design: Matt Clark
Editorial Assistant: Ashleigh Allen

ISBN: 978-0-7893-2270-8
Library of Congress Catalog Control Number: 2011925000

DRAW DRAW DRAW

Joseph Ari Aloi aka JK5

Draw, draw, draw, redraw, and draw some more; rough, fast, frantic lines until just the right note forms the song that shapes the right composition, from one client on to the next. Days, months, and years worth of paper, brain power, drawing and ultimately, indelibly etching people with stainless-steel needles, pigment, and the fire of the heart channeled through strong, gracefully wielding hands, while beautiful archaic-looking machines vibrate and hum *just* so.

Tattoo artists are constantly drawing. We are drawing, drafting, manual, mark-making machines. We love to draw, draw constantly, and with each and every client it starts with a pencil and tracing paper. The new client gives you an idea, and articulates this as best as possible; sometimes it's a word or a sentence, while some people bring reference material ranging from a single graphic image or quote (double- and triple-checked), to a stack of images, printouts, personal drawings, statues, and plates—I've seen it all. Some consultations take 30 seconds and the tattoo only 5 minutes. Others are deep, detailed, and pensive dialogues lasting several hours, and the tattoo can take 10 sessions, 5 hours each, totaling 50 hours of blood, sweat, and tears.

This is what I've been doing, something from nothing each time, since I started tattooing in September 1994. I had just graduated from the Rhode Island School of Design with a Bachelor of Fine Arts in Illustration, and with independent studies completed in Painting. I had no idea what I was going to do to earn a living, other than doing anything it took, by hook or by crook, to stay true to my art making and creative passion. It's all I've ever known.

Tattooing saved me. It was an embodying gift and vocation laying dormant for my entire life, until the storm of inspiration swirled and roared, communicating directly from the mythic gods and larger cosmic forces that this was it; this was the path, the medium, the form, and the message. The way to further etch, carve, design, and define my ever-expanding visual languages and personal and artistic identity, and to earn an honest living honing this wild, breathing, most complex and fragile hands-on craft; a craft so rich with history, power, poetry, rebellion, realization, magic, meaning, practice, intent, cultural narrative, strange and wonderful aesthetics and properties as challenging and interesting as anything I had learned about or studied in art school, and that much more, and that much cooler.

I was at a major personal and artistic impasse upon graduating, leaping into the infinite abyss from the lion's mouth with nothing but a small portfolio of sketchbook pages, upon which early 1990s tattooing vernacular was permeating every pore of my own brain-sculpted inventions and meandering musings. Living within those pages was a document, a profound event: a letter I had received from my biological mother on the 19th of November, 1993—twenty-three years, five months, and nineteen days after I was born.

That letter made me realize what I always needed. Tattoos. To rip myself inside out and finally wear my always-bleeding heart and impassioned mission as an artist on the outside. And the pain? Ritual? Permanence? Yes, I'm in. And that was it. All I could do was trust in what was unfolding, and where the winds of change and destiny were blowing me. Thankfully, I had loving parents who always supported my art, and knew I would end up doing something with it as an eventual career. Little did they or I know that it would be tattooing.

To quote my hilarious and very strict, old-school, dominant Italian father, when I came home from art school with a three-quarter sleeve as my first tattoo: "Well Joey, you drew all over everything including your sister when you were growing up, so I can't say I'm surprised that it ended up on your body." With his blessing, I got a job at a small country-biker-redneck-somehow-reputable tattoo shop an hour north of where I grew up, and the rest is his story. Seventeen years and five shops later, (one being my own from 1997 to 2002), here I am with a wonderful opportunity to curate this book and do my best to attempt some sort of introduction. We have come full circle, as many of the artists who inspired my journey are in these pages. Some of whom I now consider to be dear friends and teachers, and more importantly, brothers and sisters in creative arms; cosmic, celestial compadres; music-loving, myth-mining, mark-making, wild wonder-filled warriors; cautious, conscientious, careful craftsmen; visionary visualists, prolifically painting, pontificating, pondering, passionate, picture-peddling poets; magnificent mystic misfits; honing skill homies; and flesh-etching, fantasy-fueled, farthest-reaching, fellow seekers.

In my humble opinion, the artists and work in this collection showcase some of the strongest and most creative work happening in the tattoo world today. Yes, several I consider to be good friends, and I've had the pleasure and gift of working

with some of them here in Manhattan and Brooklyn, and most are artists I've long admired, or have been turned on to through the years into the present. These are multidisciplinary cross-pollinating artists who I can bet, as varied and unique as each our origins are, were saved in a way similar to me, by tattoos, and becoming tattoo artists.

There are artists inside this book who have been tattooing for over 20 years, others, a third of that time. What I aspired to in curating this book, and what I think unifies this particular assembly of tattooists, is a dedicated creativity and exploration, an inherent inventiveness, a distinct style, in addition to being talented draftsmen, proficient technicians, and damn good tatt makers. These artists are pushing the boundaries and confines of the form and content, forging new, out of an ancient craft. That word, *craft*…here goes: spaceship, vessel, conduit, channel, medium through which light comes through, what we are and aspire to be, and further become as we take light-long steps into this delicate and phenomenally powerful lifetime.

Some of the proverbially unique and signature crafts of these artists have imaginative coordinates set to places and spaces on different planes and time: West Coast style; USA and super graphic; hyper-articulated letterforms; Victorian ladies; ancient Japan; the elements; deities; ghosts; demons and monsters; an insanely vivid and adroit technique and mastery of the cultural school, and those surreal dreamscapes of seventeenth century Europe. Reimagining the carnival calling, or the spiritual, mythological, oldest symbolism of the occultists, imagery that attempts to harness and illuminate our true relationship to the divine, darker unseen forces, and realties best left to celebratory creation rituals.

Others are rooted in traditional American iconography that moves in exciting directions via color, with a conscious level of simplicity, an extra economy of line, a charming crudeness, and the raw liberty of formal excursions that warp and go back somewhere in the tuned-in, dropped-out 1960s, as if a young Spanish skateboarder hopped on an old Harley and shot himself into outer space with his eyes wide open, with a once-exotic foot in the waters of the Pacific. It's all here; all the timeless war generated themes of life, death, love, loss, pain, association, romance, self-definition, the unknowable, a reminder of home, dancing animals and hula girls, battle royal, survival of the natural world and its fittest, ill-fitting reliquaries, libraries, caves, churches and cathedrals of pure consciousness, mortuaries, mosh pits, pride, history and lore, new birth, angry and expressive youth, and iconographic mantras that guide and protect anew in the present day, wildly assimilated and existence affirming autobiographical manifestos not for the faint of heart, or the weak-willed wanderer wondering, Why? Why?

We engage in direct dialogue with ourselves, and that which is so humbly beyond us; that's what this work is about… Perhaps. Let the work be its own binary being. Some are richly illustrative and tell a very personal, generational story that is screaming for the most expansive and devouring colorful coverage, or a full book as completed arm. Some work meditates and chants high above the holy mountains of the Himalayas, singing the joys and discoveries deep inside the sublime internal space, and steps into transcendence and the code of pattern from the South Pacific islands while on a far-out, cosmic, psychedelic journey on the equidistant, perfectly measured, rainbow-ride of cross sections and vivisections of pure magic mathematics. Some tattoos say "I love heavy metal," the aching need for that much more black and its symphony of transportive, darkest fuel and fire, skateboarding, punk rock, and all things in the name of a damn good time. Lyrical declarations of, "I was here and I'm leaving these very specific marks." Work that says, "I need to document this moment and bleed for this." An ever-evolving stream of images, elements, emblems, icons, eulogies, and organic, eternal, thematic-collectively conscious content, for things that matter *are* matter, or are things that need to be given visual life and heat. An electric transformation, trial by sharpest fire, like being punched by razor blades with vibrating sweeping knuckles because it matters enough to them, and they found the artist to translate their impulses, dreams, nightmares, and wanting wishes. Or maybe it was just time to get tattooed. Again. And this musculature and flow from the pectoral down to the wrist is what they want, and we have to make *that* work for them. Maybe it's simply a clean piece of skin, with a strange negative shape and space where that idea will be sweet in the hands of this or that rad artist doing that rad kind of work at the time, and millions of variations as vast as new humans adorning their largest organ. What myriad ways to consider illuminating just that form and anatomy, just as long as it flows and works. Or that may not even matter. Whatever is clever, whatever *that is* is what they want. Only that. *But* that.

Some are forming new constellations, and have blasted open portals to whole other glyphic dimensions, and the fabric of the stars high above, and are so deeply under the ground of mainstream knowing, and that music, that amazing spectrum of music, that makes our senses soar and select. And grown into the seen future of our ancient earth carrying the ever-mysterious pyramids in Egypt into the flesh dot by dot, where gods and timeless symbols of our mortality, and that which teases on the other side finds its way through water and ink and the need to make it all real. While East Los Angeles cholo gangsters, and science-fiction word nerds combine elements, styles, and detailed flourishes that mutate and honor San Quentin inmates in the form of the scripted word taken to whole new levels of ornamentation, other formal integration, and stylistic evolution. I could go on forever, but this book is about what you're seeing, not so much what you're reading, dig? Man, I am stoked on the work in this book. Amazing tattoos are being crafted all over the world, every day, and I trust that the work in this book represents some of the most interesting and forward-moving tatts being made on the planet at the moment, while at heart, simply being strong, well-crafted tattoos, this being the center of importance no matter how nuanced, radiating, distinct, or searching their stylistic sensibilities may be.

I hope that the drawings, paintings, personal work, and projects in other mediums give dimension, enriching and further inspiring and informing, anyone who will experience this book. I am excited and honored to give these artists the well-earned, and deserved vehicle of a book like this, and have been thrilled to explore and absorb their work that much more in the process. No matter what happens to the larger, pop cultural, rapidly evolving, and expanding waves of tattooing that wax and wane like the moon and are subject to trend and cycle like any art form, fashionable or fleeting, one thing is for sure: the true artists will be the ones with their heads down, deep in thought, pencil in hand, staring at thousands and thousands of sheets of blank paper that stack high into the heavens of the folded out future; climbing onto each one, one at a time, staring, studying, mentally wrestling with the idea for hours and days, or, freely, quickly banging it out with such fluid aplomb and ease just for you, cohesively conjuring the requested, researched, or spontaneously sparked force of the present moment, one human, energized mark at a time.

Written in Ink

Carlo McCormick

12

Tattoos are celebrated or (more often) reviled in our culture, yet we have spent a great deal of energy parsing out the reasons people get tattoos without wondering nearly so much about what sort of person makes it their mission, craft, and business to be a tattoo artist. As this book collects some of the most prominent and accomplished contemporary figures in this field, it also begs the bigger question of what they have in common beyond the sum of their individual talents and particular visions. People have their own personal reasons for why they choose to adorn their flesh with tattoo art, and these causes are in fact historically contiguous to long traditions of form and functions tattoos have followed throughout myriad cultures for many centuries. Certainly, in understanding the need and desire for such art, we have some clue about its practitioners, but as elusive as any artist's persona may be, we will also have to dig elsewhere as well in order to fully fathom what sort of person decides to become a tattoo artist.

Though the practice of tattooing is too ephemeral for us to know how far back into the shadows of time the practice of tattooing extends, we know from the discovery of "Otzi the Ice Man," a more than five-thousand-year-old tattooed man discovered frozen in the Alps between Austria and Italy, that it is among the earliest and most enduring of our visual languages. Although history has not been kind to the art of ancient tattooing, often minimizing or misinterpreting the evidence, we now know that it existed in every continent and most cultures across Europe, Asia, the Middle East, Africa, the Americas, and (most famously) Polynesia, indicating that as a creative act of representation it is practically hardwired into the human condition. That tattoos were employed for differing reasons among the greatest of our ancient civilizations including the Egyptian, Greek, Roman, Persian, Celt, and Viking, also suggests that as far as any other mode of writing or drawing, our bodies—or more specifically, our skin—have long been considered as worthy a canvas for the distillation of meaning, design, and creativity as any other surface out there.

Anthropologists have, to the best of their interpretive skills, come up with pretty plausible theories regarding why different societies chose to make a custom of these forms of body adornment, and considering how they love to bicker among themselves, we must take their relative consensus on these interpretations as a veritable truth. They've also figured out the different implements that were used to get the ink into the skin across the vast

expanses of time and geography—details this writer must confess to find as boring as the nerdish rapture some tattoo artists have for the evolution of early tattoo guns. Not a tool man, these discussions often seem as beside the point as wondering what sort of paintbrush was used to make a masterwork. In all this however, there seems to be very little consideration for the artists themselves, as if so complex an iconography, so painful and labor-intensive a process, so careful a craft and deliberate a hand were simply reducible to an artifact like a stone spearhead or monetary token. If we take the paintings in the caves of Lascaux to be art and can debate their creator's intentions ad nauseam, perhaps tattoos deserve some similar consideration.

As tattoo is a migratory art form, so often conveyed across the world on the bodies of seafarers, it is possible to historically trace the migration of the art and its primary forms from culture to culture both as a matter of custom and stylistic influence. Remarkable, however, is that even without definitive cross-cultural interaction tattooing has often arisen spontaneously and independently around the world. For all this diversity, it is notable that tattoos have served a very limited consistent set of meanings and uses. These of course go further in explaining why various people choose to be tattooed rather than the nature of who made them, but lacking the ability to talk directly to the ancients we also gain a clue as to the kinds of people, then as well as now, who undertook this cause. From the earliest example there is some indication of medical or therapeutic use—the Ice Man tattooed as a palliative for arthritis—and it has also been used to indicate where on the body surgeons must operate. Ancient medicine, however, was a magical art and by far the greatest lineage of tattoos in the world has served ritualistic purpose. Certainly to this day we see signs of the contemporary tattoo artist standing in some surrogate role as a shamanic figure for his or her subjects.

Among the many reasons for tattoos, if we had to divide them into two basic sorts, we could roughly describe them as either iconographic or decorative. This split between content and design is fundamental to all art forms. If the former is more often weighted above the latter (decorative remains a slightly condescending term in the arts), as a matter of pure aesthetics there is much to be said for the kinds of intricate ornamentation found in some tattoo art. Furthermore, as a matter of adornment, it would be hard to see how calling a tattoo beautiful, despite

the wages of modernism, could be a pejorative term. This too is complicated in the tattoo world today by the fact that so many of its most popular motifs, from the bold abstractions of the neo-pagan to retro stylings of its classic symbols (such as the talismanic imagery used by sailors), are far more a matter of design than content. Nostalgia, as with so much related to fashion, may have a lot to answer for in this regard.

As to the meaning of tattoos, though particular to the lore and traditions of each society, their objectives are notably direct and limited to but a very few motives: they serve as amulets, or talismanic protectors; status symbols, most commonly of nobility or coming of age, though in some cultures like those of ancient Greece and Rome, China, or Nazi Germany, as a punitive stigma; and personal declarations, predictably of love and faith. Connotations and imagery may have shifted and evolved a great deal over the centuries, but these changes remain almost idiomatic considering how constant the cause for tattoos has actually been. Of course the savvy heads among us will be able to come up with aberrant examples that may prove some exception to the rule, but considered on a psychological basis, it would be hard to find any tattoo that did not in some essential way bestow its wearer with a superstitious sense of empowerment, a degree of status, or in some way proclaim their affection for and affiliation based upon representation. In this we have a crucial descriptor of the tattoo artist—they are those in society who choose (or are chosen) to be the conveyors of such meaning. It can perhaps be argued that all art caters to these basic roles, but in doing so we must also acknowledge that tattoo artists above all others are keenly attuned to these properties of their medium.

Because we are talking about contemporary tattoo artists rather than those of prehistory, we need also address the more recent position this craft has held in our society. The resurgent popularity of this medium was triggered in a large part by the explorations of the nineteenth century, most notably Cook's discovery of Hawaii, but also interactions with other cultures like the Maori in New Zealand. Also, its spread was facilitated by the class of sailors who traveled the world, at once bringing it to places where it was less common or forgotten and interacting with native forms, such as those in Japan, that further evolved the art. Two other subcultures that were just as fundamental to the rise and proliferation of tattoos were the criminal class

and the demimonde around circuses and carnivals. More than continuing to perpetrate this art form, however, we must recognize their significance has also been in qualifying it as a kind of visual taboo. From the identification that certain artists and writers manifested with criminals, there is a direct link to the embodiment of the marginal and working classes within youth culture of the postwar era. Long before fashion models, movie stars, and affluent suburban youth would ever have considered getting tattoos, its purpose as a rebel and renegade signifier made tattoos spread throughout the rising ranks of rock-and-roll outlaws.

The tattoo artist is all the things today—a shaman, an outlaw, a carnie, an itinerant journeyman, a manufacturer of status and immunity, a scribe of our most heartfelt devotions. More than all these other attributes, however, they are first and foremost artists. Just as we understand that a painter, a musician, a writer, a filmmaker, a sculptor, and a performance artist are each intrinsically different because of their medium, so too we should in closing make some observations on how the nature of tattoos defines the character of those who create them. Not as lucrative as the top echelon of a fine-art career, tattooing is a steadily remunerative profession. Like many "commercial" arts, one can generalize that its populace is more directed by working-class concerns of making a living than, say, the fame and fortune that is the elusive promise of being a blue-chip art star. Though it has come a long way since it dwelt in the shadows of midways, seedy port towns, and jailhouse cells, those who go that route accept and often embrace the dubious patina of an outsider lifestyle.

While it is often posited that all art is an individual search for immortality—to make work that will last the millennia tattoos are by nature ephemeral, prominent for a while but by and large existent for only the lifetime of their wearers, and subject at that to the inevitable degrading vicissitudes of aging. Because it is so personal a medium, signifying just as much if not more to the bearer as to the maker of the art, it is inherently a collaborative process. Most art making is a solitary pursuit, and while there is ample evidence that social skills have been helping artists since the beginning, few mediums would require the artist to spend nearly so much time with their patrons. These of course are just a few general observations. Thankfully with this book we have the art and the artists here to speak for themselves.

DANIEL ALBRIGO

18

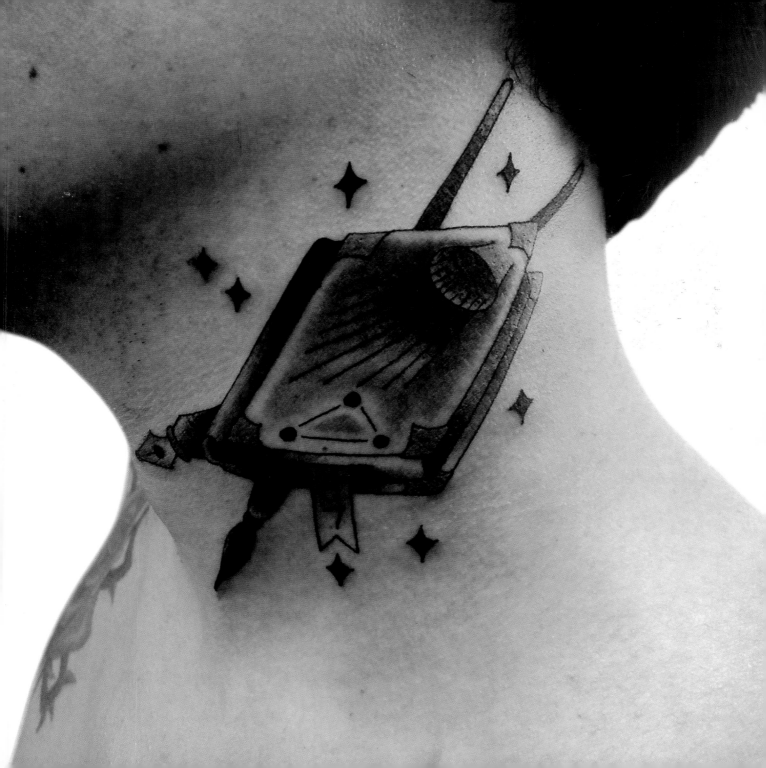

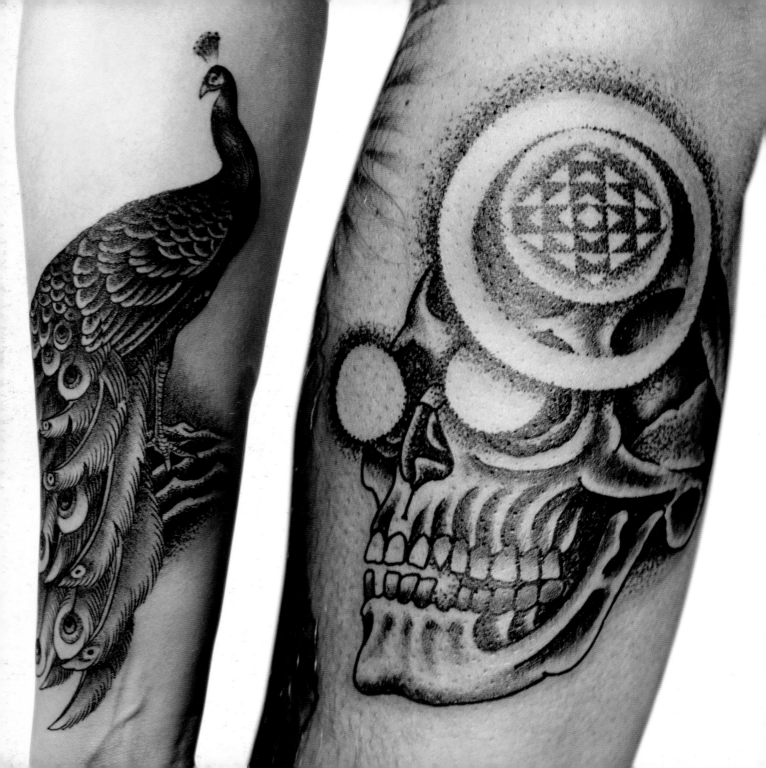

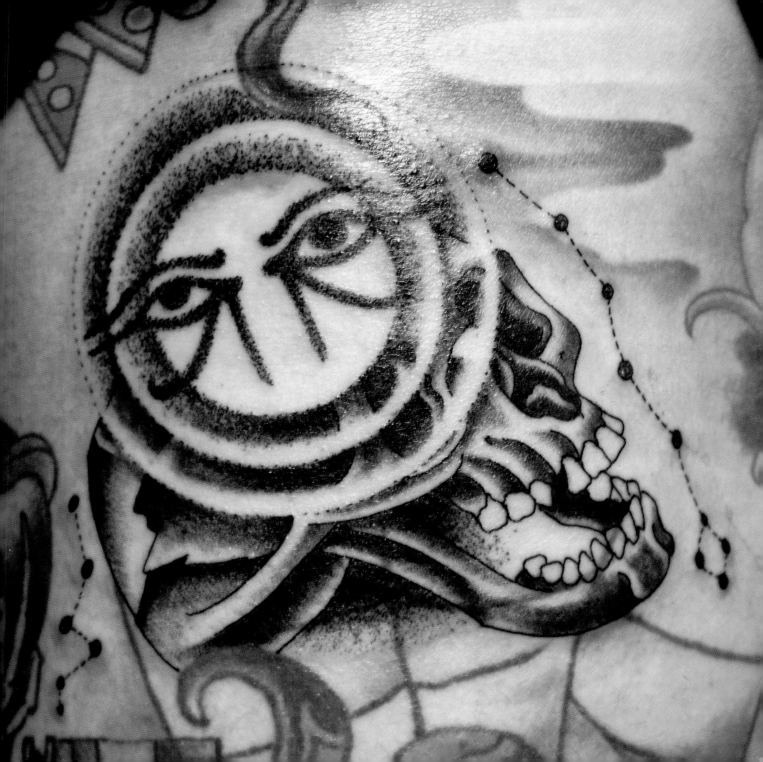

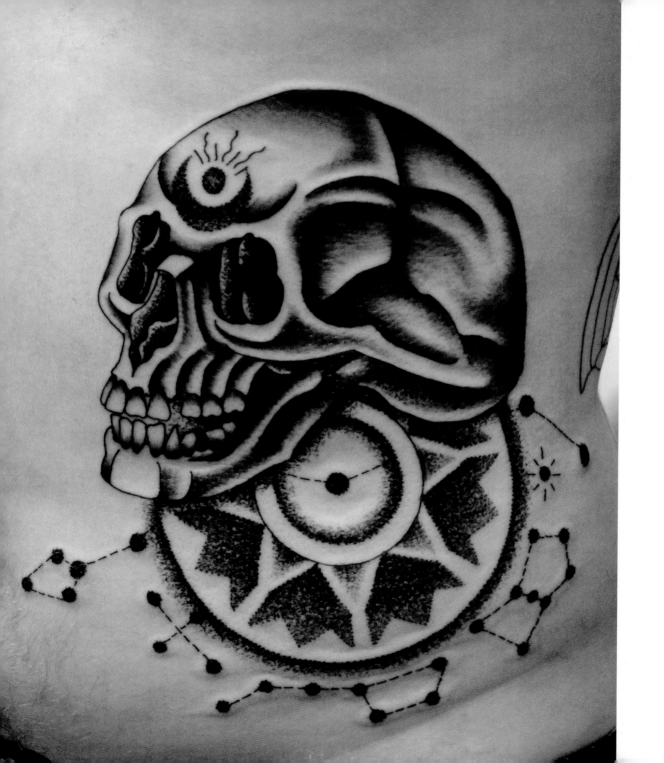

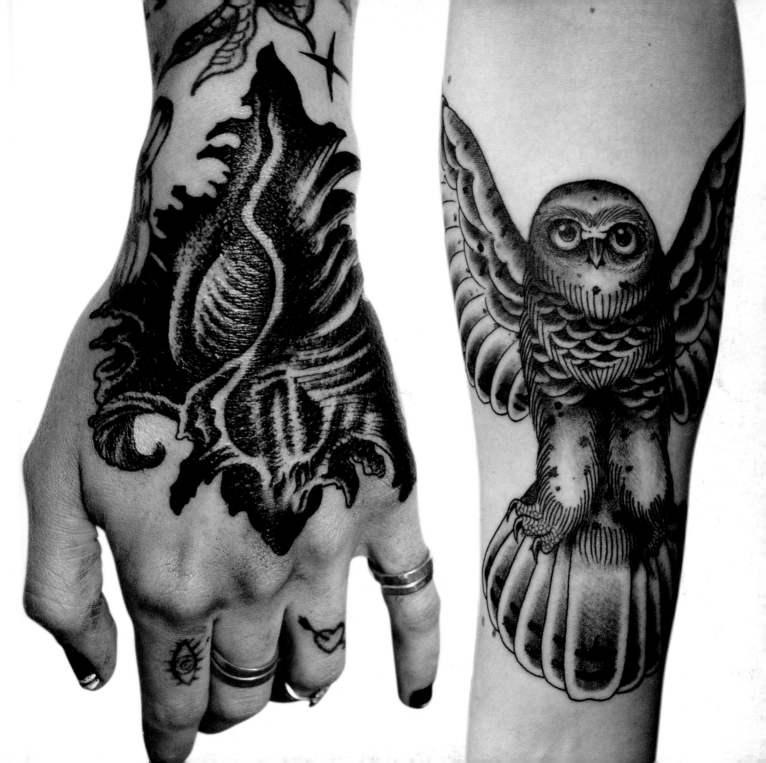

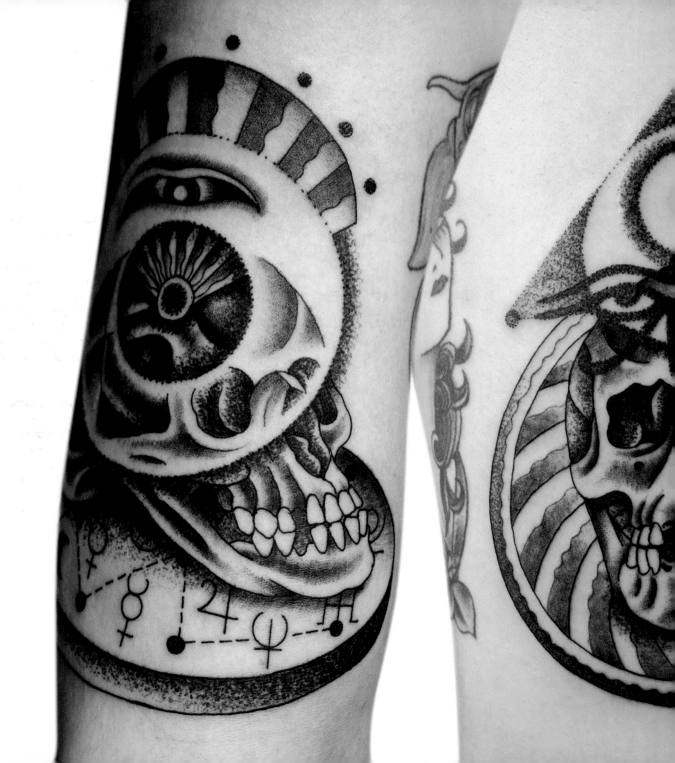

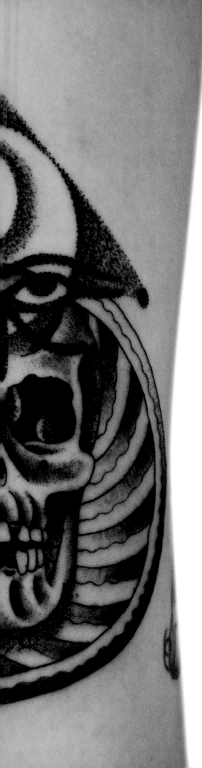

Daniel Albrigo's art and paintings have been strongly influenced by artists such as Titian, Correggio, Holbein the Younger, Rembrandt, and Jacques-Louis David. Most intrigued by what he interprets as their use of the sublime and esoteric, his tattoo work also looks to early European etch artists Albrecht Dürer and Gustave Doré for inspiration. Using the great masters as a foundation, he looks towards contemporary artists such as Sean Cheetham, Alex Kanevsky, Banks Violette, and Alyssa Monks for inspiration as well, and describes his process of drawing upon past and present artists as "attaching new horses onto an old carriage."

His connection to the late tattoo artist Sailor Moses of Biloxi, Mississippi, sets the bar high for him to create work that is special and unique, and that pays due respect to Moses's legacy. "Over the past nine years of tattooing, my work has changed and evolved dramatically and will continue to do so. I don't want to grow stagnant and produce the same thing my whole life; my art should grow like a relationship. The aesthetic evolves with your knowledge of your craft and your tools," he explains. Moving from California in 2008 was part of this evolution, as was working alongside Thomas Hooper, whom he credits as being another essential influence.

Albrigo's most recent series of paintings was a split exhibition with the English artist Genesis P-Orridge. The show focused on the death of Genesis's late wife, Lady Jaye. Reflecting on the synchronicity of their collaboration, he notes, "There was an incredible amount that happened along the way; I almost feel like we were led to each other. I believe that we all have a psychic presence and if you allow it to guide you, things will start happening. It was my internal world leading me to an external meeting with Genesis, which led me to my first major exhibition. That shit is real."

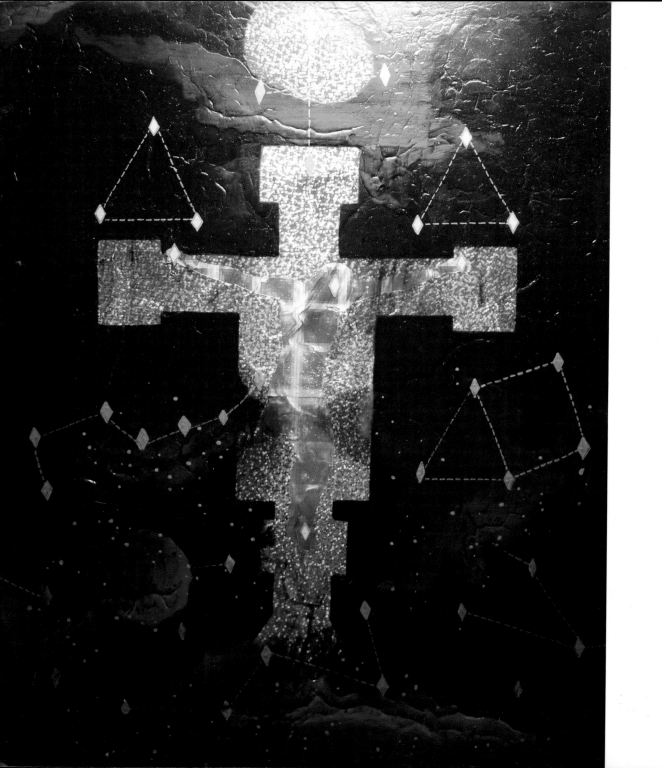

Opposite: Untitled, 2010

Untitled, 2009
Untitled, 2010

Untitled, 2009
Untitled, 2010

Opposite: Untitled, 2009

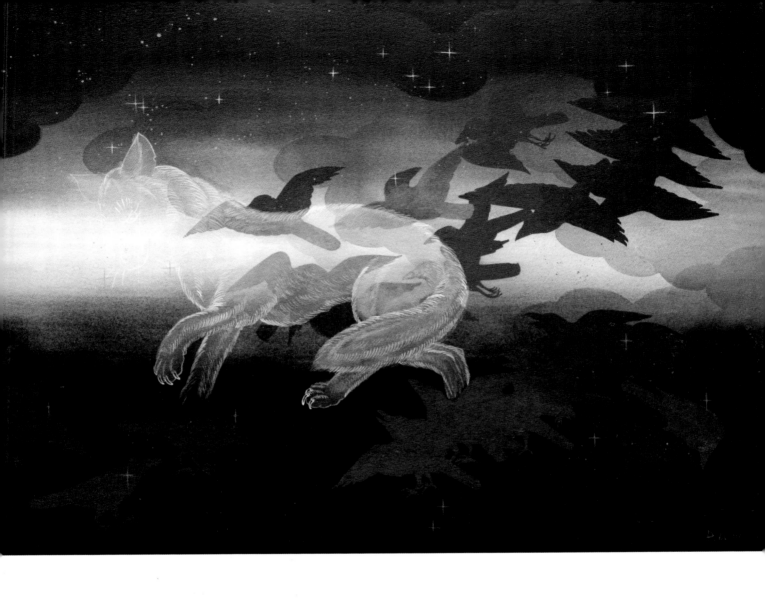

JOSEPH ARI ALOI AKA JK5

30

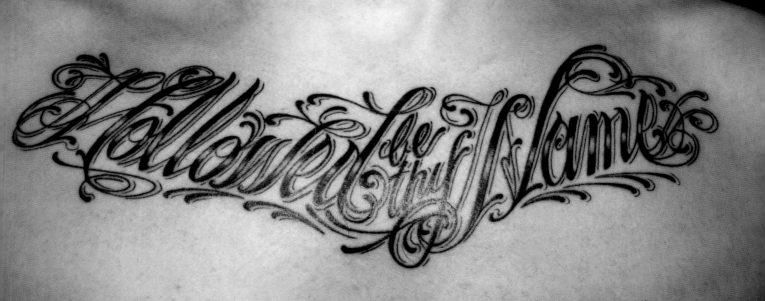

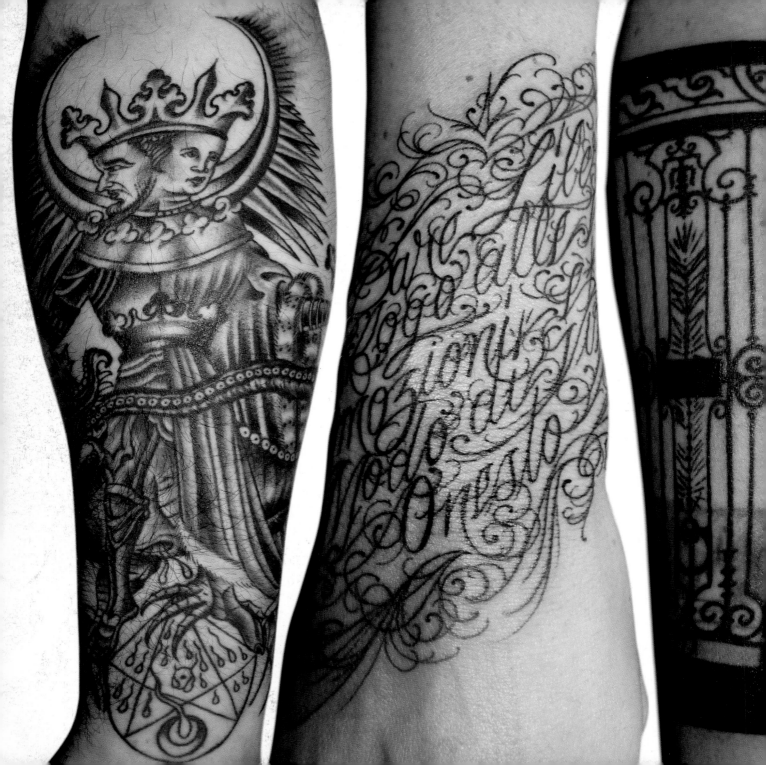

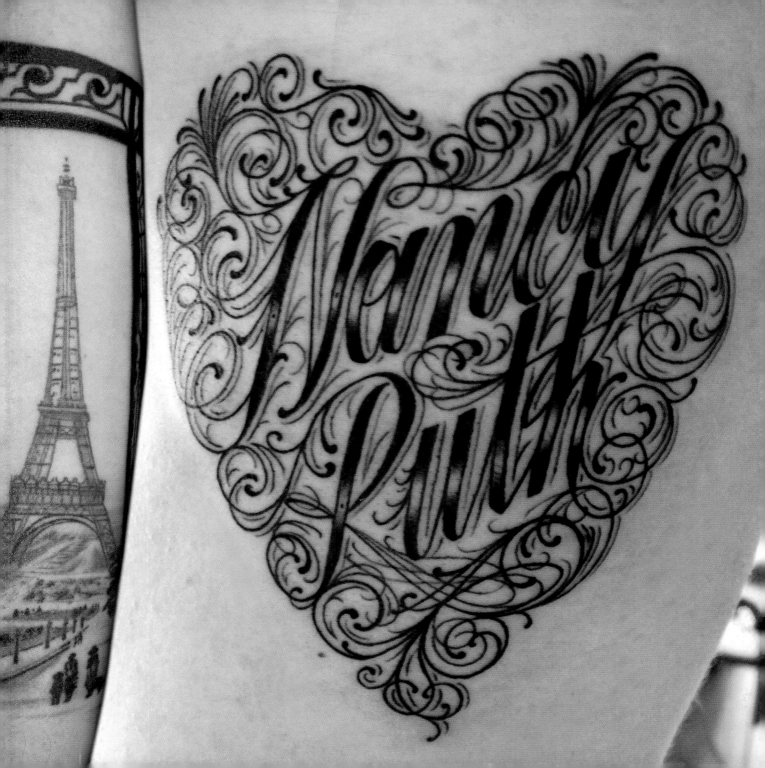

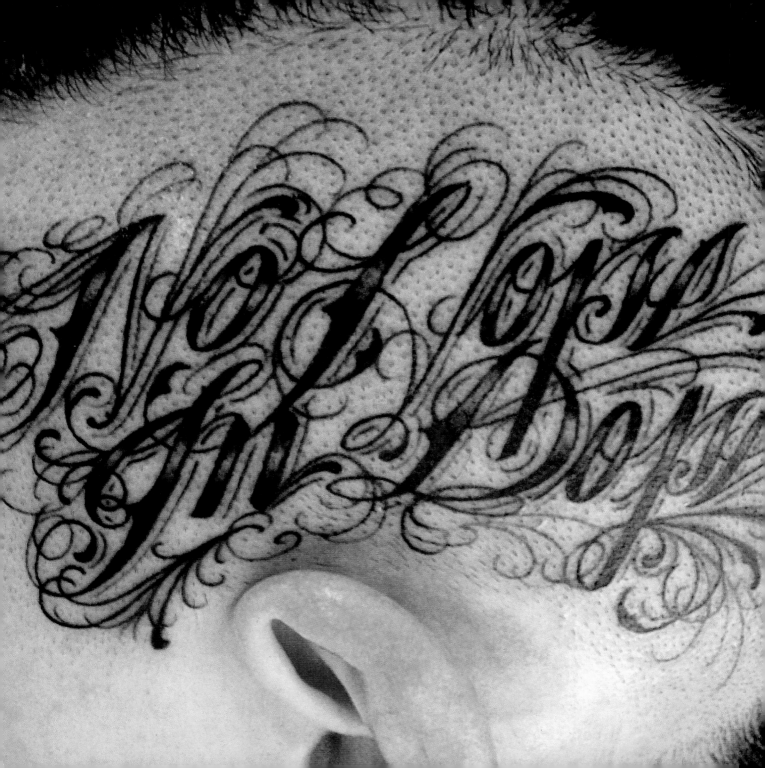

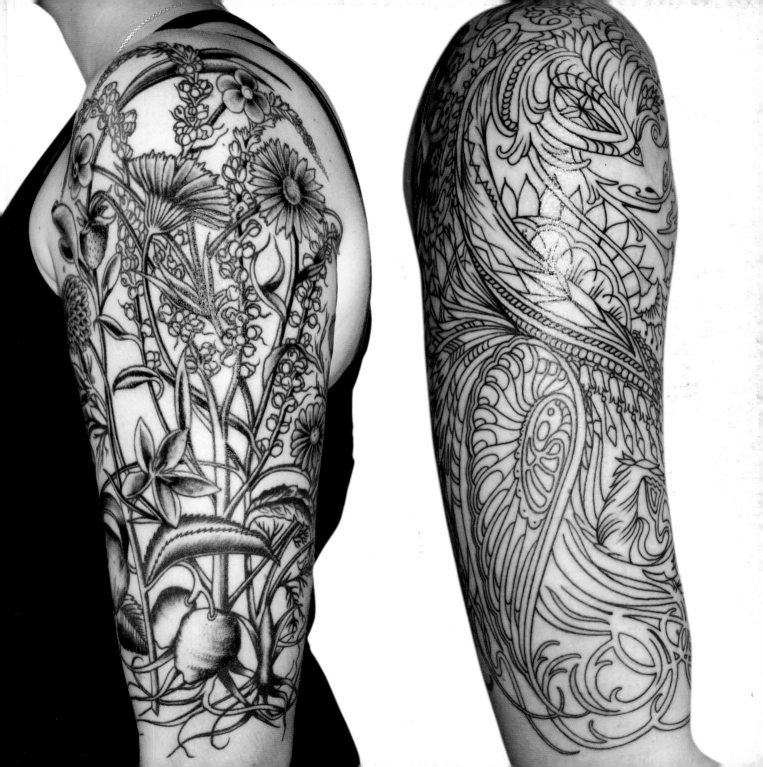

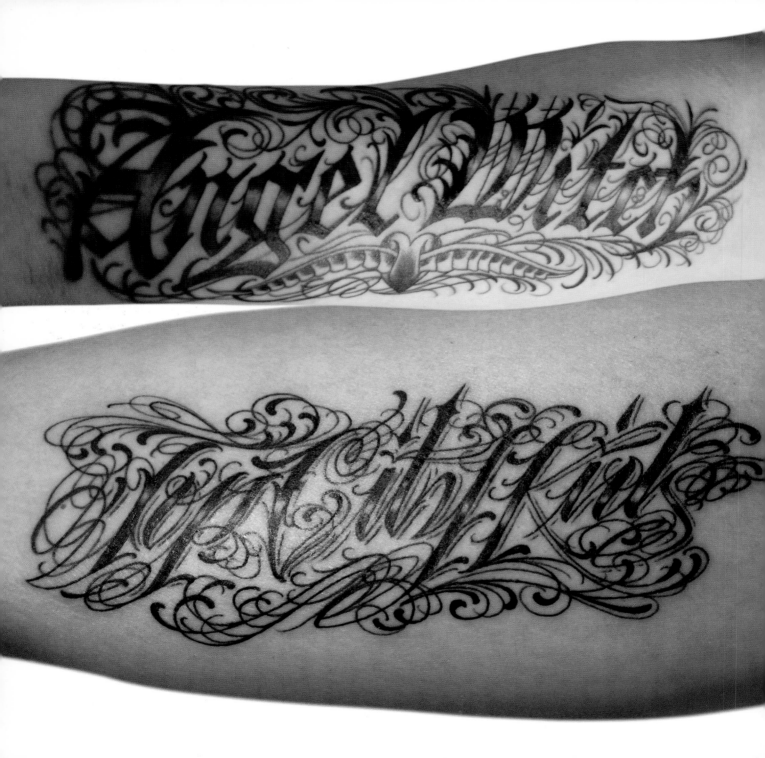

"Tattoo artists have a complex and unique relationship to the world because we are permanently marking and adorning its inhabitants. It's a deep, powerful exchange," says Joseph Ari Aloi, aka JK5. "I've had some of the most wild, extraordinary journeys while tattooing someone. We all have endless stories to tell. And if all goes well, the client will have a good one to share and remember, too."

Over the years, he has also developed his artistic pursuits outside of tattooing to an impressive degree. "My overall aesthetic is ever evolving no matter what tools I'm using," he says. "I am always working on stuff that has its own form, style, and intent." When asked about the parallels between his art and tattooing, he admits that though there is a stylistic sensibility between the two, the similarities stop there, saying that, "I've always felt that cross-pollination is vital between mediums for one's growth… But I'm not really interested in my other work looking like my tattoos; it always seemed redundant to me. Personally, other mediums and projects are opportunities [for me] to explore new ideas, narratives, and territory."

He has always tried to exceed his client's expectations, while also keeping his own process fresh and exciting. But he also acknowledges that, "It all comes down to giving the client what they want with the right individual degree of guidance. Dialogue is key. In essence, it's about designing a tattoo to the best of your ability that they will love forever. For me, it's about integrity, originality, distinction, and newness… My philosophy is at its core, a human and deeply creative one."

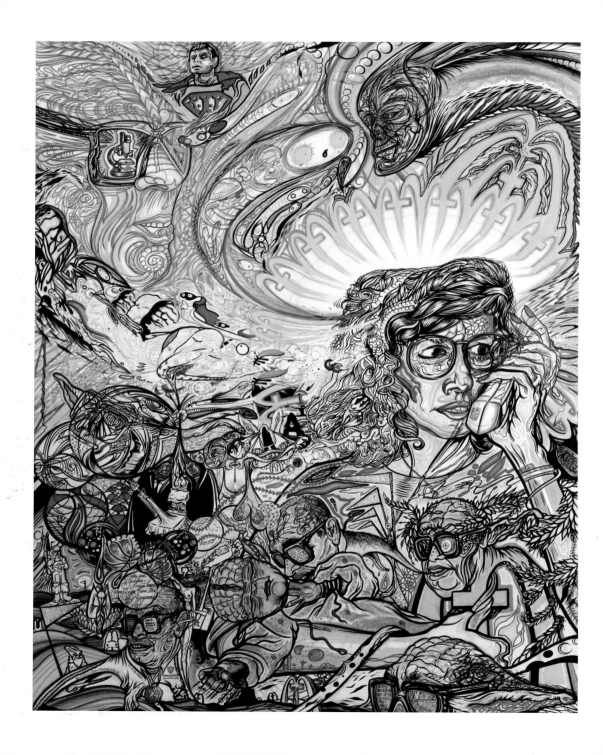

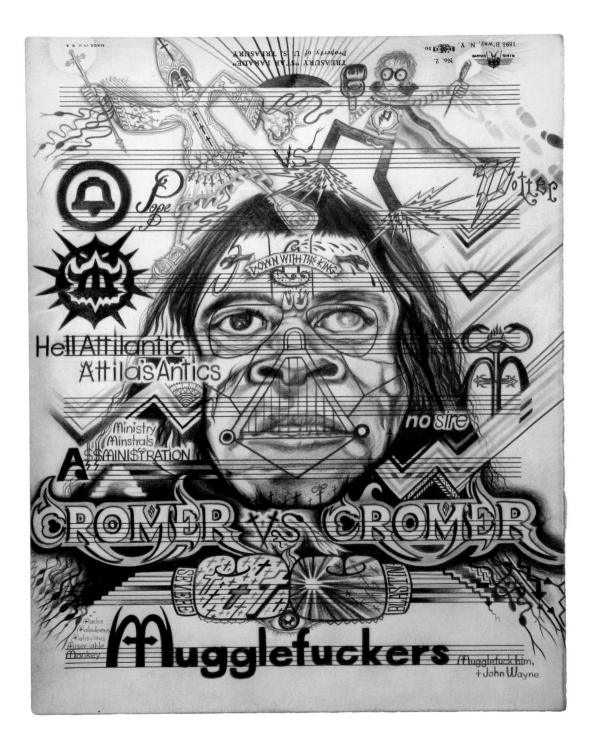

Kidrobot Flowbots, 2007
Timex Watch, 2009
Mishka New Era Hat, 2008
Mishka Sweatshirt, 2008

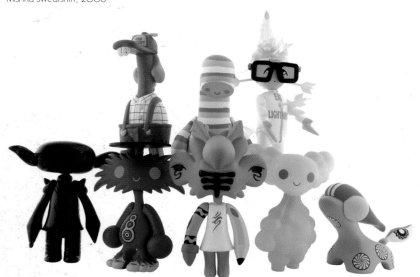

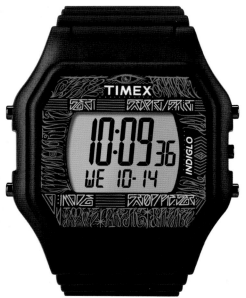

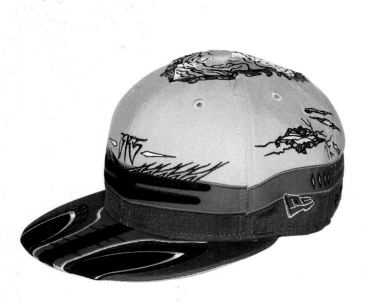

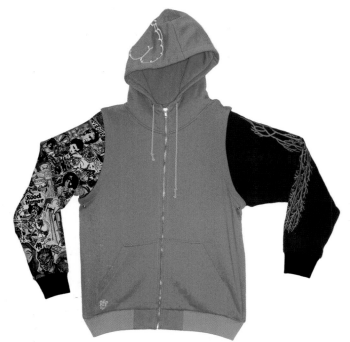

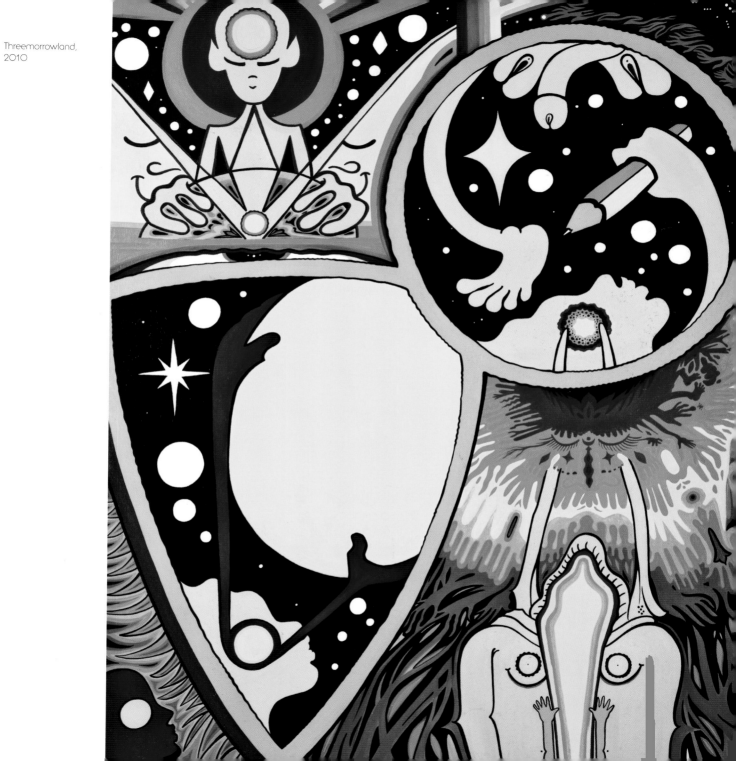

Threemorrowland,
2010

BIG STEVE

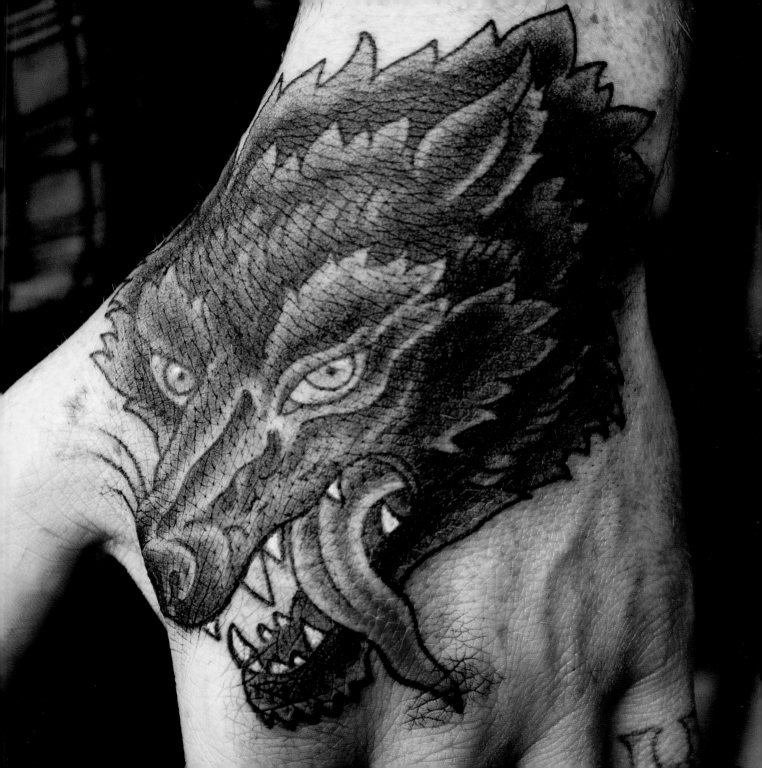

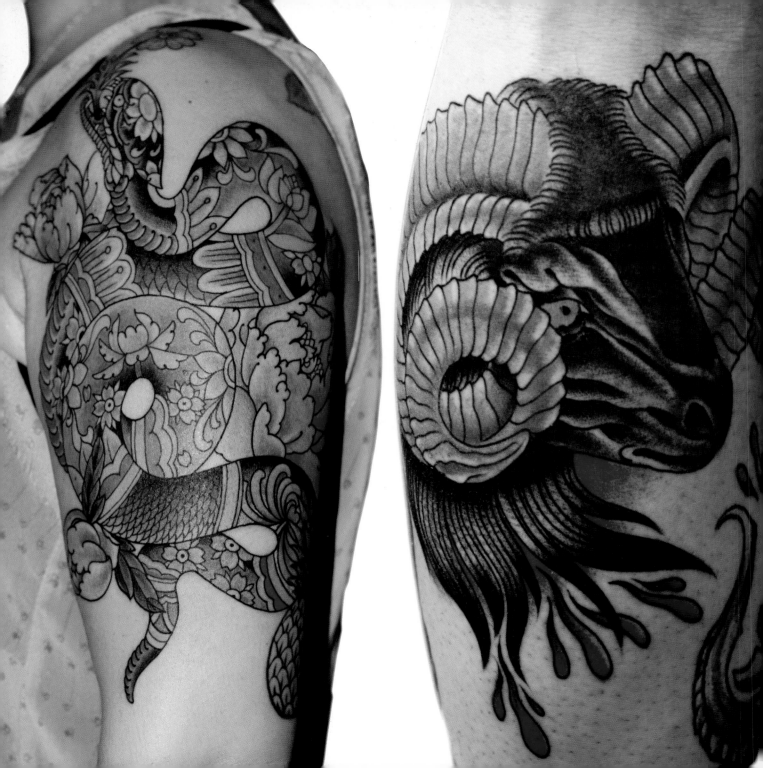

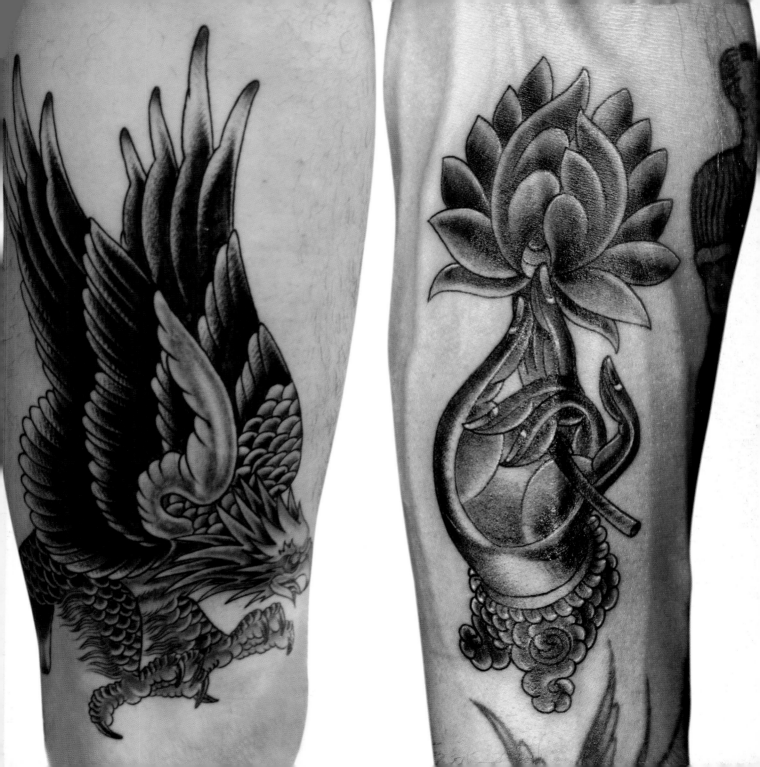

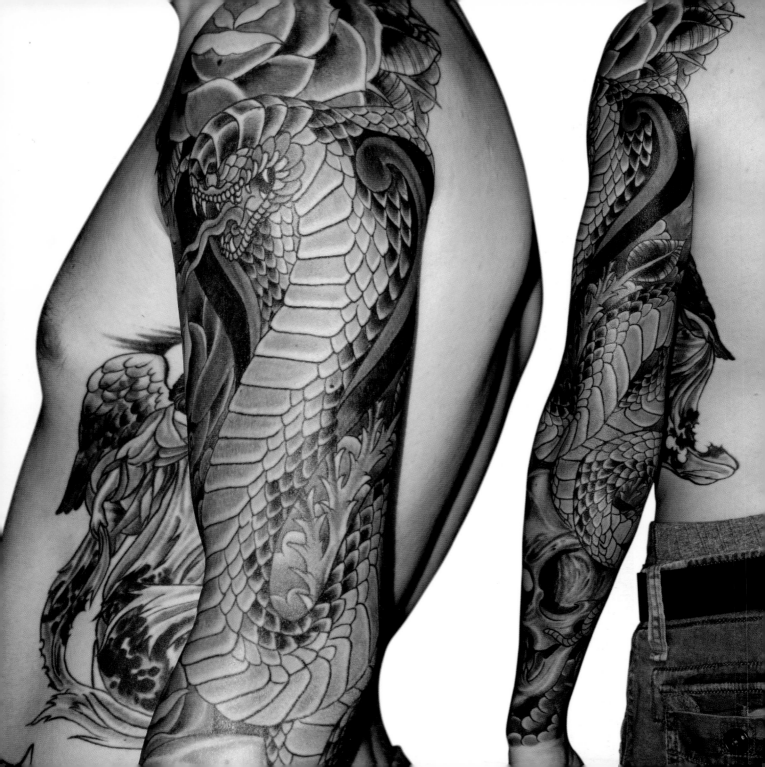

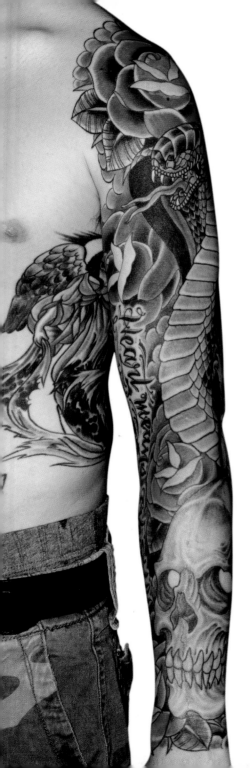

A man of self-professed "humble beginnings," Big Steve describes his technique and philosophy as being "fast and dirty." Inspired by friends and fellow tattoo artist such as Filip Leu, Brad Fink, Mike Rubendall, Grez, and Jack Rudy, as well as by the 1920s and the invention of the electric tattoo machine, his style has evolved over the past seven years. He came to tattooing as someone who "hadn't drawn much," and has since grown into an artist with a gifted hand. But don't ask him to reveal his secret to navigating the creative waters. "That is a deep question that I don't think I have to answer," he replies.

49

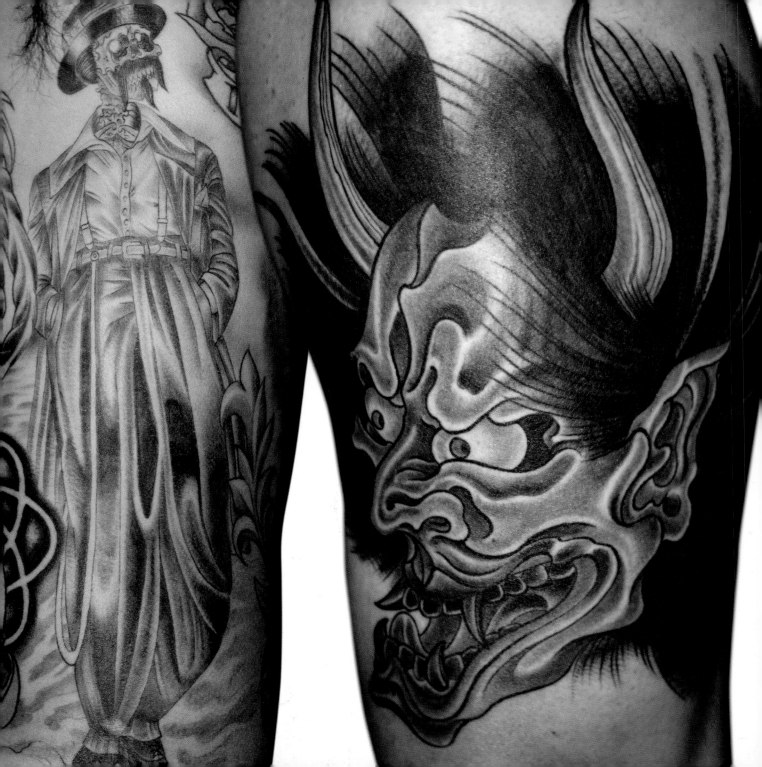

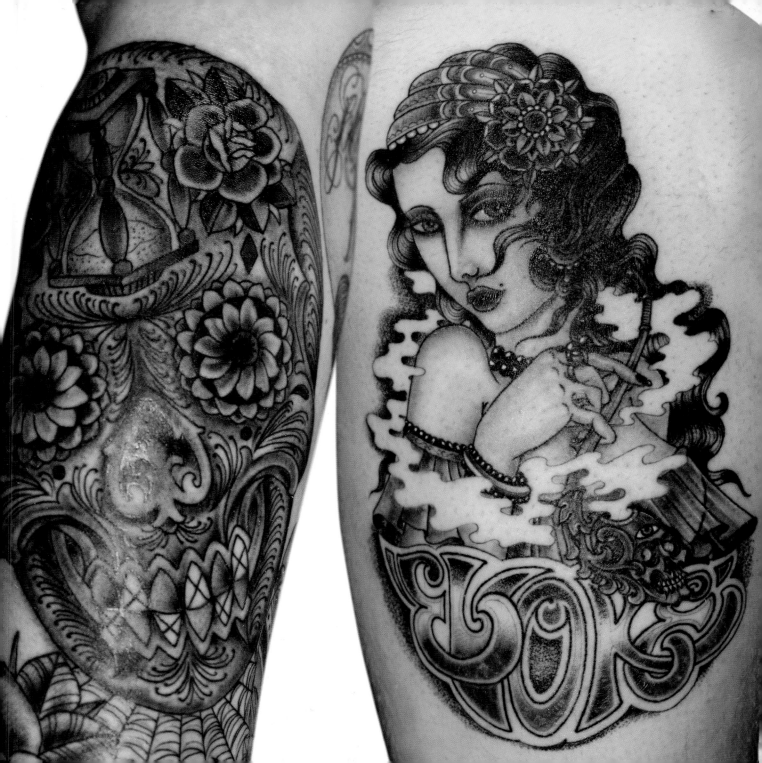

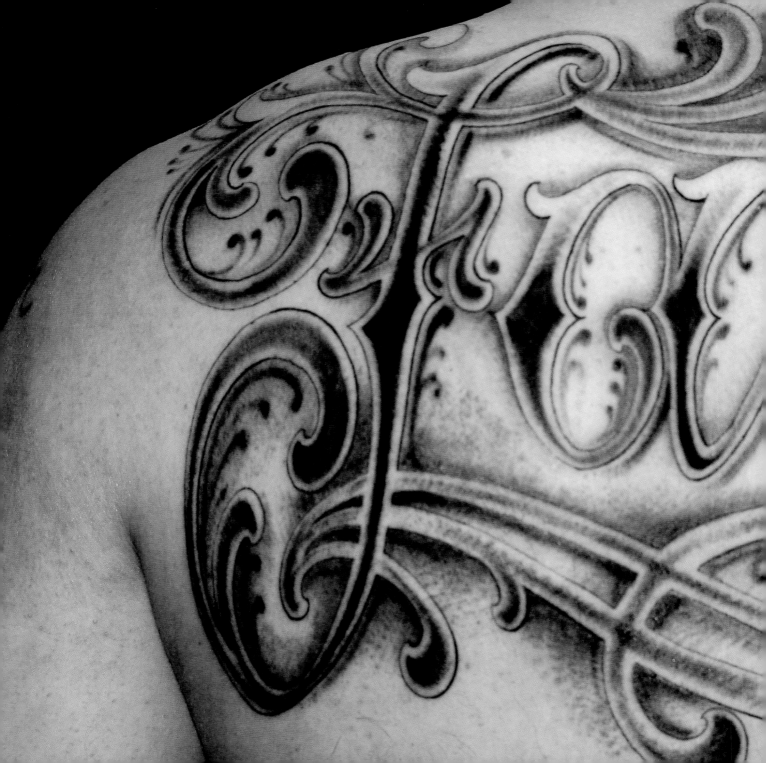

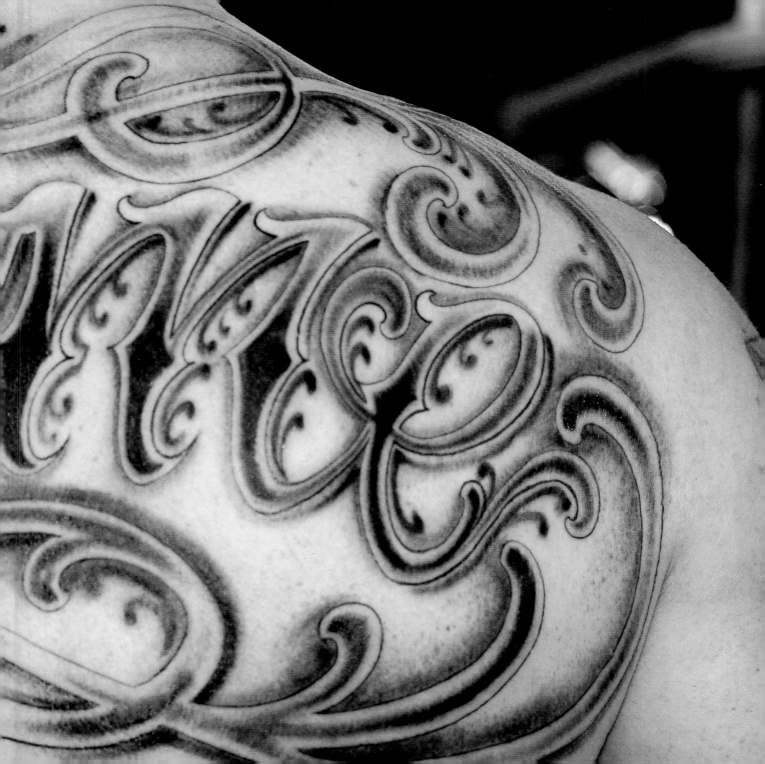

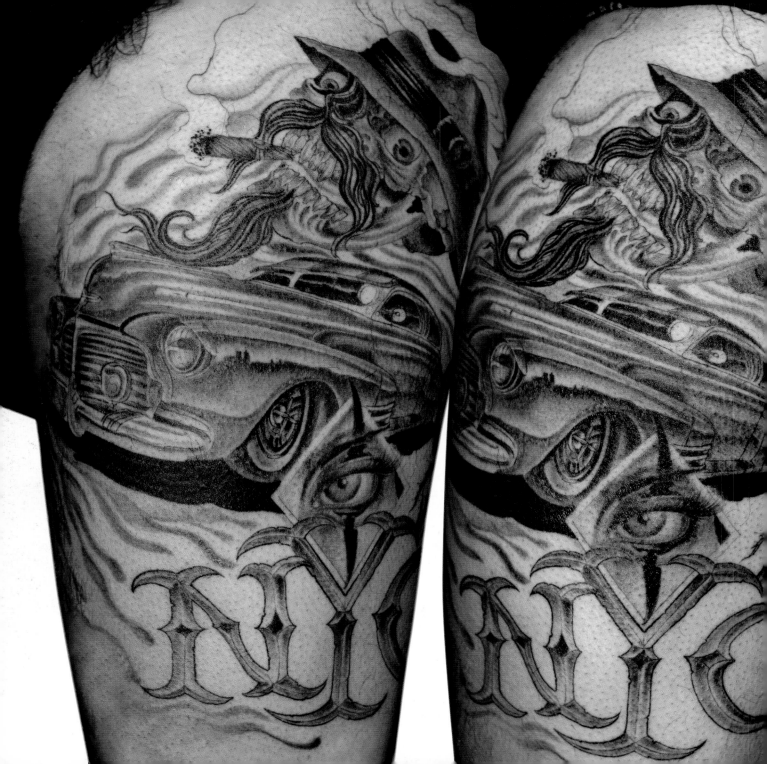

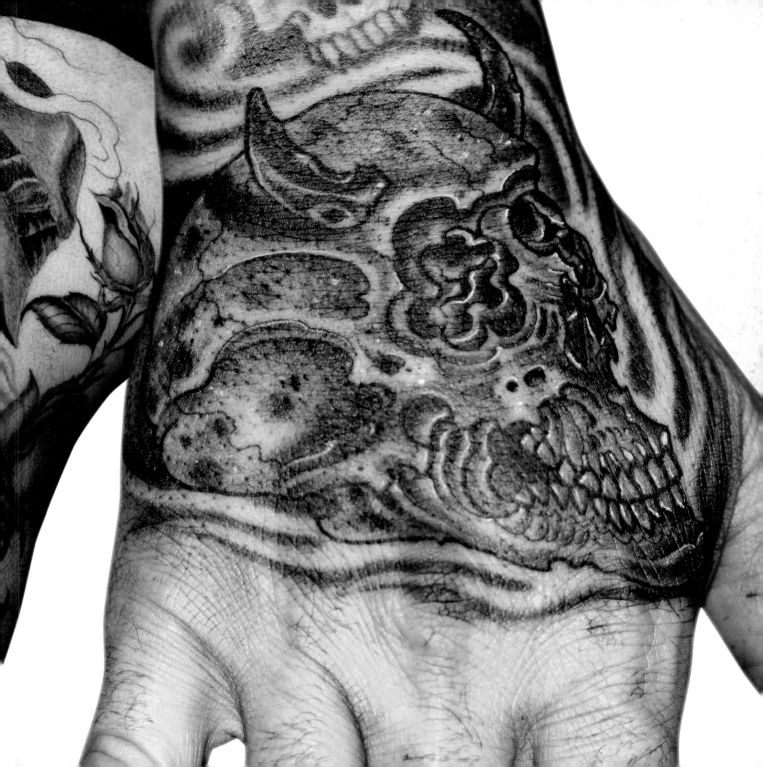

PAUL BOSCH

56

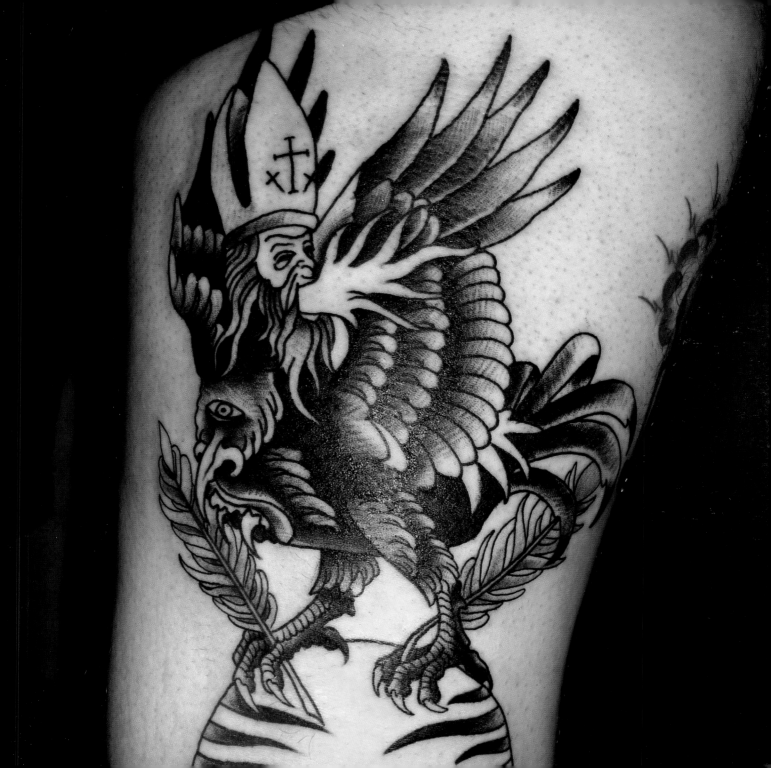

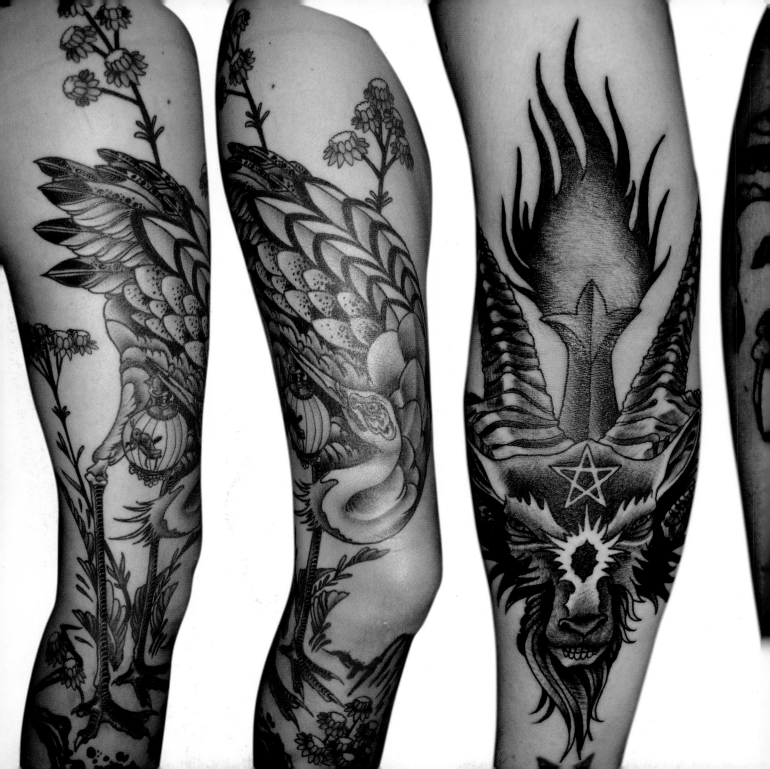

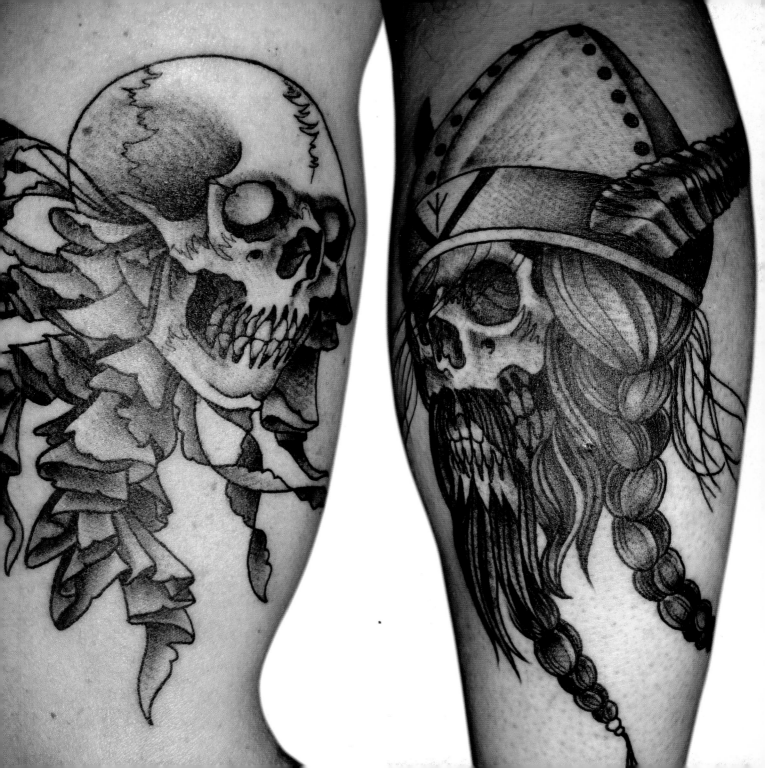

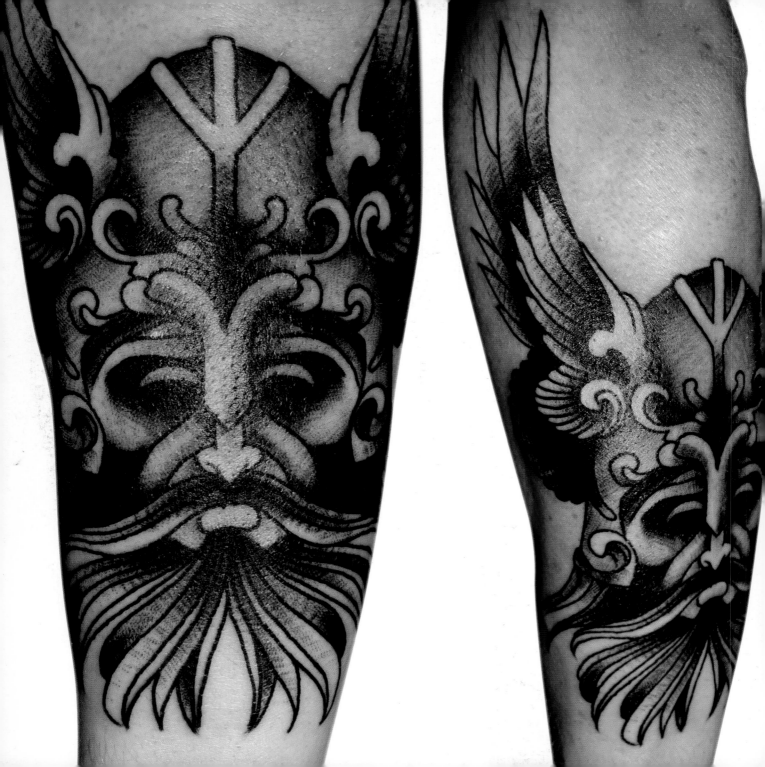

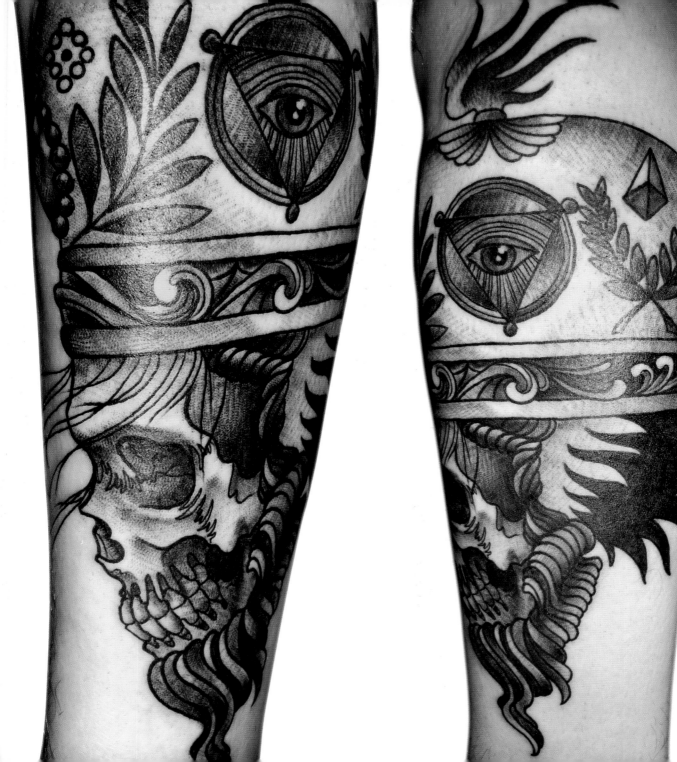

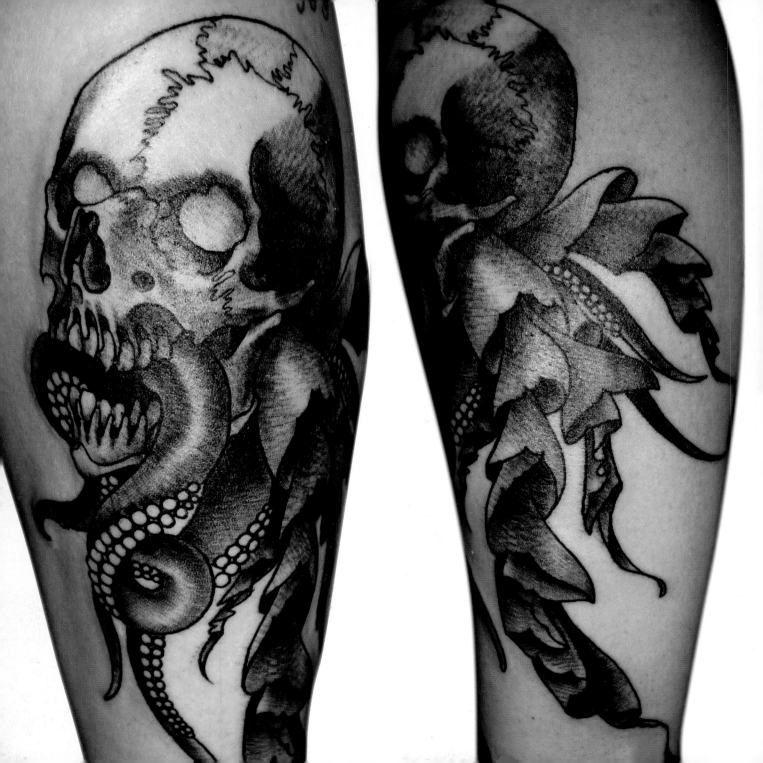

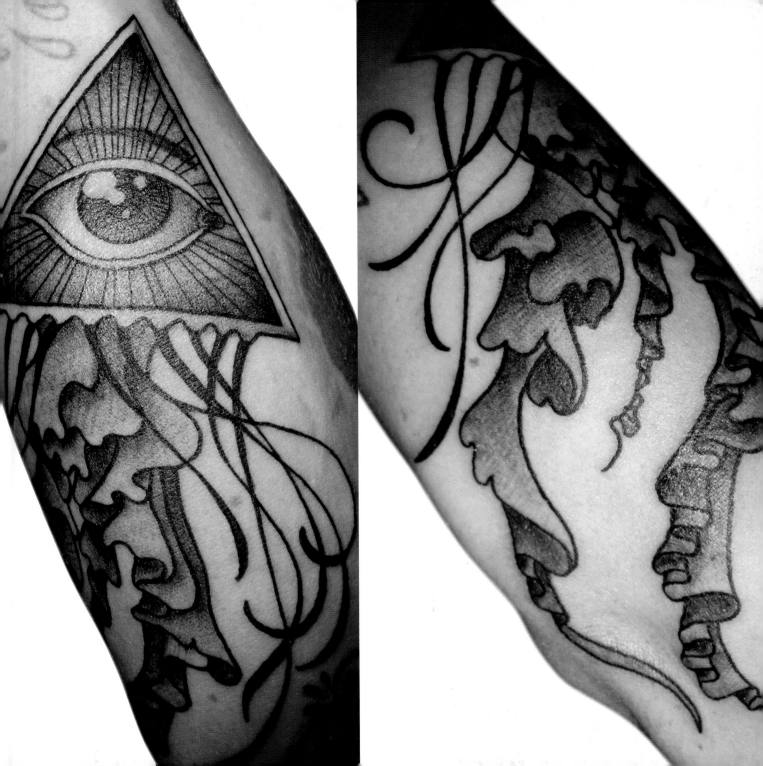

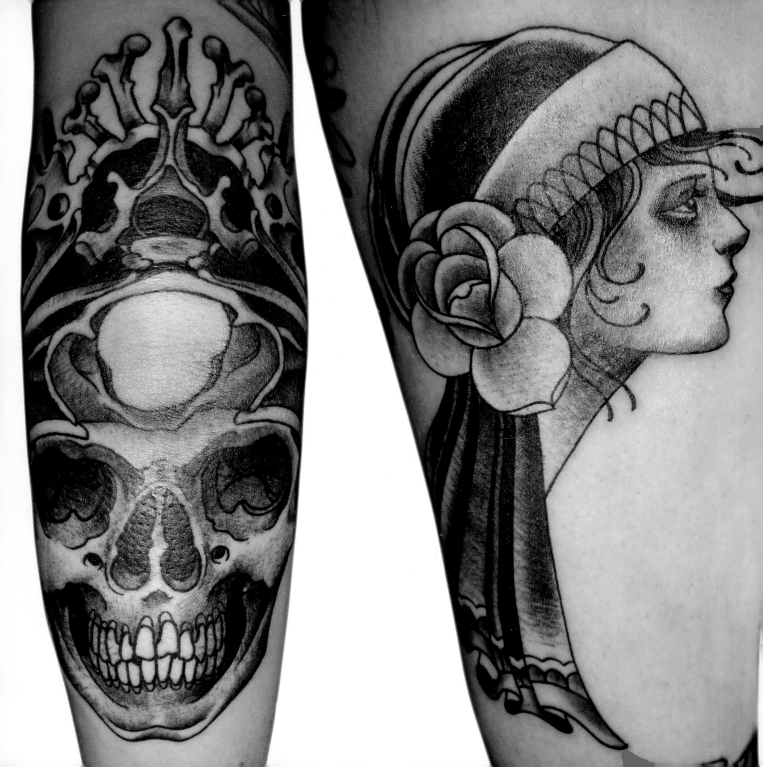

"I try to draw things in a way that comes naturally to me rather than copying someone else's style. I don't want my tattoos to look like whatever the next popular thing is; I would like them to have a more timeless look," says artist Paul Bosch. Currently residing in New York City, his work is inspired by life, death, nature, heavy metal, fishing, science fiction and fact, the mysteries of the universe, ancient history, black magic, and religion; as well as by his contemporaries. "Everyone I've worked with has influenced me for the better or worse," he says.

He describes his approach to tattooing as being primarily a mental one, saying, "I usually sit and think about what it is I am supposed to be drawing, planning it out completely in my head before I even touch a pencil to paper. I stare at blank sheets of paper for hours sometimes before anything happens." When he started tattooing, he was doing traditional American designs, which would later come to inform his own style. He has started to focus mainly on black-and-gray tattoos, while "still keeping the heavy black formula that has been tried and true for [him]."

When he's not tattooing or creating art, Bosch prefers to be outdoors. "I need to go to the woods more often," he says. "Fishing is very important, and I love walking my dogs."

Anunnaki-nefilim-human, 2010

Opposite:
Untitled, 2010

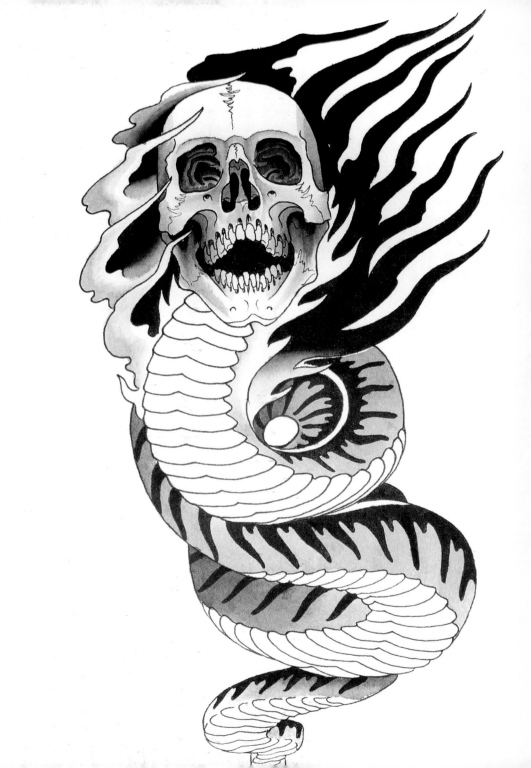

STEVE BYRNE

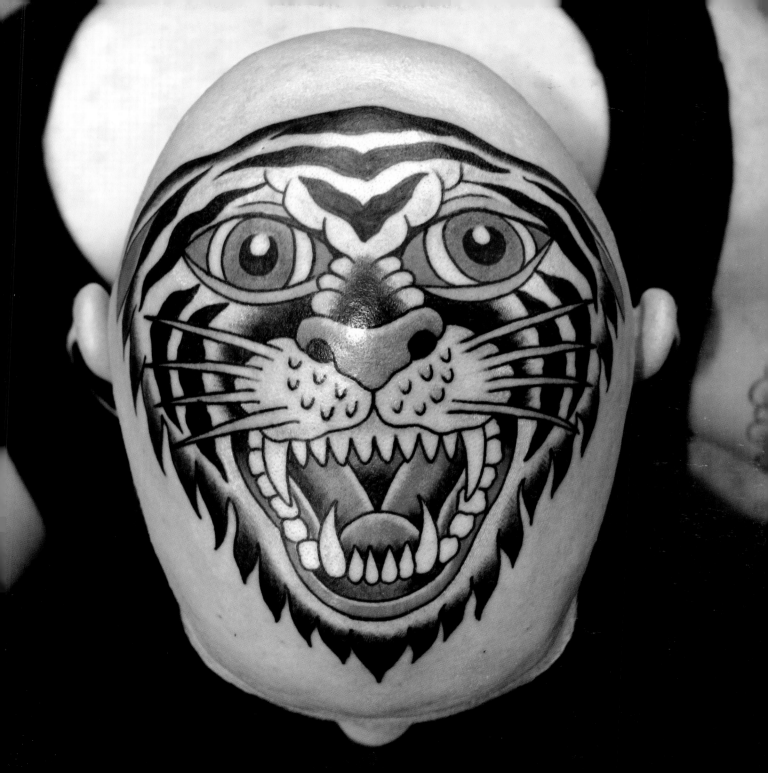

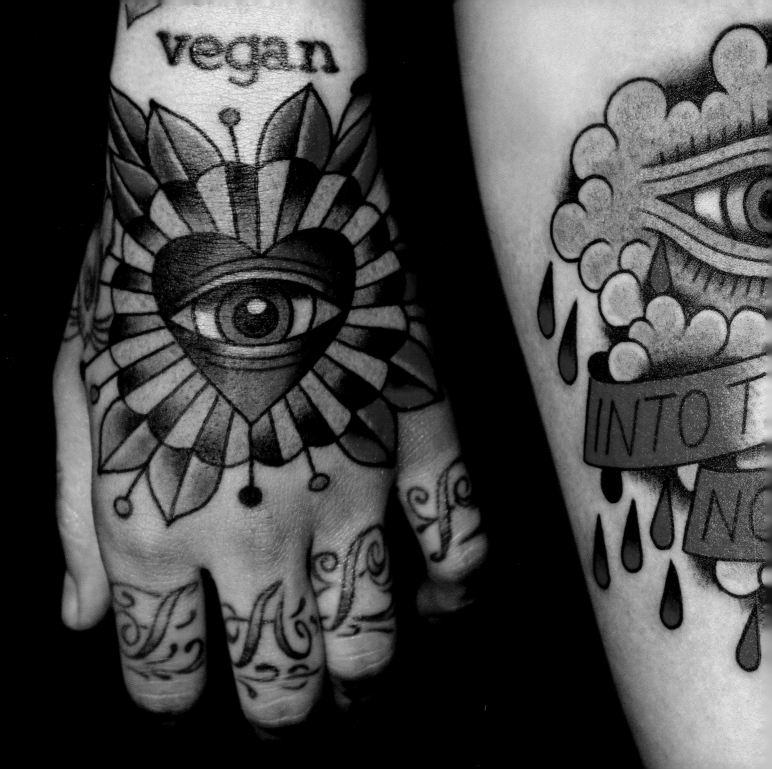

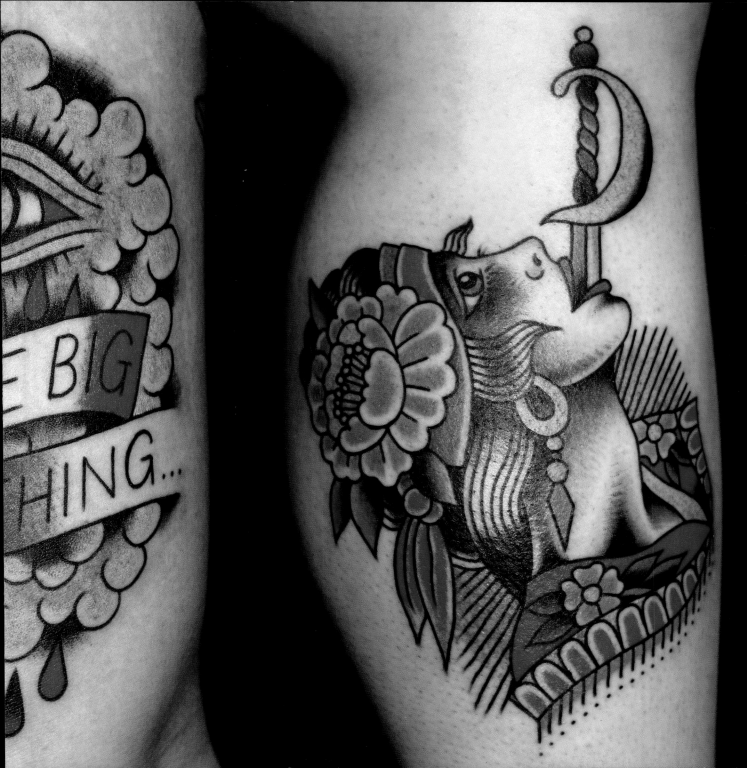

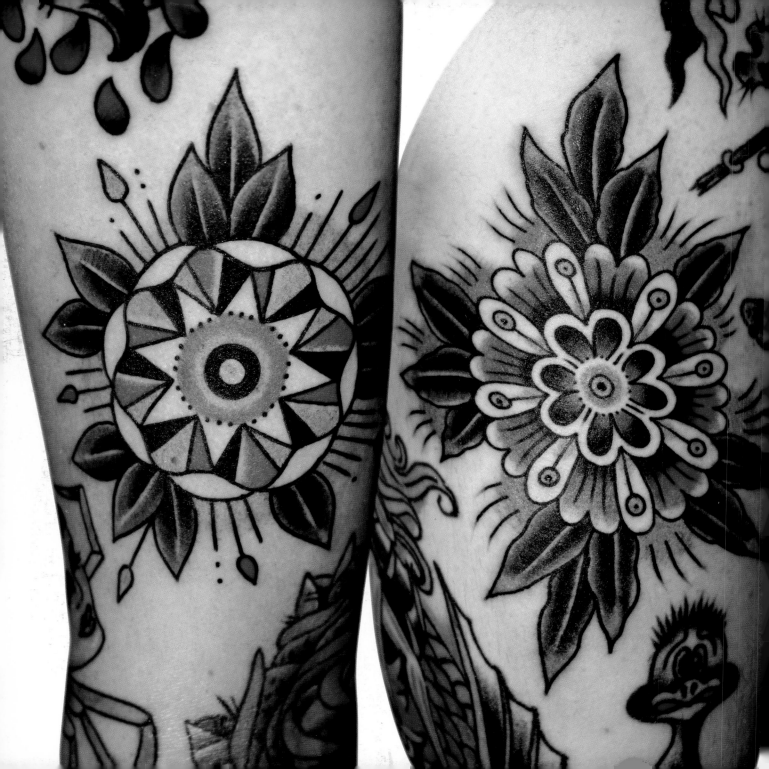

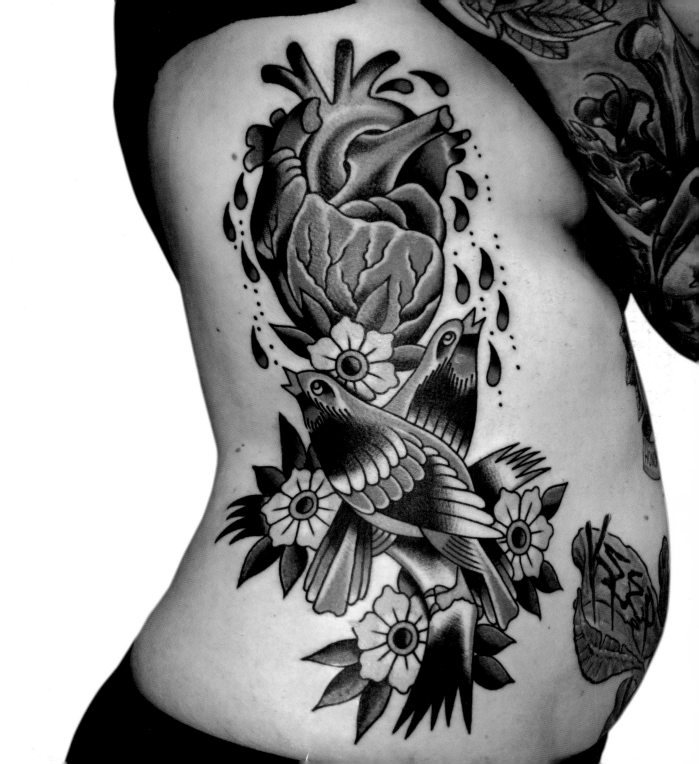

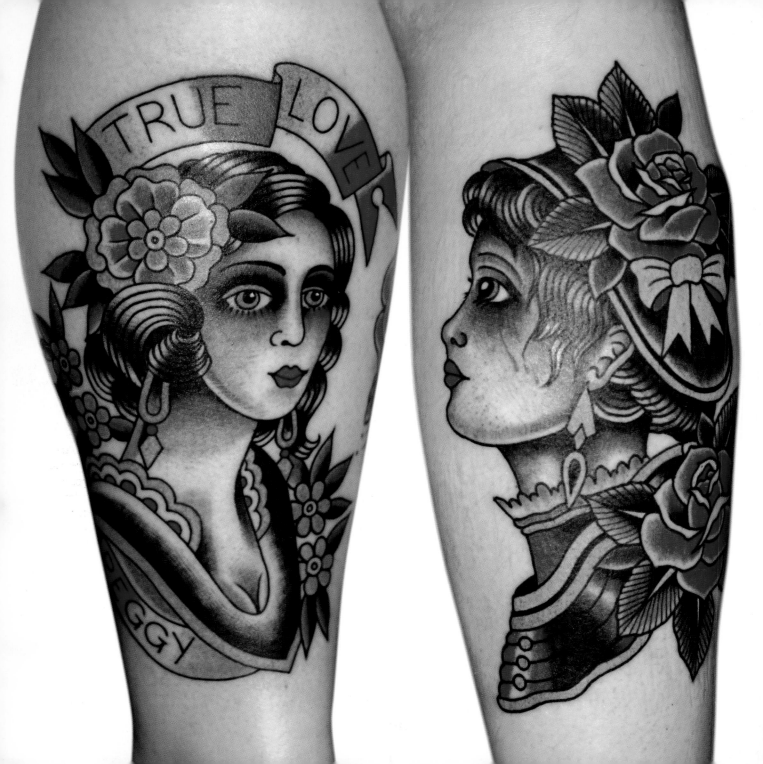

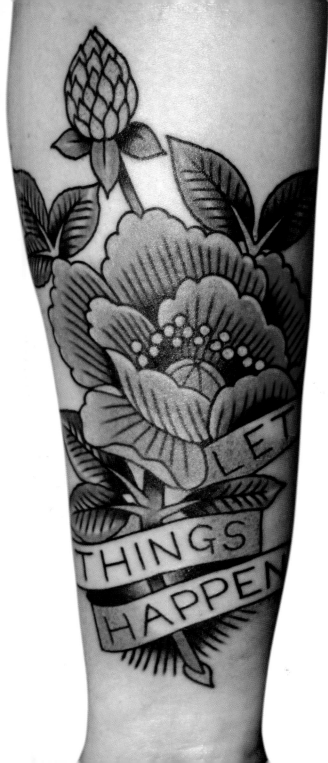

Steve Byrne cites his peers as being his greatest day-to-day influence. Currently working alongside fellow tattoo artists Tony Hundahl and Jay Chastain, he has worked in shops around the world with artists such as Chad Koeplinger, Thomas Hooper, Jason Brooks, Chris O'Donnell, and Mike Wilson. He emphasizes the influence that traveling has had on his artistic development by saying that, "If I were to give advice on anything about tattooing, it would be to travel with your work. It's the best way to learn and keep moving forward."

For further inspiration, he turns to his collection of vintage tattoo flash. With many of his favorite tattoo artists long dead, he explains that, "It's a true testament to them and their craft, that they made artwork which has endured long enough to be rediscovered by an entirely new generation of tattoo artists." Byrne started out not knowing where tattooing would take him, but after a few years of trial and error with various styles, he found what works, and that has kept him excited about tattooing every day.

His philosophy when it comes to his work is simple: "It has to look like a tattoo! It has been talked about for decades now, but that's what a lot of tattoo artists forget and that is where they fail. Much of the work being produced these days, tattoos without nice line weight and good solid shading, will look like mud in years to come. Who wants to wear that?"

His role in the world has shifted in the last few years from being a good tattoo artist first and foremost, to being a good father above all else. And at the end of the day, he simply wants to do good work that people notice. When pressed for words of advice, he answers, "Those who know don't say, and those who say don't know. Keep it secret, keep it safe."

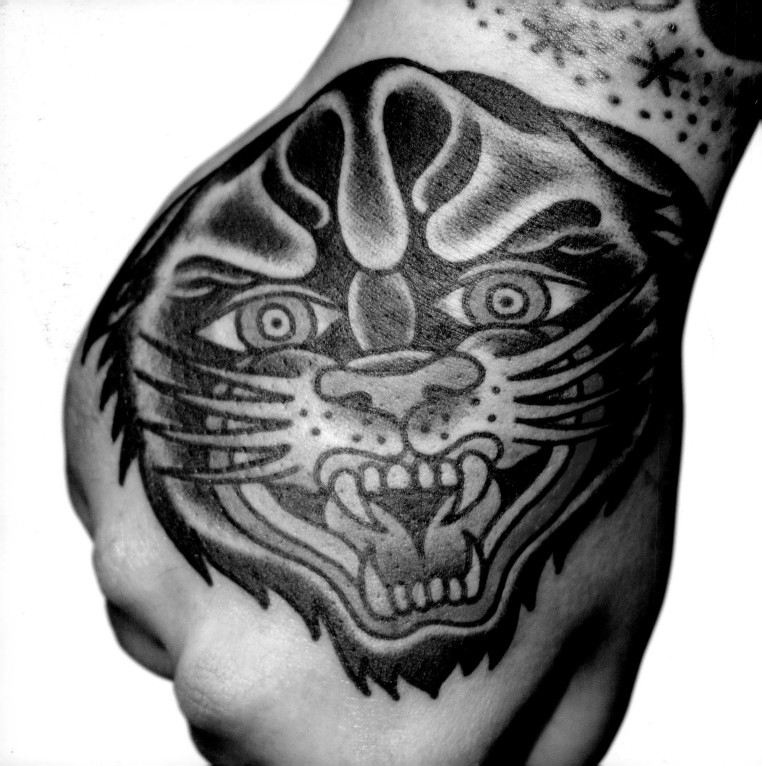

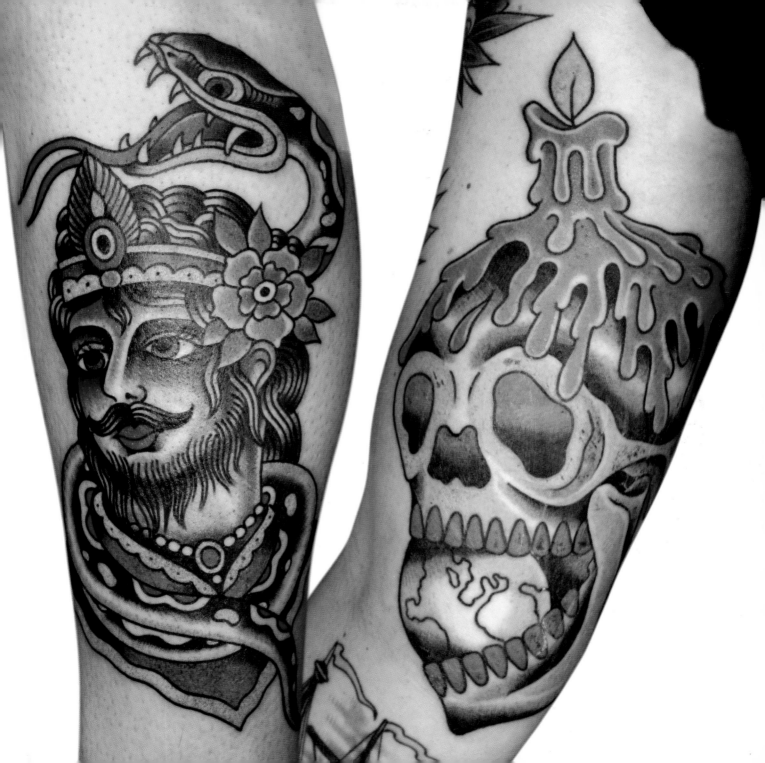

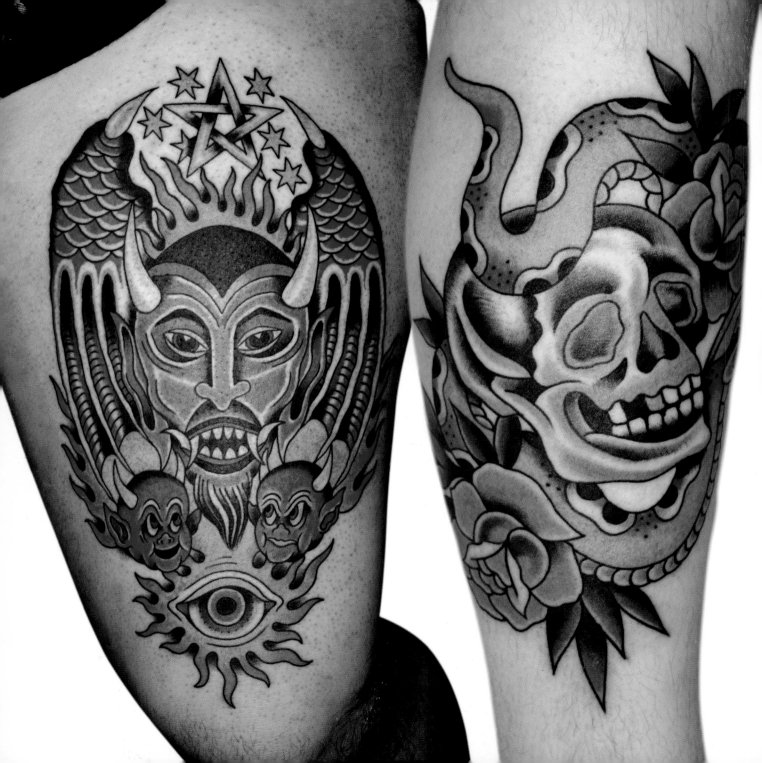

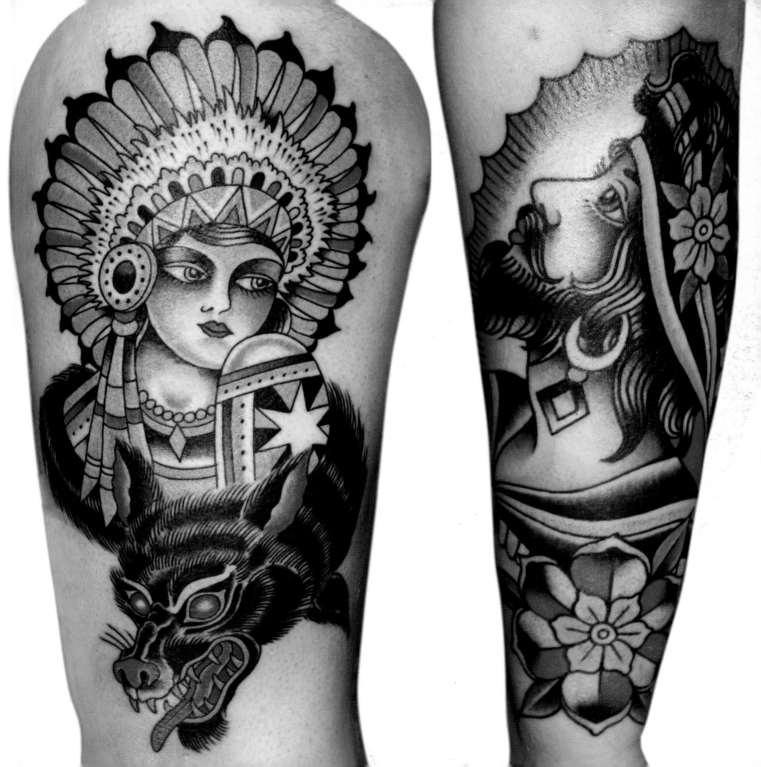

GEORGE CAMPISE

80

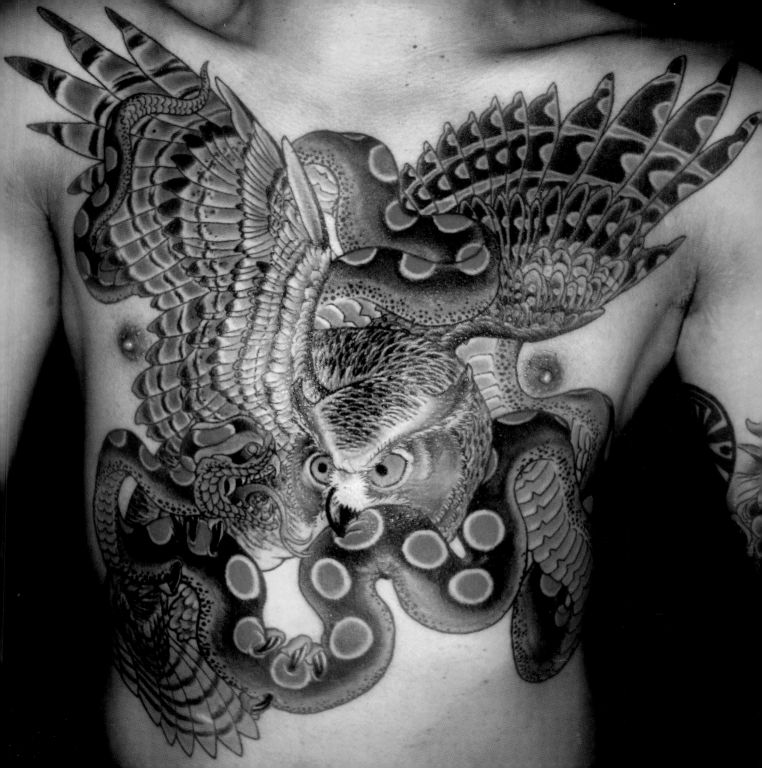

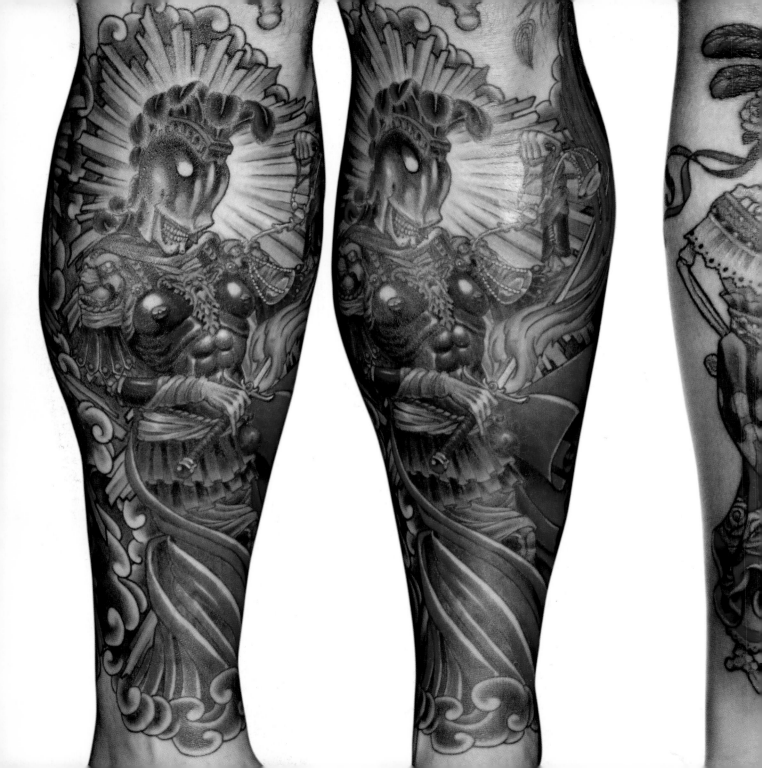

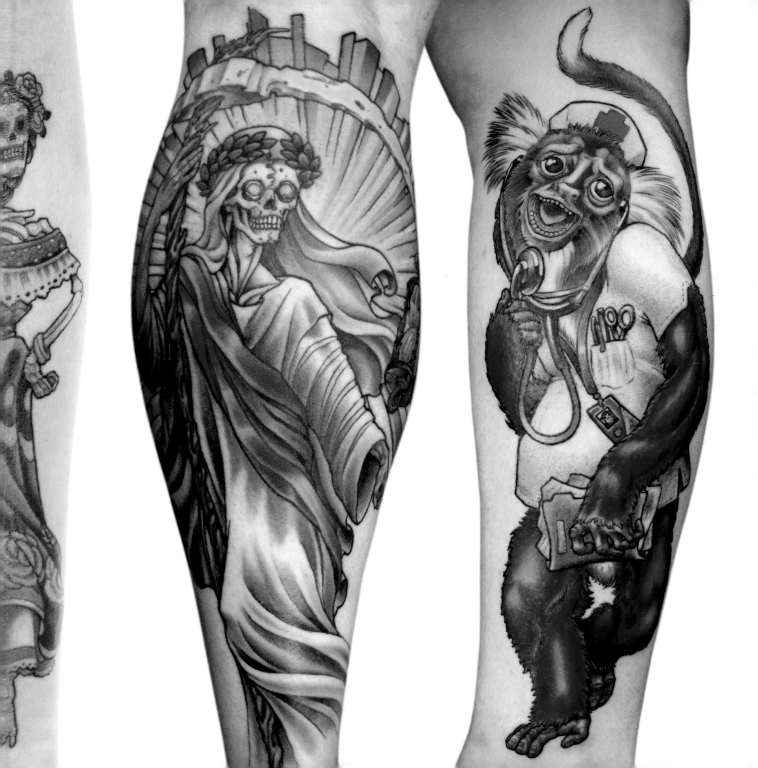

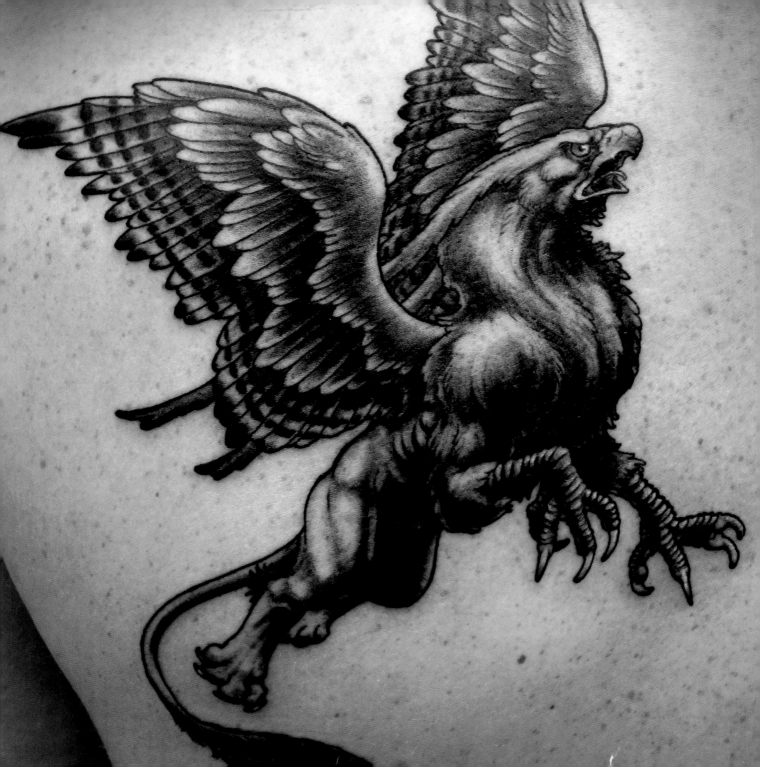

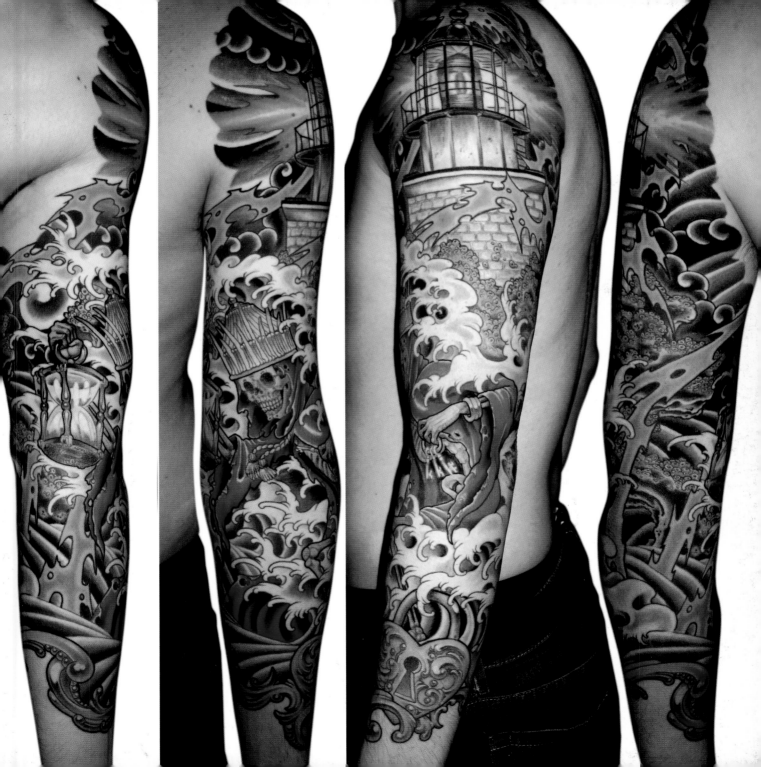

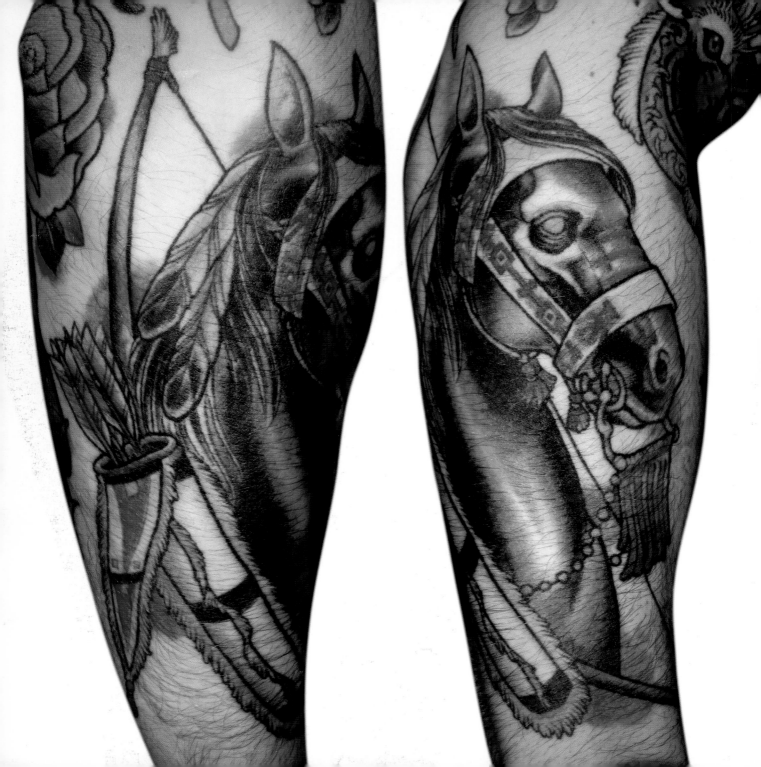

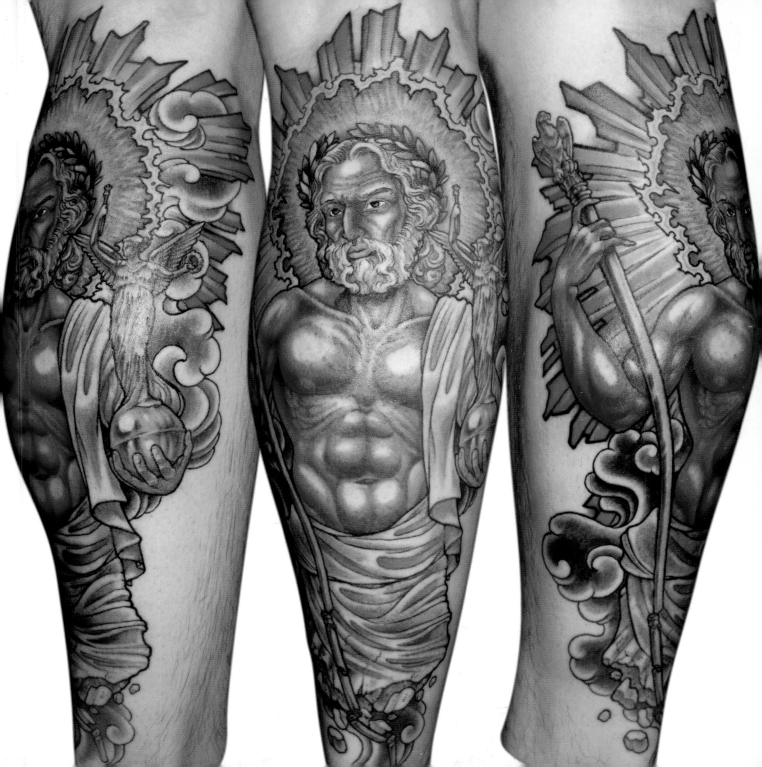

George Campise appreciates anyone who loves what they do while also maintaining a sense of humor. Currently, he is inspired by the natural illustrations of John James Audubon and J. Fenwick Lansdowne, as well as by the comic and fantasy illustrations of artists such as Bernie Wrightson and Frank Frazetta. Beyond these sources, his inspiration varies from day to day. "I'm very much like a dog in that respect: whatever is right in front of me is where my inspiration comes from."

With his aesthetic evolution determined by his "desire to reproduce as accurately as possible what is in my head," he respects the restrictions of his chosen medium. He sees the artistic limitations that present themselves as a set of challenges to which he must find a creative solution: how can he meet the client's needs while also honoring the look, mood, and emotion of his own artistic integrity, and simultaneously create work that will stand the test of time? He describes his ultimate goal as an artist as being able to "put out something positive, as opposed to just adding to the noise," and sees his creative output as a response to a culture that promotes dead-end options and selfishness. "I want my work to make people feel inspired, anything other than numb and distracted," he says. "It's time to burn it all down, hit the reset button, and start over."

Campise also wants his art to remind people of possibilities, changes, and that the future is unwritten. He believes that a little self-sacrifice can go a long way, and that the role of the tattoo artist is to honor the art form and literally record in the flesh the experiences and moments of their clients' lives. He asks, "Why shouldn't we, as practitioners and recipients of all the rewards tattooing has to offer, not have to give of ourselves? The tattoo gods reward those whose intentions are true."

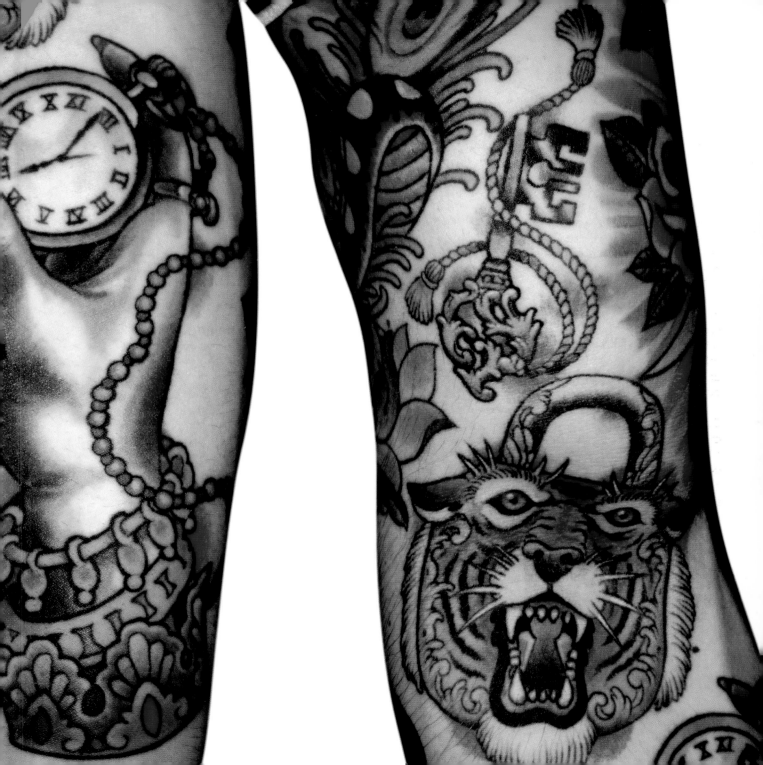

3 Year Roost, 2009

Opposite:
Any Port in a Storm, 2008

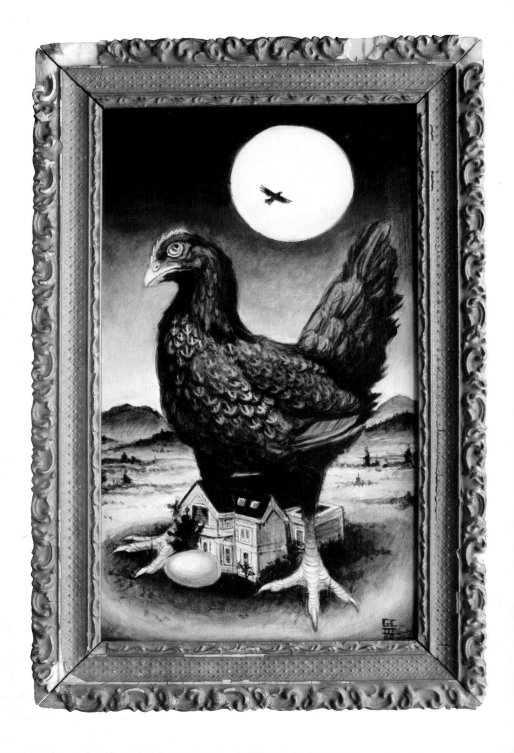

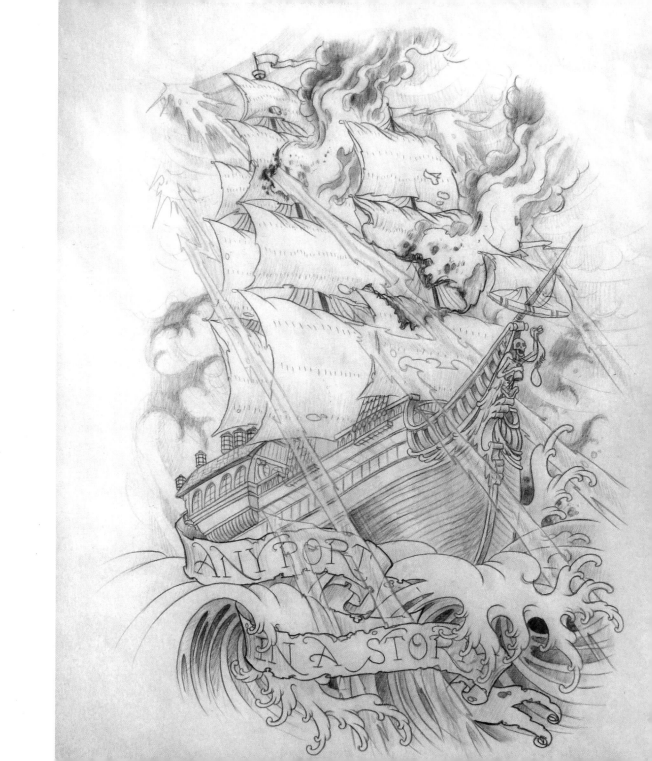

MIKE DAVIS

92

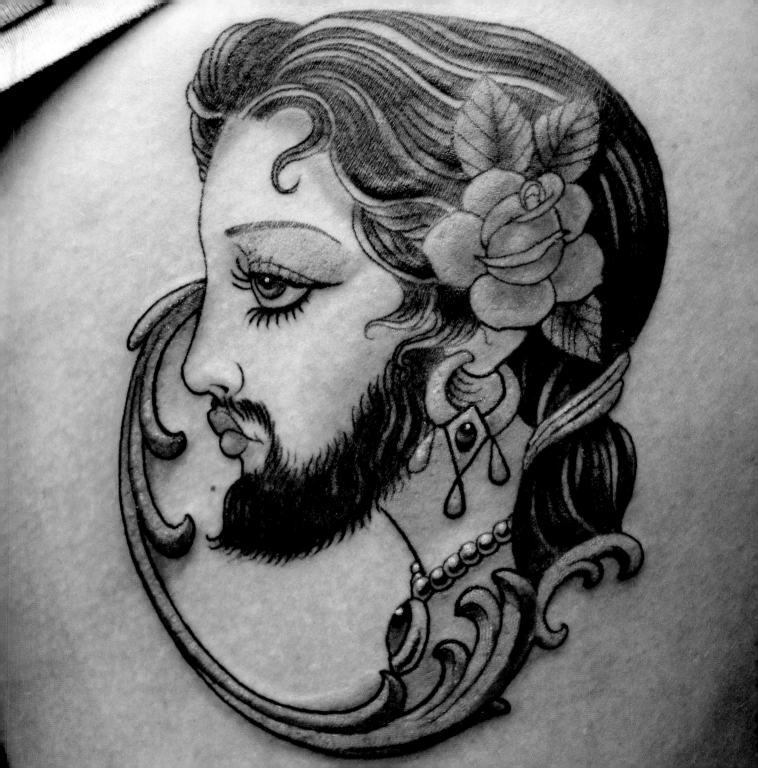

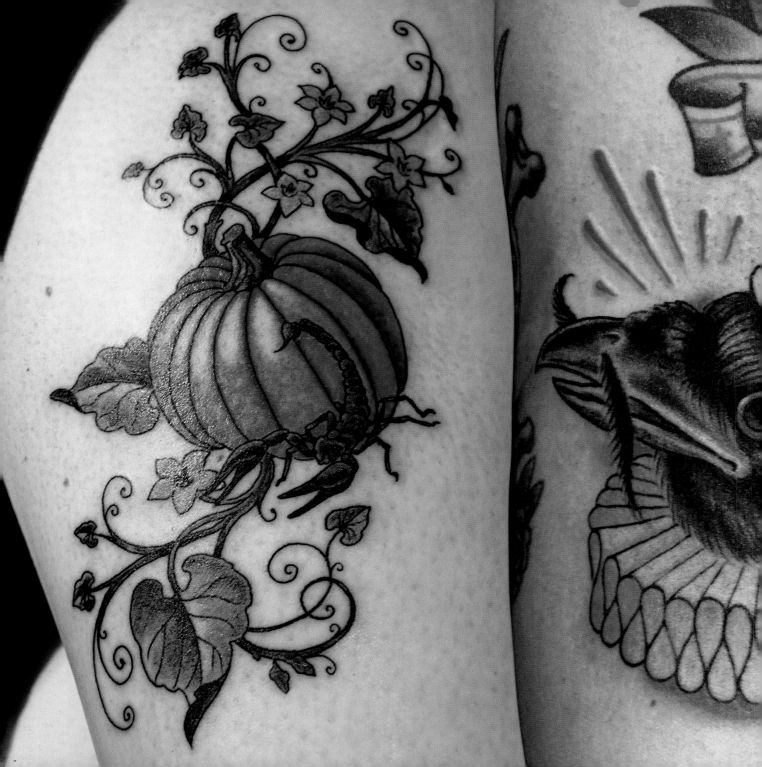

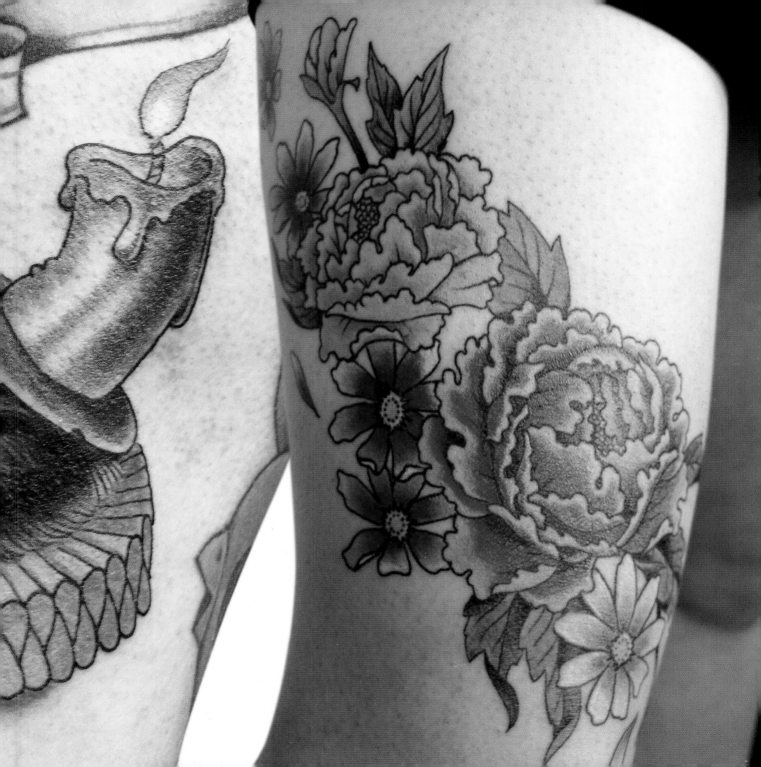

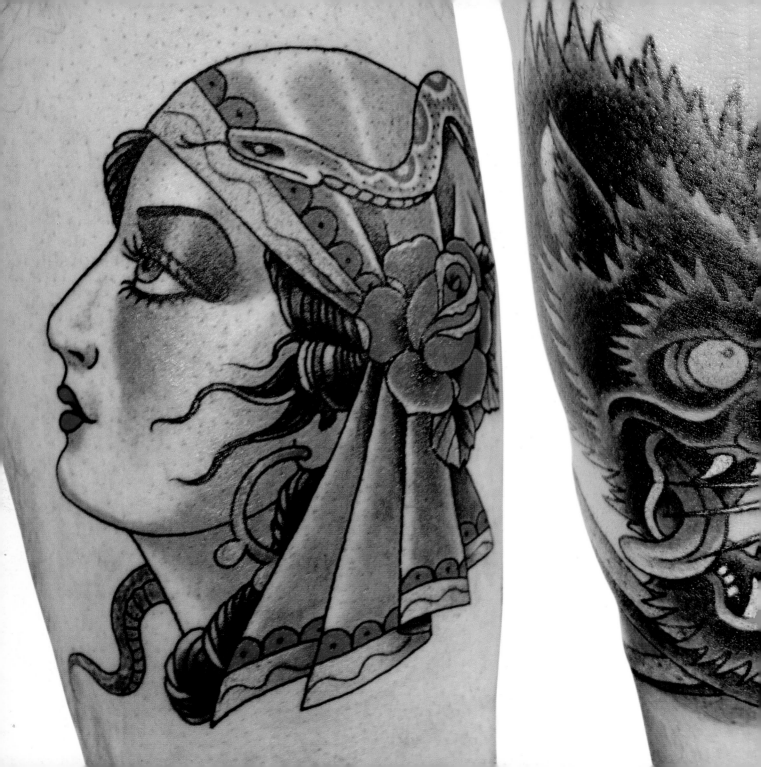

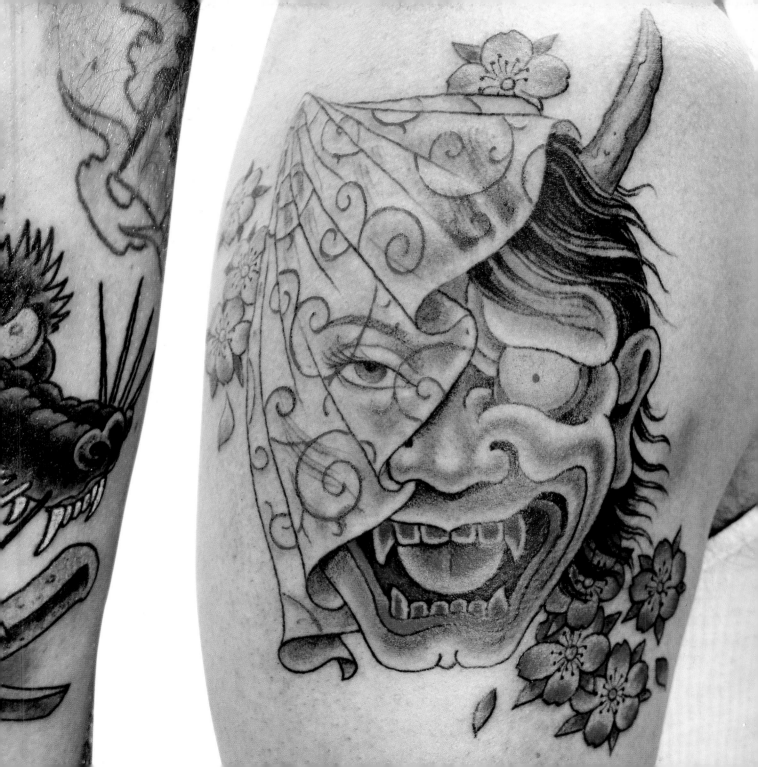

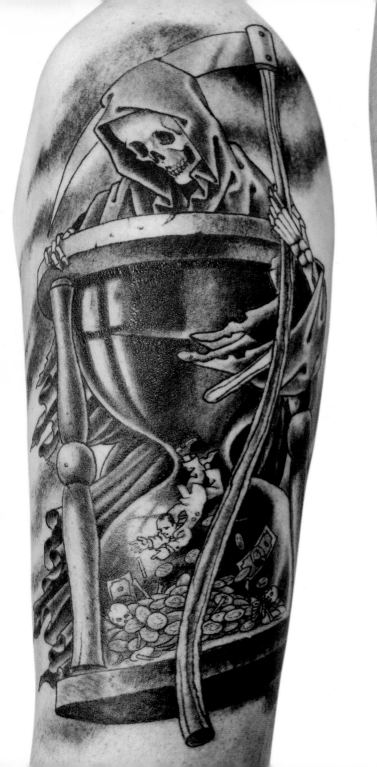
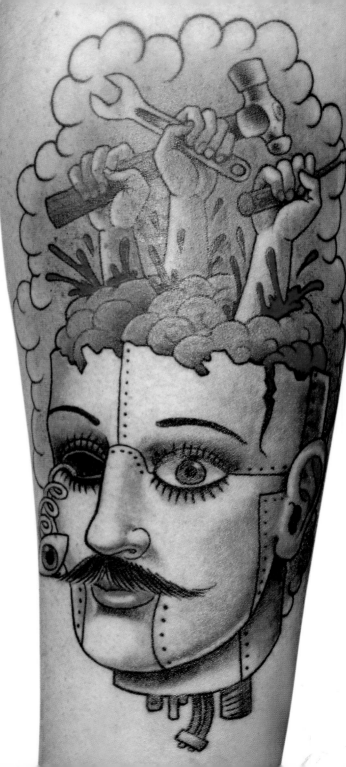

For Mike Davis, quotidian happenings such as a fleeting image or unexpected sound can inspire his tattoo work. He finds himself drawn to the unusual, saying that he "really loves the more 'creepy' or 'weirder' imagery found in traditional work." His art, which he describes as "99 percent autobiographical with tons of symbolism and puzzles for the viewer to decipher," is also inspired by Netherlandish painting, as well as work from the Italian Renaissance and Dutch Baroque period. Although his tattoo work and artistic endeavors inform one another, he claims that painting is "truly freedom," whereas tattooing has its parameters. He hopes to continue to evolve as an artist while creating humorous and unusual tattoo pieces when he can.

One observation Davis has made of contemporary tattooing is regarding the newer artists themselves. "It's incredible what folks are putting out after tattooing only a short time." Unlike when he got started, he believes that it's nearly impossible to stand out now and sees the trend of "shortcutting the craft," or taking on every aspect of running a shop, as a potential hindrance. "All these things—needle making, pigment mixing, machine tuning, maximizing your time, running a shop by yourself with no assistants—I had to learn because you couldn't just go pay for everything like people do now," he says, "I think it's important to learn these things in order to understand the craft fully. I'm probably gonna catch heat for that statement, but I don't care."

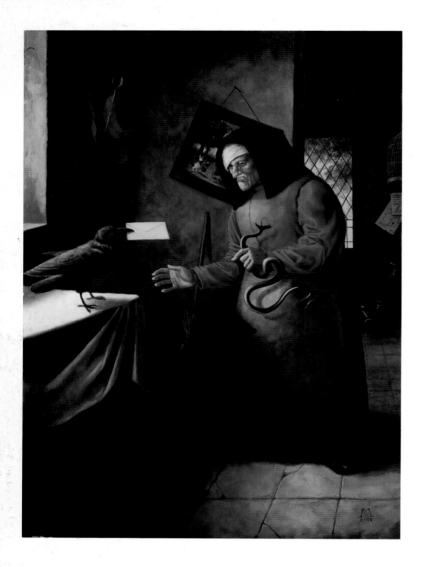

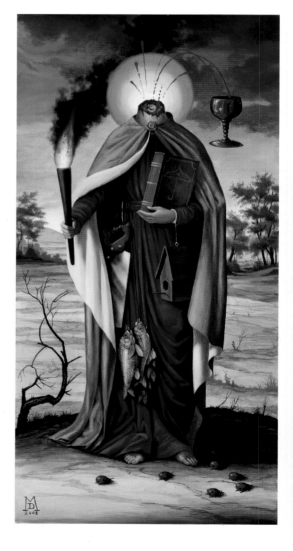

A Fair Exchange, 2008
We Meat Again, 2008

Opposite: Twilight, 2008

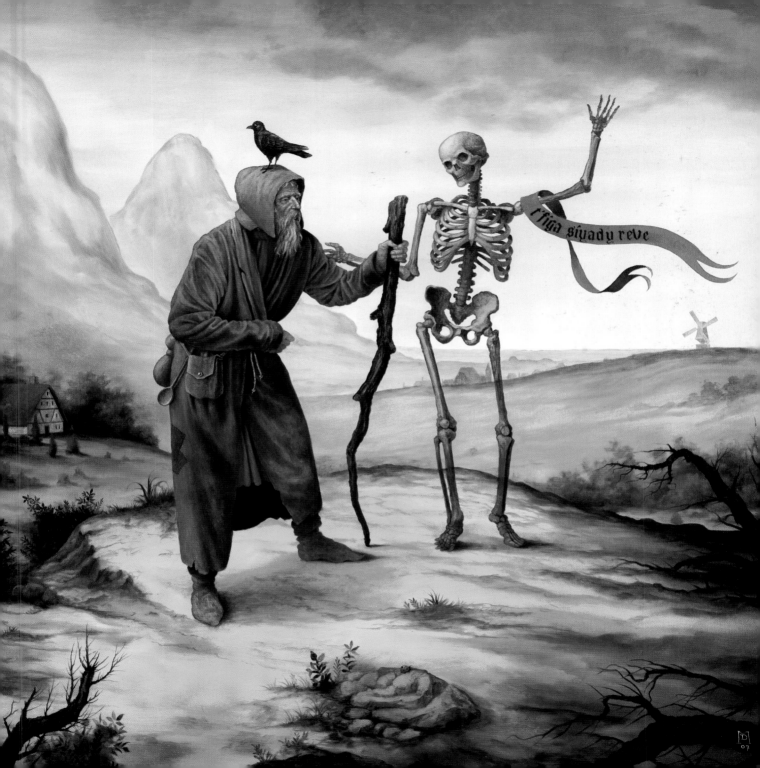

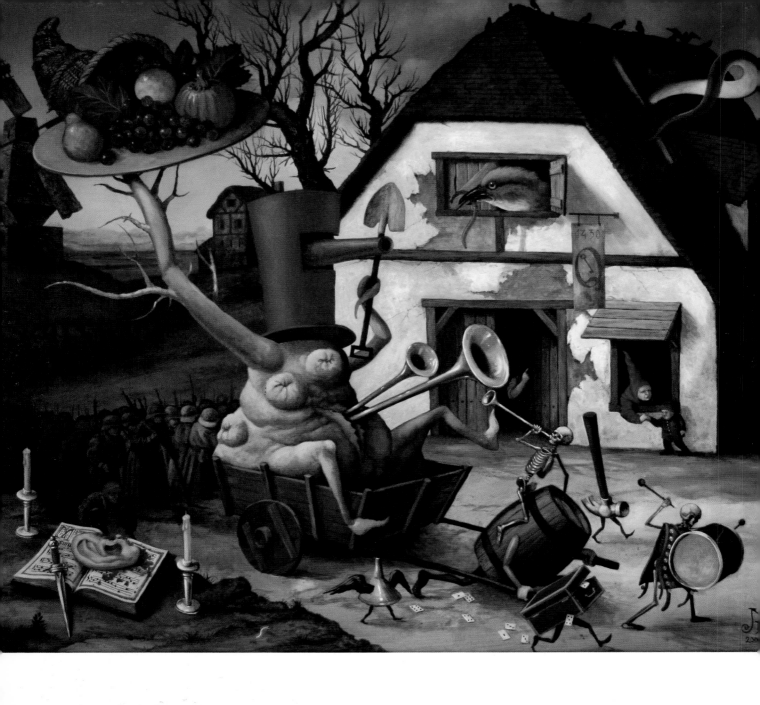

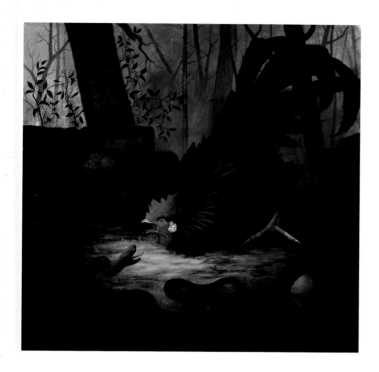

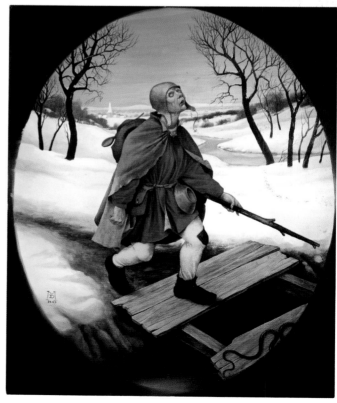

Opposite: Moving Day, 2005

The Rooster and the Snake, 2009
Sing a Song of Solitude, 2005

BRAD
FINK

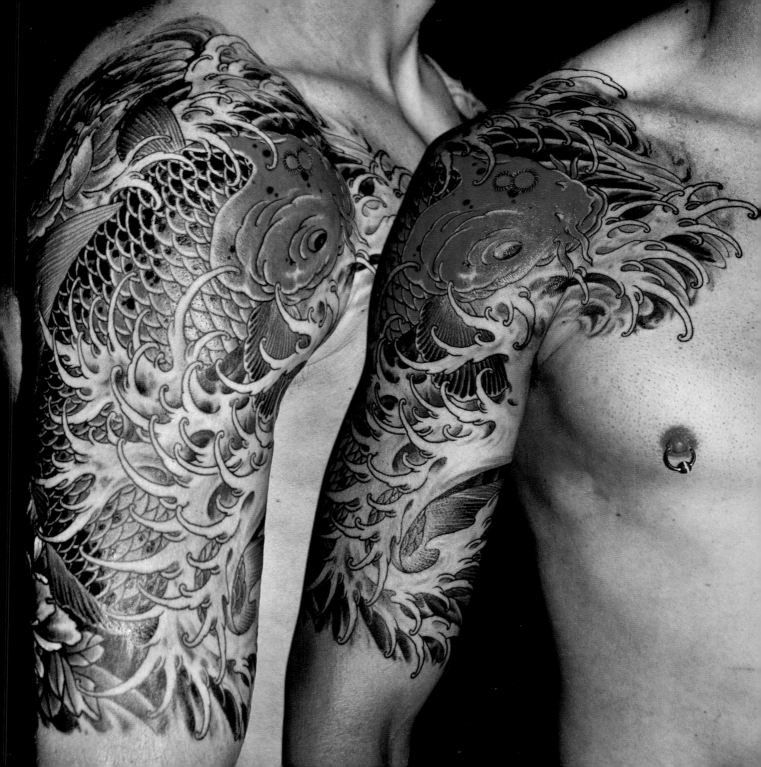

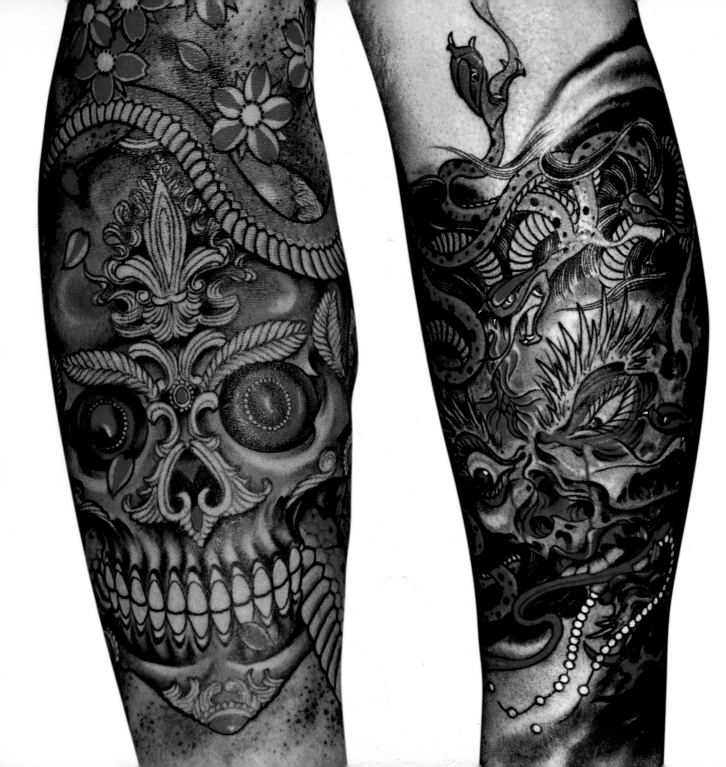

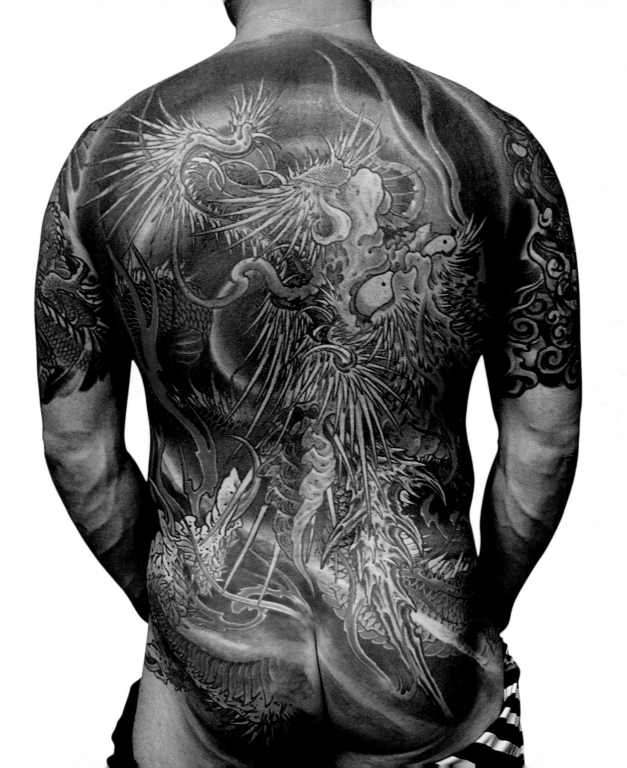

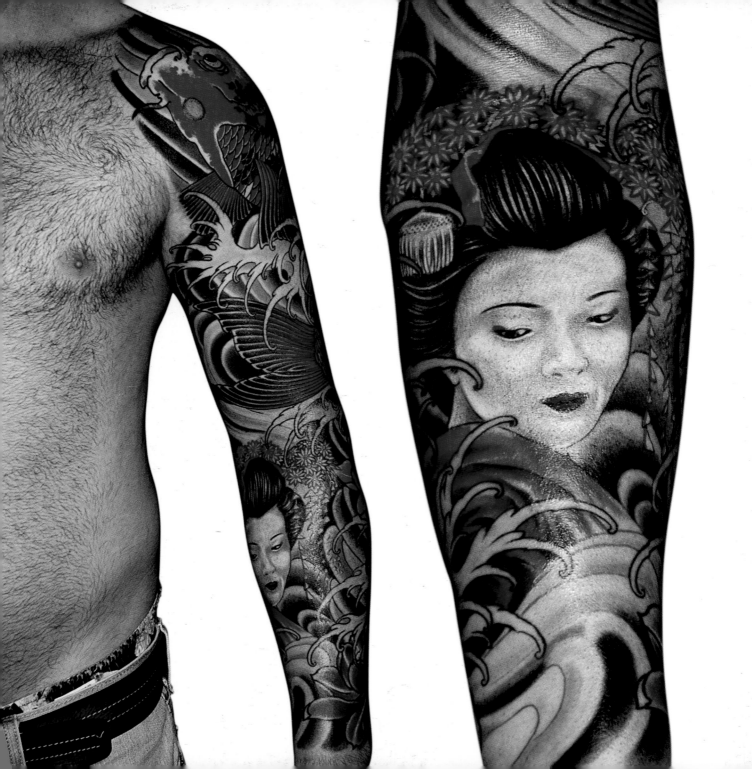

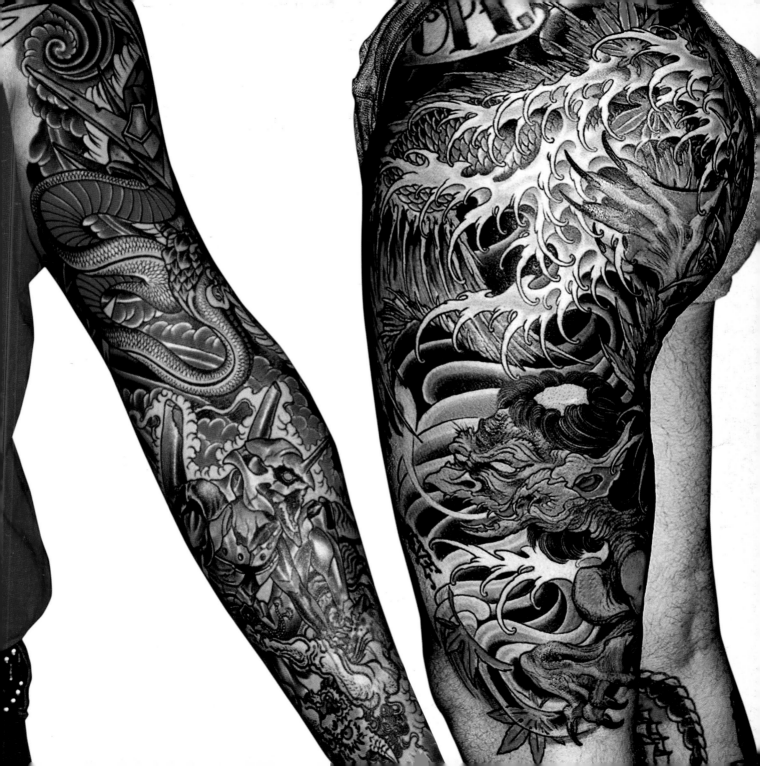

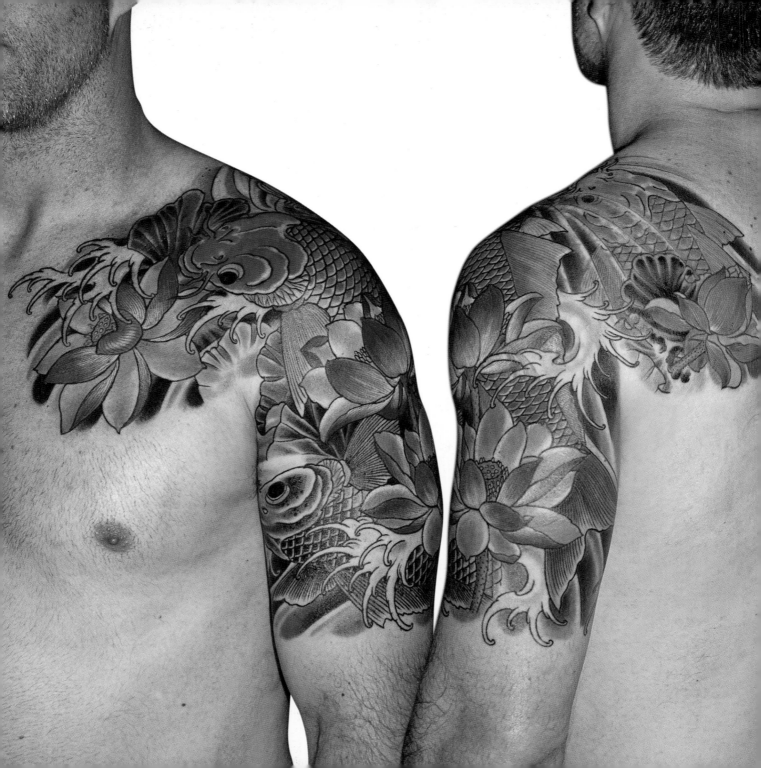

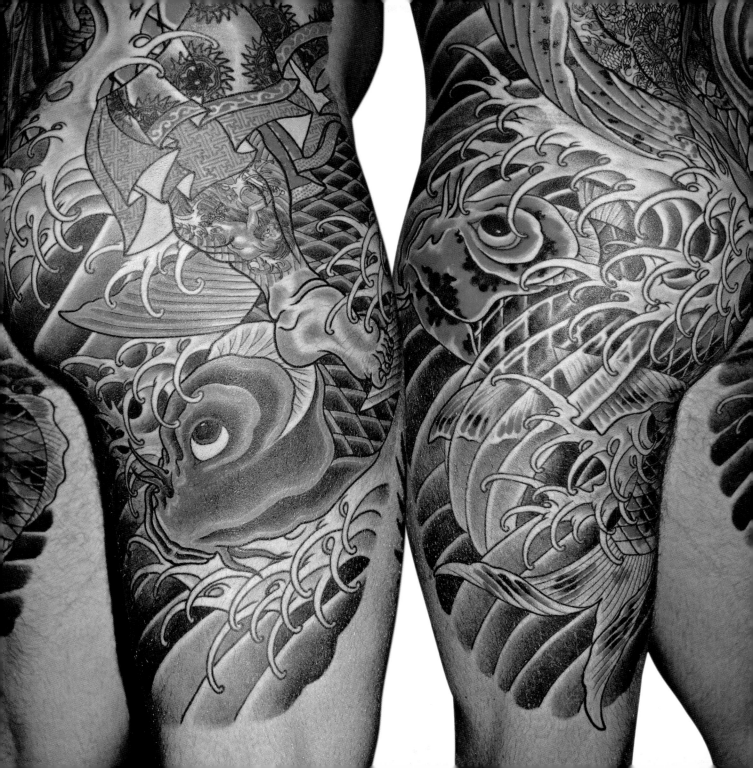

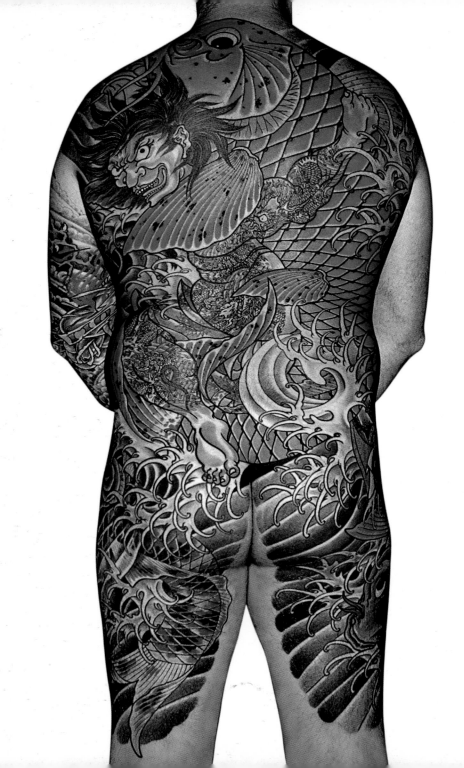

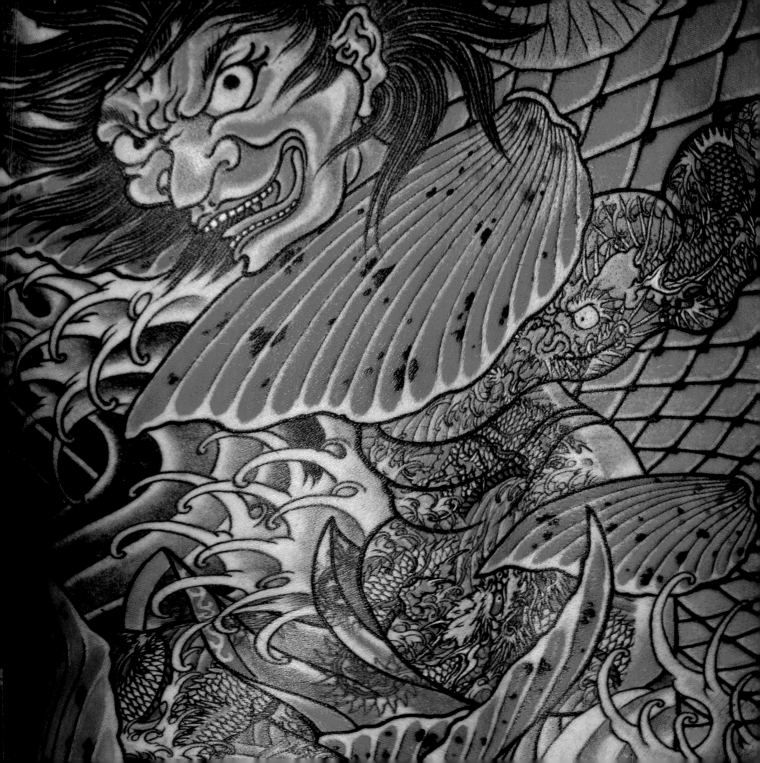

Brad Fink has always tried to visually absorb everything around him. He started working at an established tattoo shop in St. Louis, Missouri, at the age of seventeen and recalls that, "The walls were covered with dingy, nicotine-saturated tattoo flash from the forties and fifties. At the time I felt these designs to be interesting, but minimalist and unchallenging. Several decades later, I now fully appreciate and realize the historic importance of my beginnings, and understand what has brought me to this point."

As an obsessive collector, stumbling upon something is as exciting as creating actual art. Sculptures, paintings, advertisements, and taxidermy all serve as inspiration to him. A small portion of his artwork touches on erotic satire, which stems from his interest in early Japanese *shunga* paintings. He also takes cues from an abundance of nuanced sources—for example, a meticulously carved eagle from a carnival carousel provides an inspired symbol of angst and tenacity.

With a deep-rooted appreciation for the history of tattooing, he embraces the traditional while also incorporating graphic elements. Woodcarving and printmaking provide an artistic outlet that allows him to stray from the two-dimensional thought pattern of tattooing. He claims, "Being able to dive in and feel the curves and formation of a high relief carving is essential to exercising my right brain."

Fink primarily views himself as the messenger that brings an idea to fruition, a piece of the creative process that works to interpret the client's vision. "At the inception of the tattoo process, I visualize what kind of feel or flavor lends itself to a particular subject matter," he says, "all the while taking into consideration the wearer and how they will carry their tattoo. It is important for me to capture their personality as much as possible."

With his "more the merrier" approach, he appreciates all productive contributions to the art of tattooing. Speaking poetically on behalf of his fellow tattoo artists, he says, "For a lot of us, there are times when it seems as if there is so much energy that needs to flow from us that it hurts."

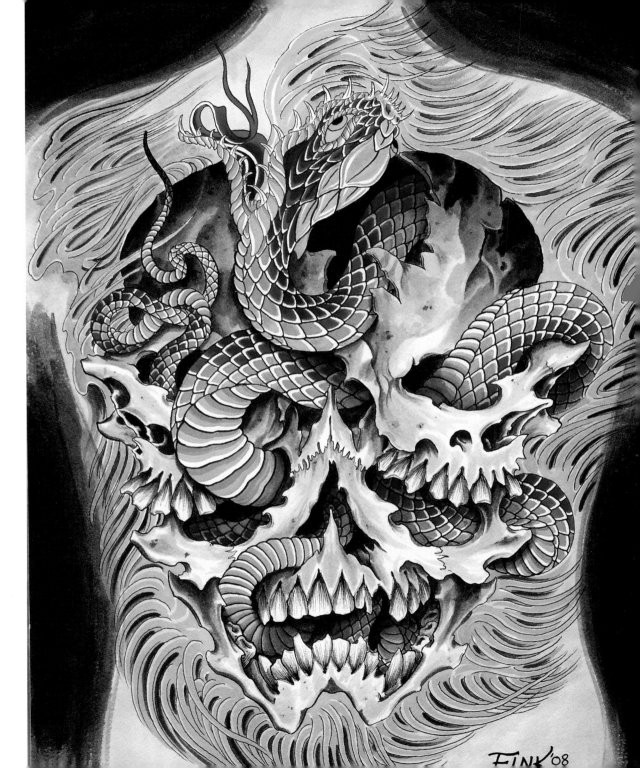

FiNK '08

For My Sweetie, 2008

Opposite:
Reapin' While You Sleepin,' 2008

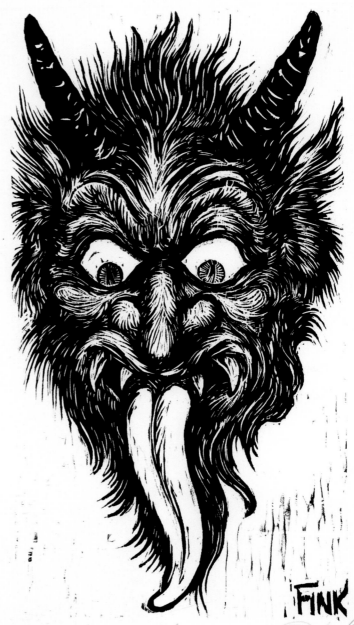

3/6 For My Sweetie

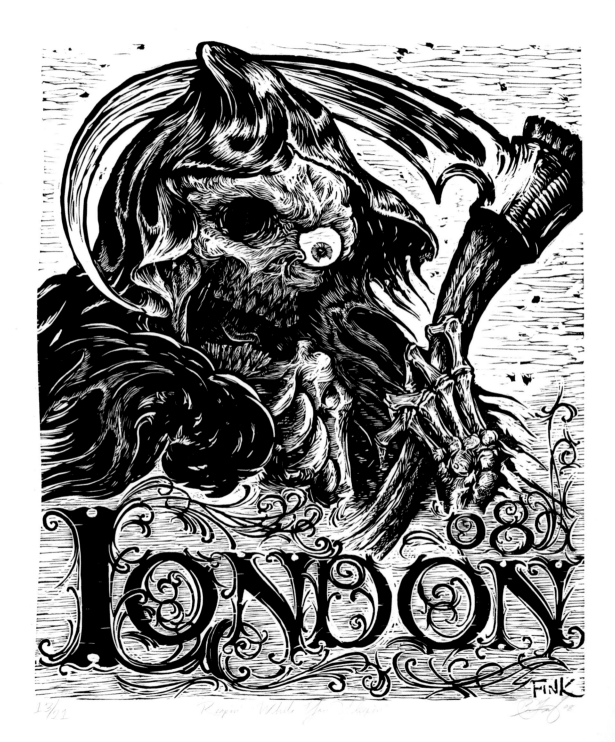

LONDON 08

FiNK

MIKE GIANT

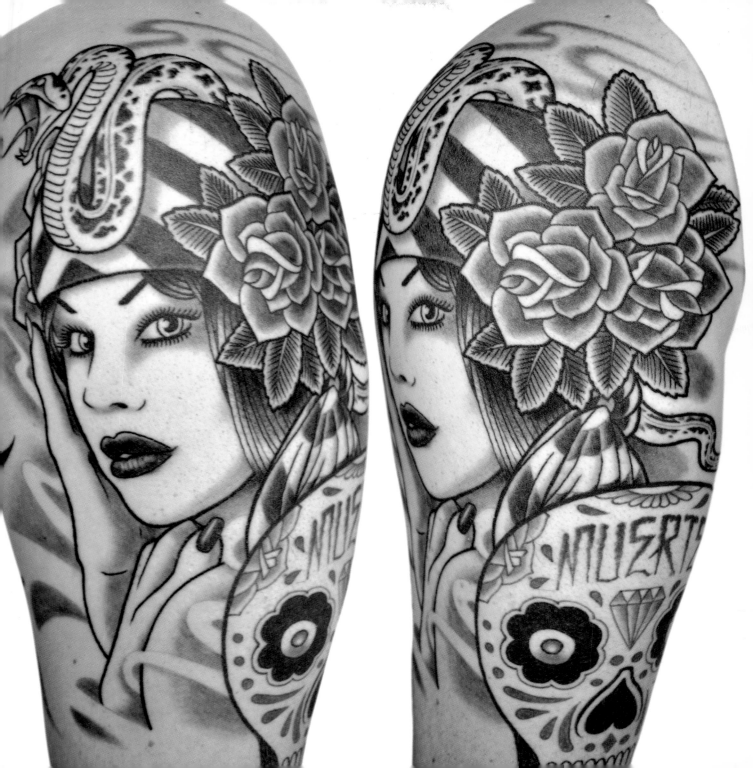

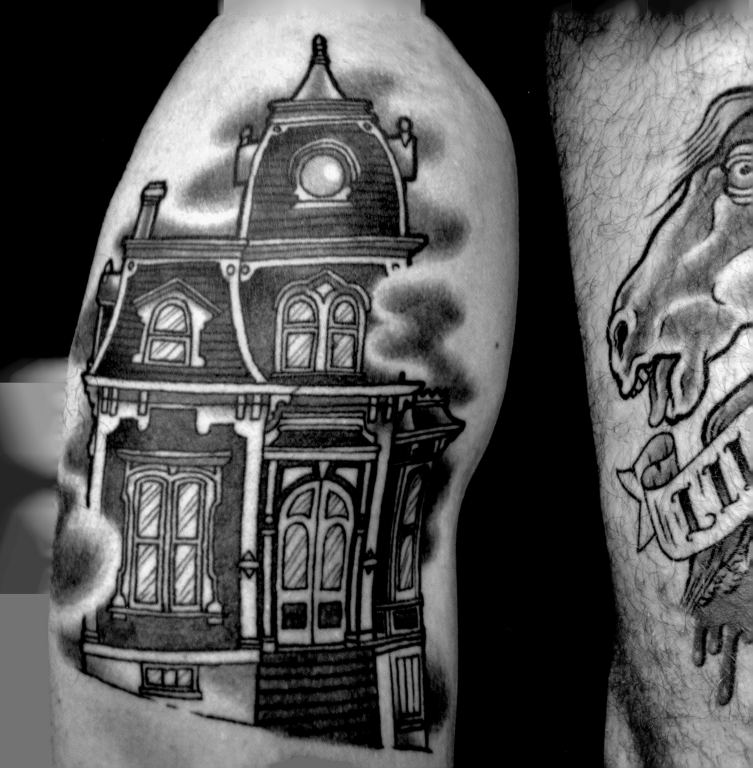

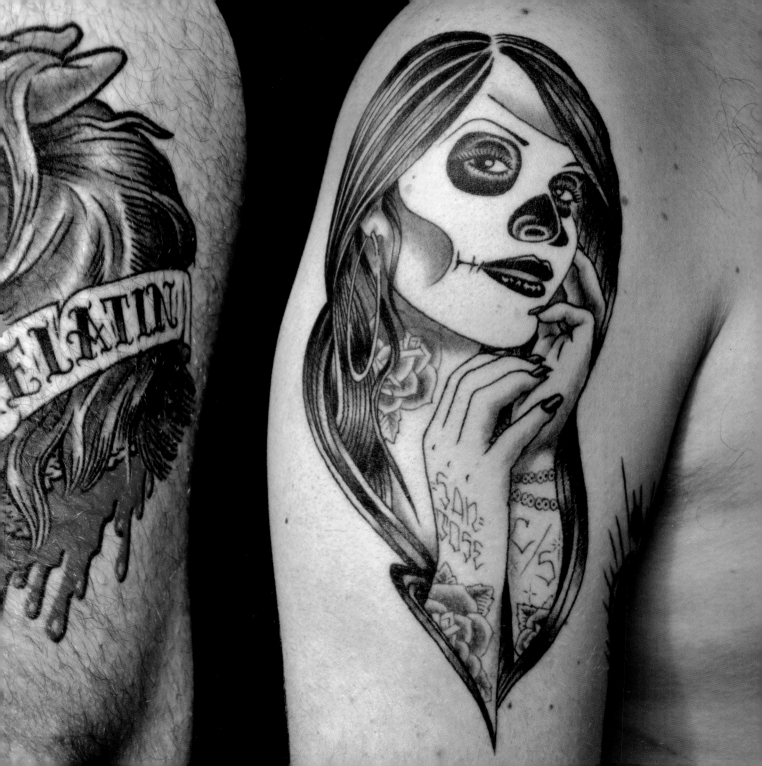

"As an artist I give the work life, and then I release it to the world," says Mike Giant. "A client comes to me with an idea, I draw it out for them, tattoo it, and then they walk out the door. When the client dies, so does the tattoo. But the idea behind it may live on in the minds and hearts of those people touched by the idea or the vision of the tattoo itself." In the early 1990s, while still developing his own inking style and working full-time drawing skateboard graphics, he was introduced to the work of Charles Burns as well as Ed Hardy, whose San Francisco shop he was getting tattooed in. Nowadays, though, it's friends such as Wes Lang, John Copeland, and Scott Campbell that get him excited about tattooing. "I was visiting their studios in New York City recently," he says, "and I continue to feel the good vibes. I love the process of seeing their work evolve over the years."

Though he feels "drawn to the illustrations styles of the late 1800s and early 1900s," Giant draws much of his joy and inspiration from activities such as cycling, skateboarding, and meditation. His satisfaction with the everyday can be linked to his Buddhist practice, which is an essential element to his approach to art making, as he continues to discover the positive effects of his religious practice. "I try to rest in the middle so that I can be present for inspiration in my day-to-day activities, but also stay quiet in my mind so that I can stay close to my base intentions of compassion, joy, equanimity, and love."

He describes the evolution of his style as "a continuance to [his] intention to make work that is precise, direct, and elegant," and goes on to conclude that, "Art lasts when it resonates in the hearts and minds of people so much that they have to show it to each other, over and over for centuries. That is art, *living* art."

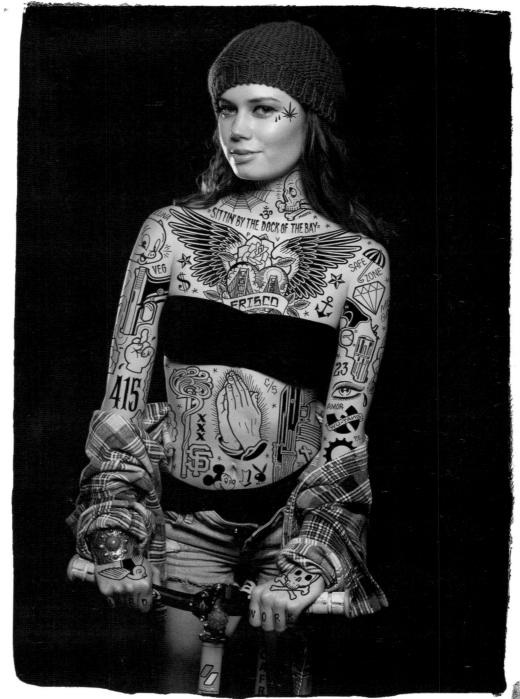

Chola Karina, 2010

Opposite:
Sad Girl, 2010

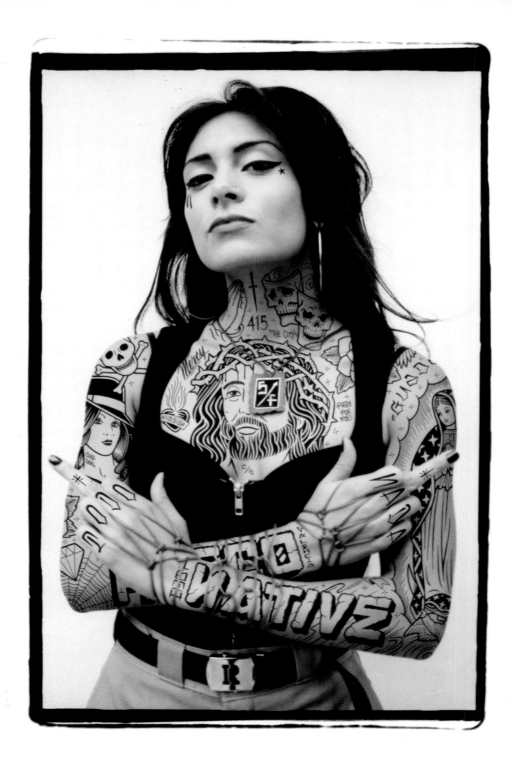

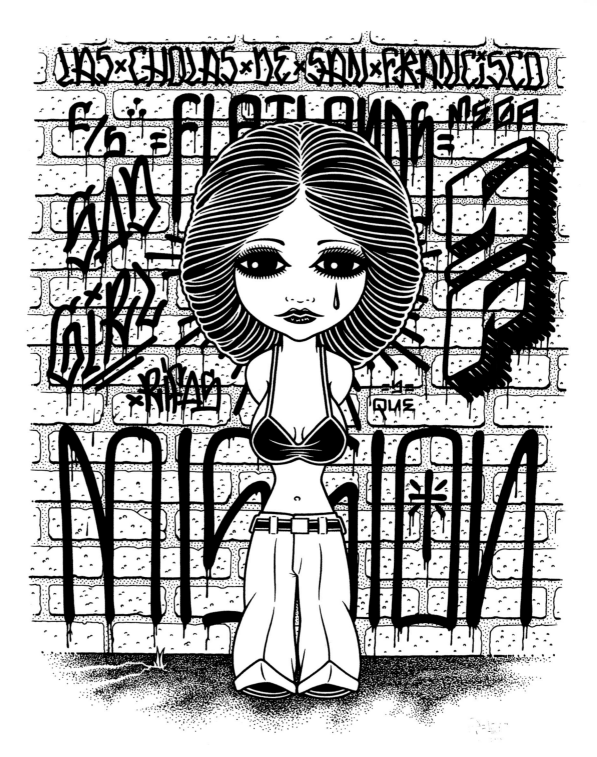

Liberty Torch, 2010

Opposite:
Pro Ho, 2010

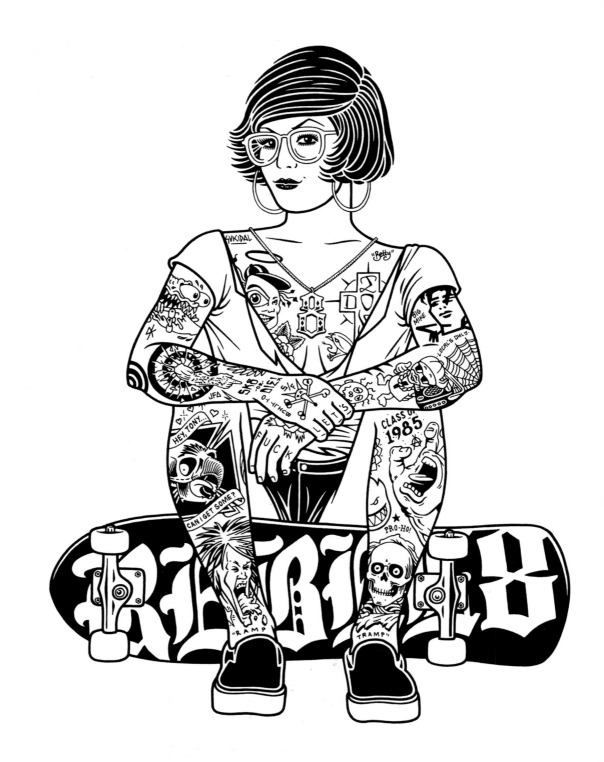

LA Mission Tattoo Flash, 2010

Opposite:
The Modern San Franciscan, 2010

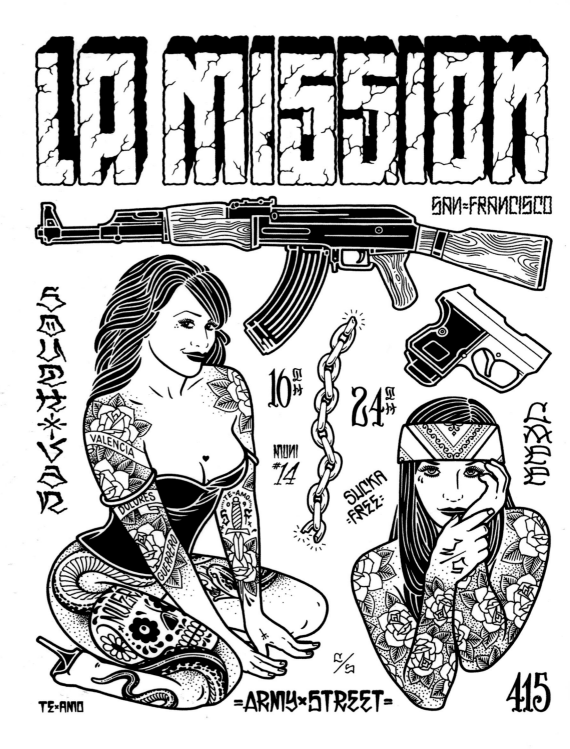

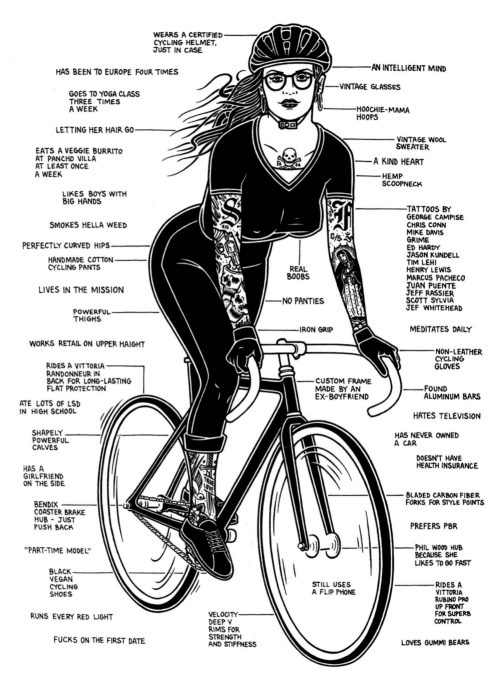

WEARS A CERTIFIED CYCLING HELMET, JUST IN CASE

AN INTELLIGENT MIND

HAS BEEN TO EUROPE FOUR TIMES

VINTAGE GLASSES

GOES TO YOGA CLASS THREE TIMES A WEEK

HOOCHIE-MAMA HOOPS

LETTING HER HAIR GO

VINTAGE WOOL SWEATER

EATS A VEGGIE BURRITO AT PANCHO VILLA AT LEAST ONCE A WEEK

A KIND HEART

HEMP SCOOPNECK

LIKES BOYS WITH BIG HANDS

TATTOOS BY
GEORGE CAMPISE
CHRIS CONN
MIKE DAVIS
GRIME
ED HARDY
JASON KUNDELL
TIM LEHI
HENRY LEWIS
MARCUS PACHECO
JUAN PUENTE
JEFF RASSIER
SCOTT SYLVIA
JEF WHITEHEAD

SMOKES HELLA WEED

PERFECTLY CURVED HIPS

HANDMADE COTTON CYCLING PANTS

REAL BOOBS

LIVES IN THE MISSION

NO PANTIES

POWERFUL THIGHS

IRON GRIP

MEDITATES DAILY

WORKS RETAIL ON UPPER HAIGHT

NON-LEATHER CYCLING GLOVES

RIDES A VITTORIA RANDONNEUR IN BACK FOR LONG-LASTING FLAT PROTECTION

CUSTOM FRAME MADE BY AN EX-BOYFRIEND

FOUND ALUMINUM BARS

ATE LOTS OF LSD IN HIGH SCHOOL

HATES TELEVISION

SHAPELY POWERFUL CALVES

HAS NEVER OWNED A CAR

HAS A GIRLFRIEND ON THE SIDE

DOESN'T HAVE HEALTH INSURANCE

BENDIX COASTER BRAKE HUB - JUST PUSH BACK

BLADED CARBON FIBER FORKS FOR STYLE POINTS

"PART-TIME MODEL"

PREFERS PBR

BLACK VEGAN CYCLING SHOES

PHIL WOOD HUB BECAUSE SHE LIKES TO GO FAST

STILL USES A FLIP PHONE

RIDES A VITTORIA RUBINO PRO UP FRONT FOR SUPERB CONTROL

RUNS EVERY RED LIGHT

VELOCITY DEEP V RIMS FOR STRENGTH AND STIFFNESS

FUCKS ON THE FIRST DATE

LOVES GUMMI BEARS

~THE MODERN SAN FRANCISCAN~

scott Harrison

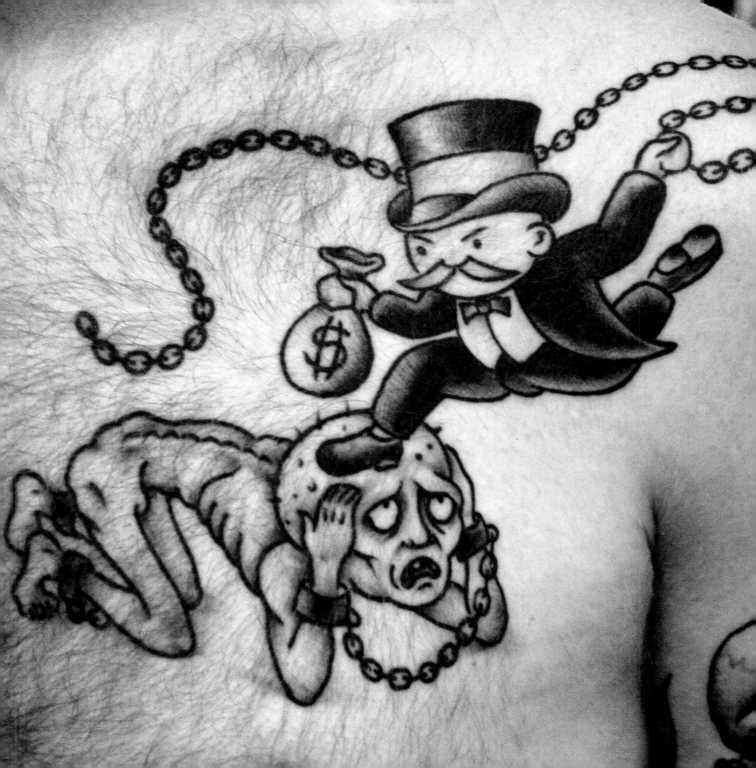

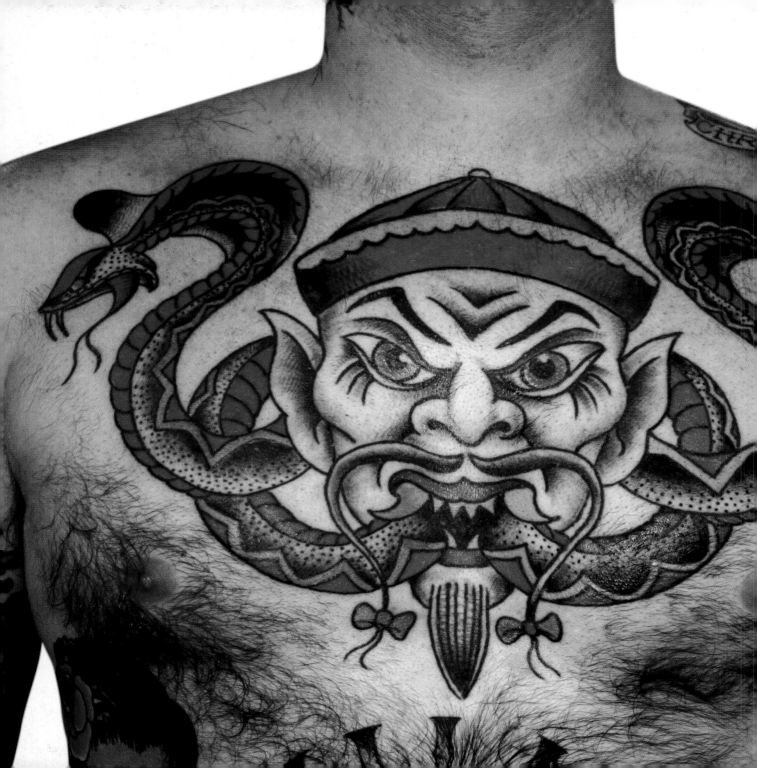

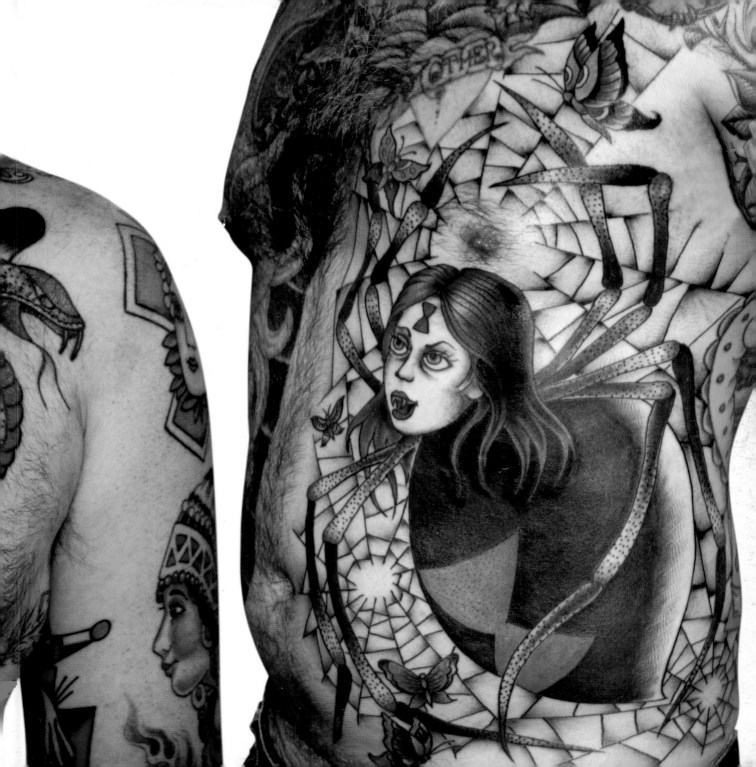

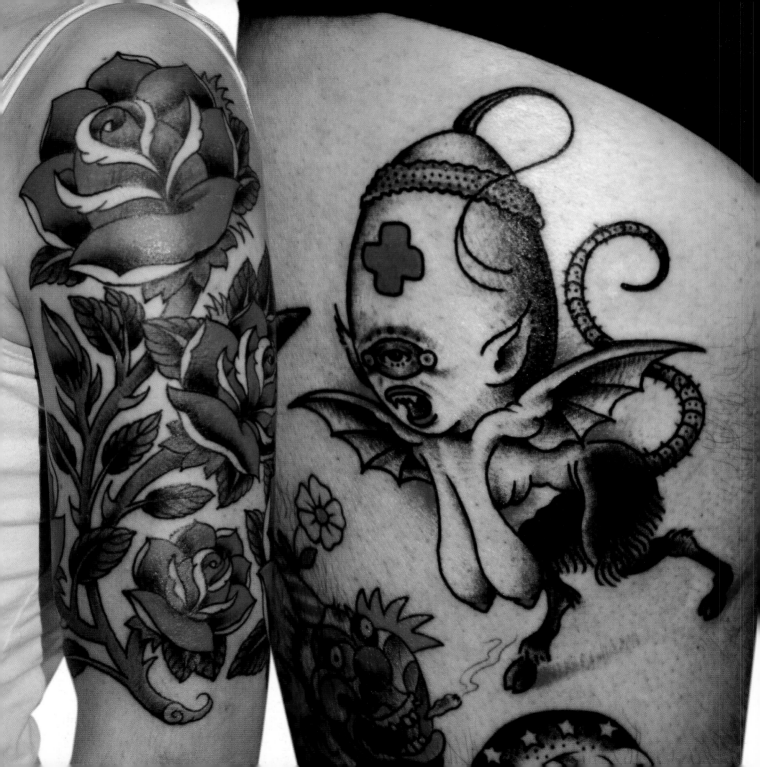

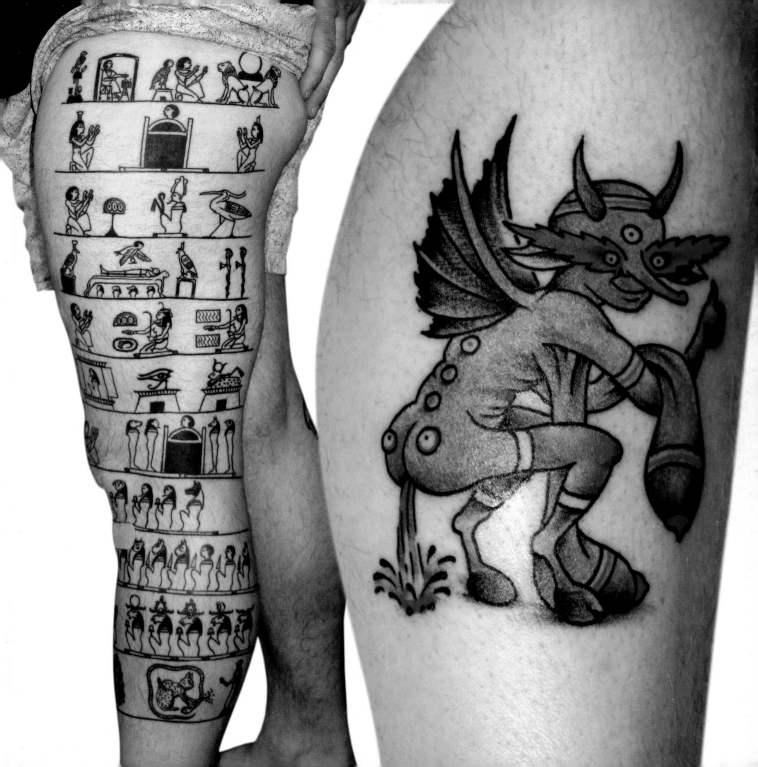

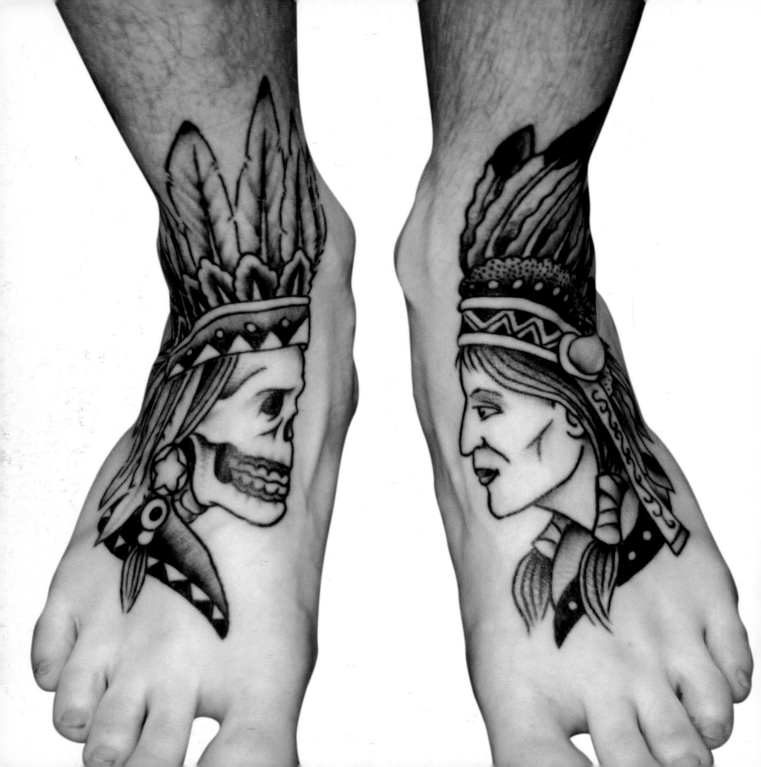

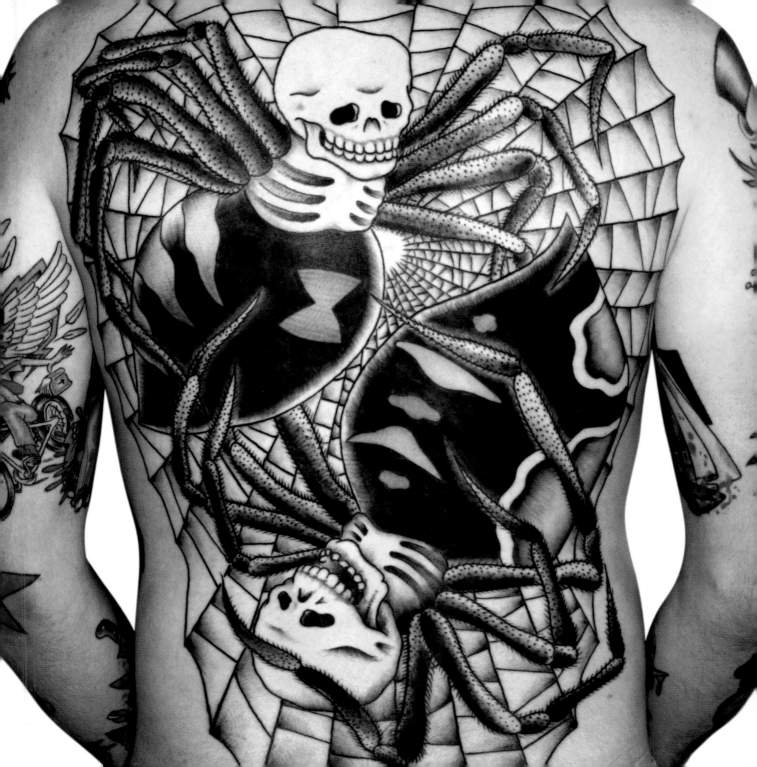

As a child, Scott Harrison loved the luminous ink wash quality of the black-and-white Fleischer Studios cartoon, *Popeye the Sailor Man*. His teen years found him attracted to painter Soga Shohaku's eccentric brushstrokes, and use of humor, while later the drawings and sketches of Goya, with his eye for the depravity of human society, would also strike an artistic chord.

When he first began tattooing, Harrison read Alan Govenar's *Stoney Knows How: Life as a Sideshow Tattoo Artist* and *Bad Boys and Tough Tattoos* by Samuel M. Steward. He says that, "Stoney St. Clair's amazing stories, philosophy, humor, humanistic insight, and warmth of draughtsmanship were, and remain, a huge inspiration. The image of a strange old carny sitting in an environment completely saturated with his own hand-painted icons, waiting for someone to come in and choose one, was precisely what I aspired to."

It wasn't too long before he met artists Ed Hardy, Michael Malone, and Thom Devita, each of who would be key in influencing his growth as an artist in a positive, necessary way. "Hardy was a perfect guide to the history and approach of the more artistic and creative lineages of tattooing. Malone was my primary inspiration for business philosophy as well as flash-painting techniques and storytelling. And Devita has remained an ideal of artistic practice for me."

Harrison's technique and philosophy have been with him since his apprenticeship days, but he has evolved within the parameters of classic folk art, as it remains the style he loves the most. "Because most tattoo artists are almost full-up with tattoos, for those last oddly placed spots they are not looking for a powerful visual statement, nor an exhibition of technique, but something more like a mysterious, eccentric curio, a conversation piece. That is what I provide—conversation." He also claims that his "personality and artwork have a queer, slightly harsh sense of humor" destined to reach only a "tiny demographic of loyal oddballs," which he sees as a blessing.

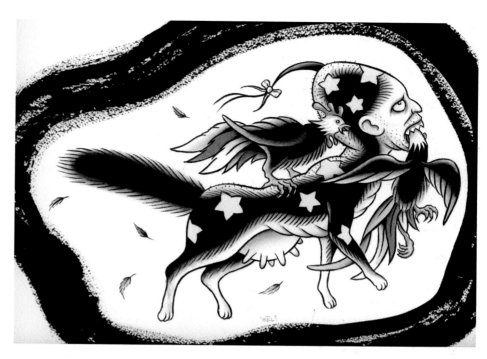

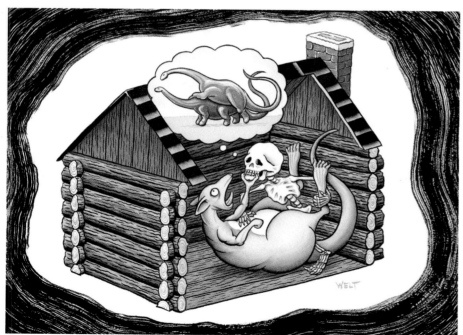

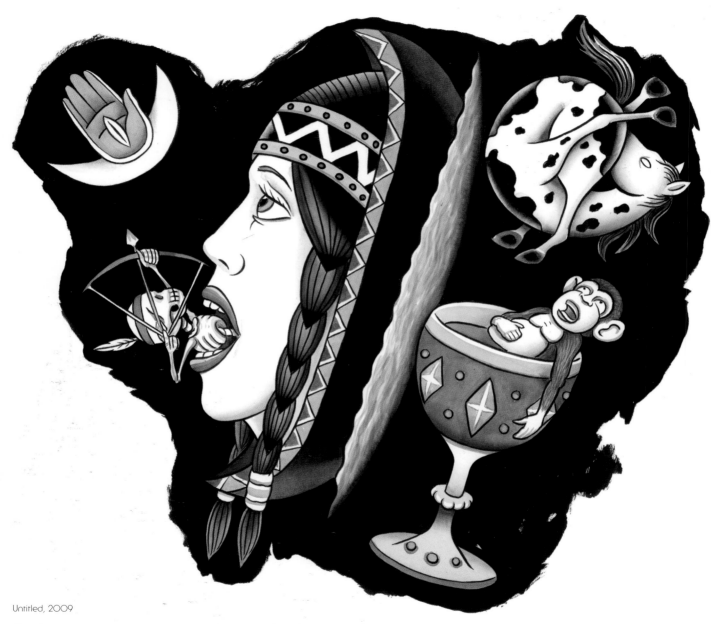

Untitled, 2009

Opposite:
Untitled, 2009
Untitled, 2009

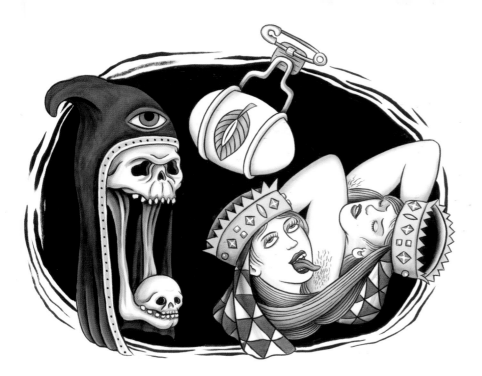
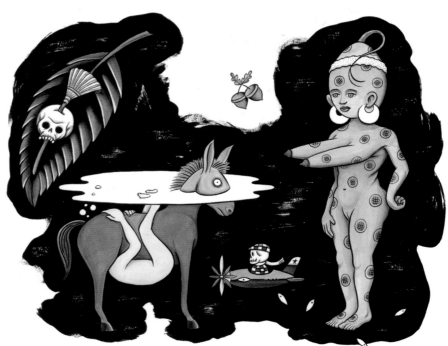

JONDIX

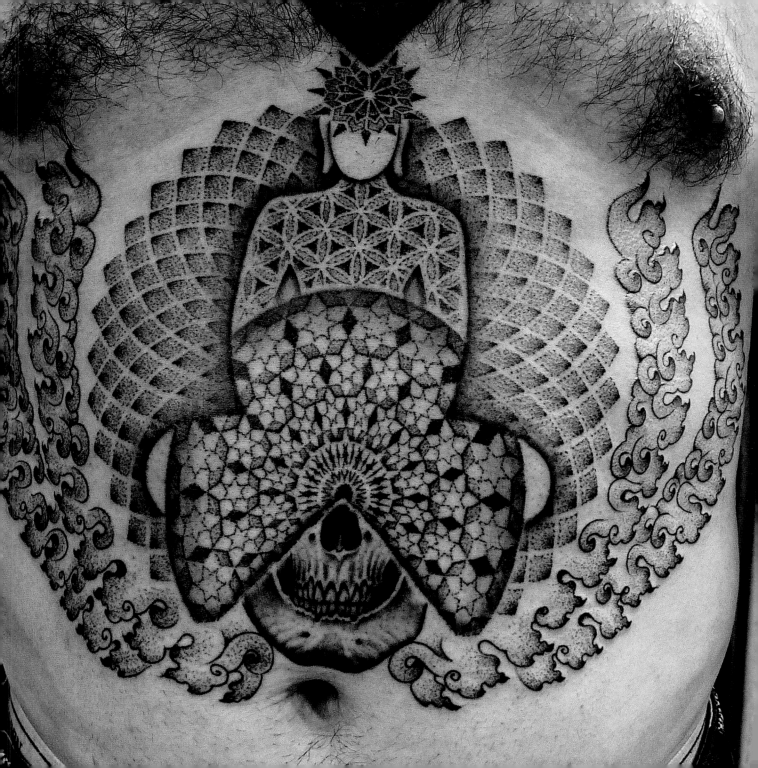

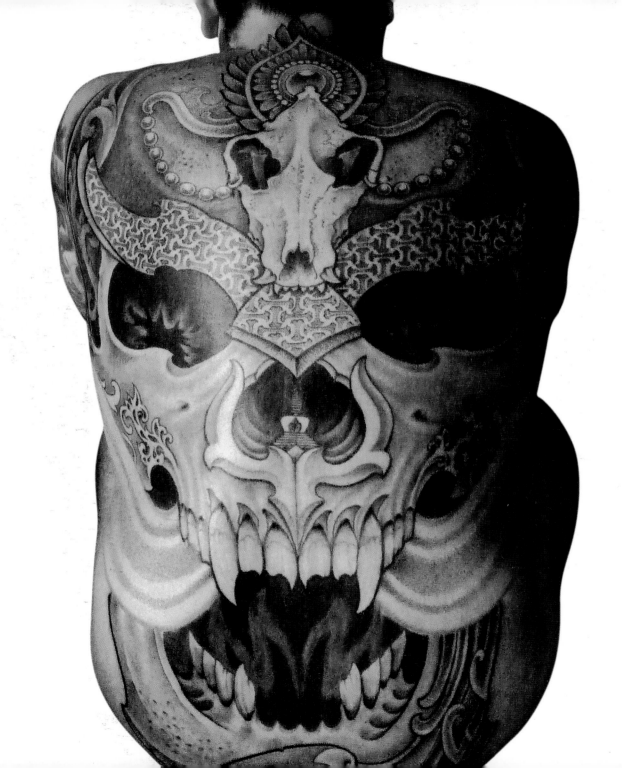

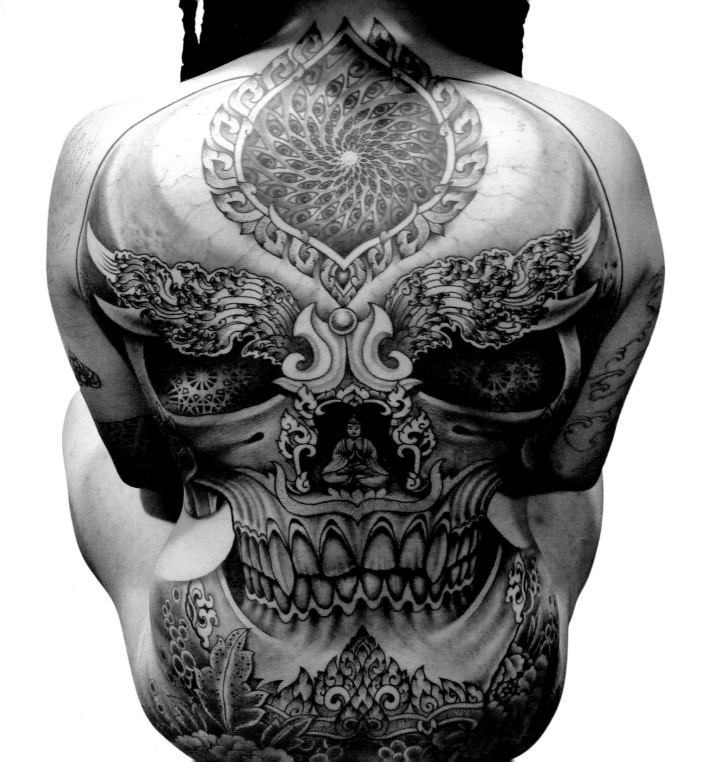

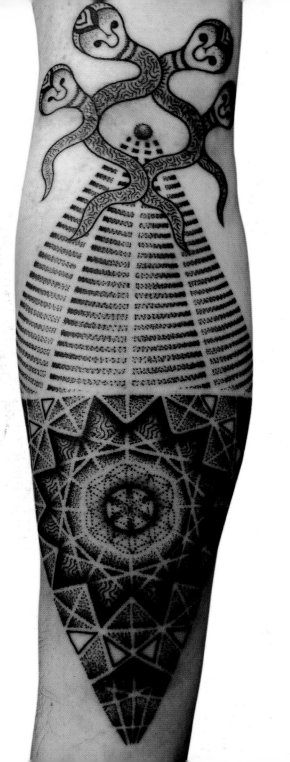
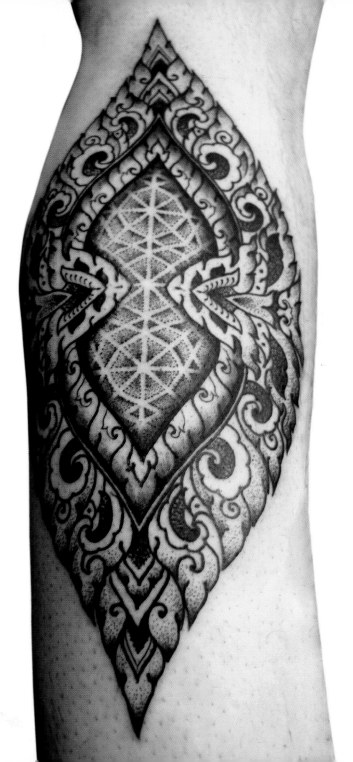

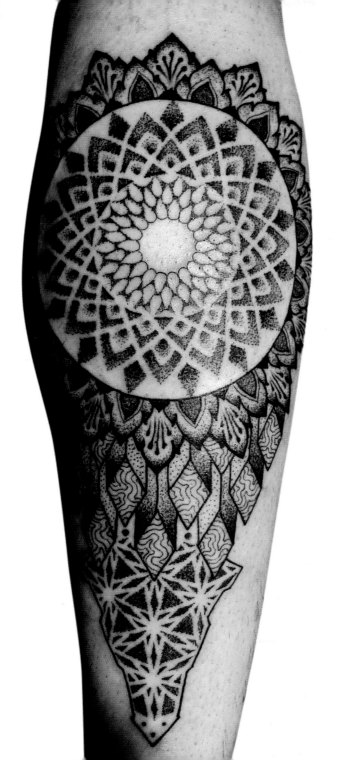
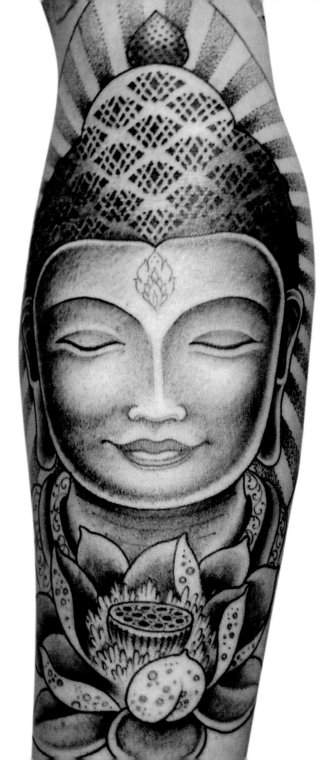

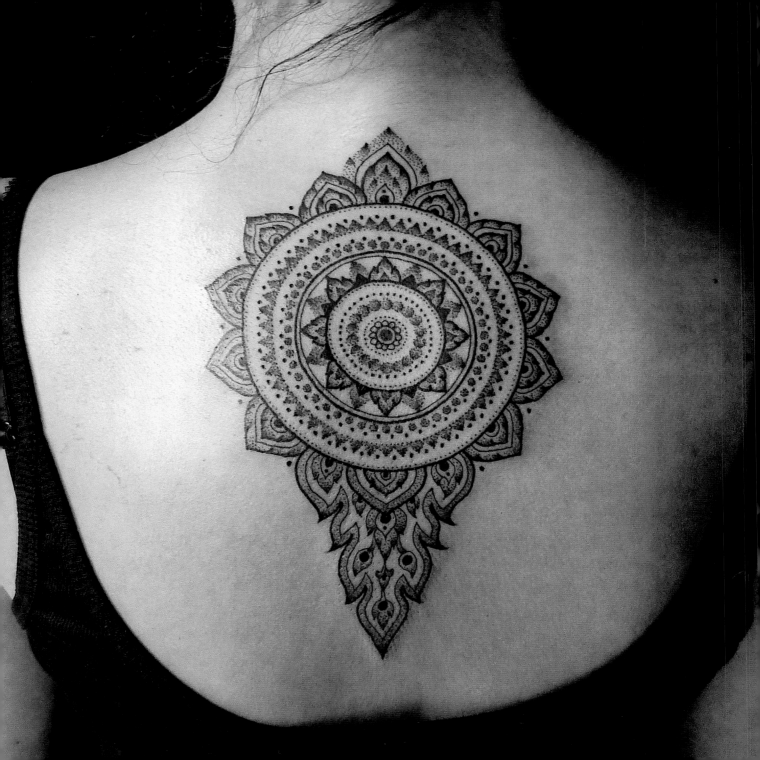

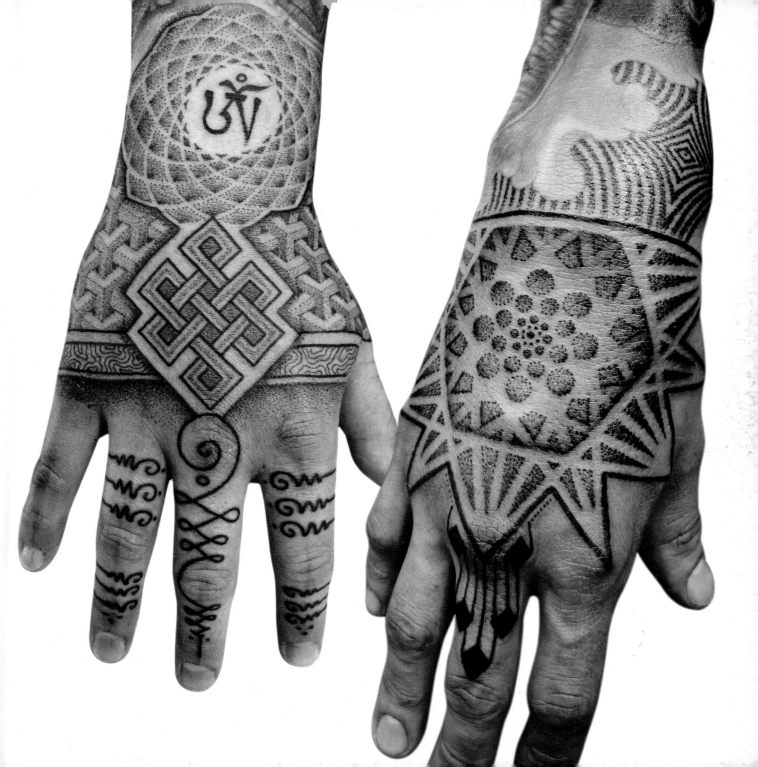

The evolution of Jondix's aesthetic can be abbreviated into an eclectic list of inspirations that include fellow Spaniards Antonio Gaudí and Salvador Dalí, visionary artist Mati Klarwein, the doom metal band Electric Wizard, as well as shamanism, death, emptiness, sacred geometry, and black light.

Using mainly dot-work and gray shading techniques, he admits that his primary focus has shifted, and that he now concentrates more on the moment of conceptual creation that happens in his mind, which he refers to as the "visionary second." He describes his relationship between himself and the art he creates as an "access to spirit," and believes that everyone's imagination is unique and able to create many versions of ideas depending on their individual experiences.

His spiritual approach is evident when discussing the current state of contemporary tattooing, as he acknowledges that, "Some tattoos stay only on the body, while other are deeper in the spirit. A real tattooist who believes in tattooing will make it deep, but if he only believes in money or ego—well, that's a sign of our times—but I still have hope. In the end, I think everything is a big illusion; nothing is real. Maybe only love and death."

Saturn Delta, 2010
Valleys of Neptune, 2010

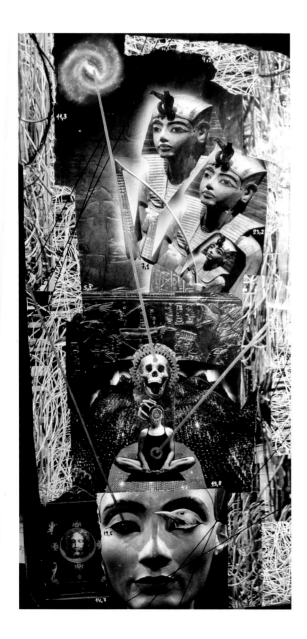

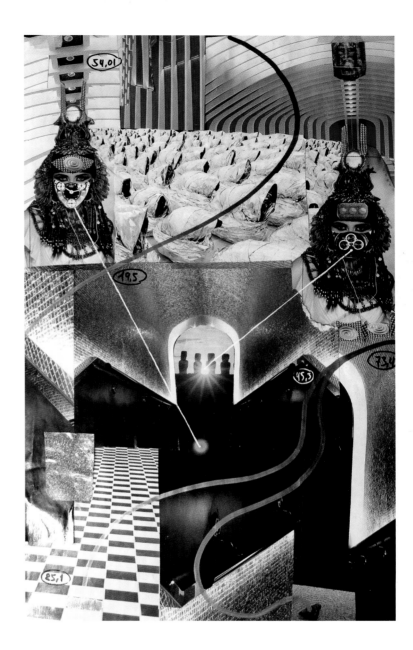

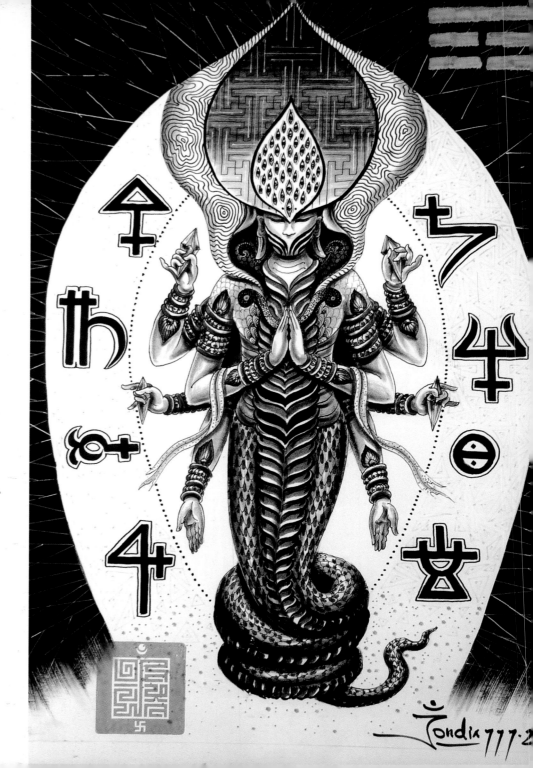

Nagascope, 2009

Opposite: Majesty of Ä·A, 2009

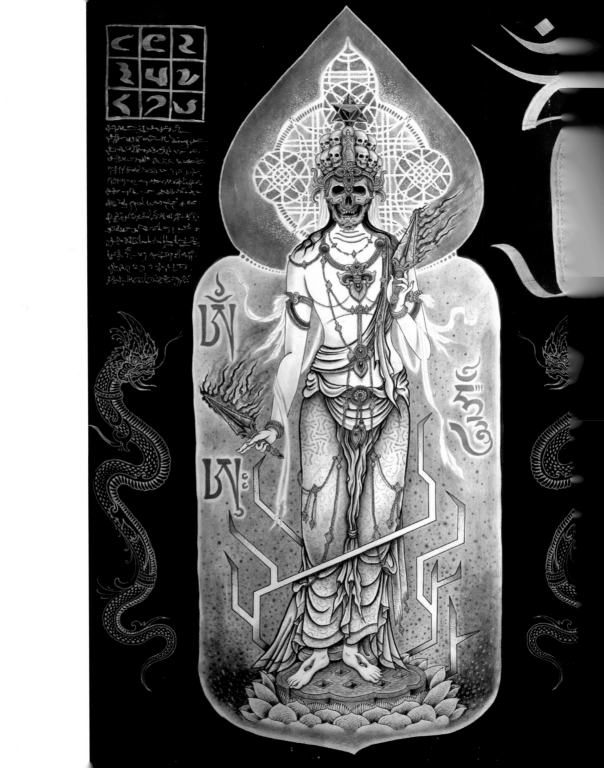

MYLES KARR

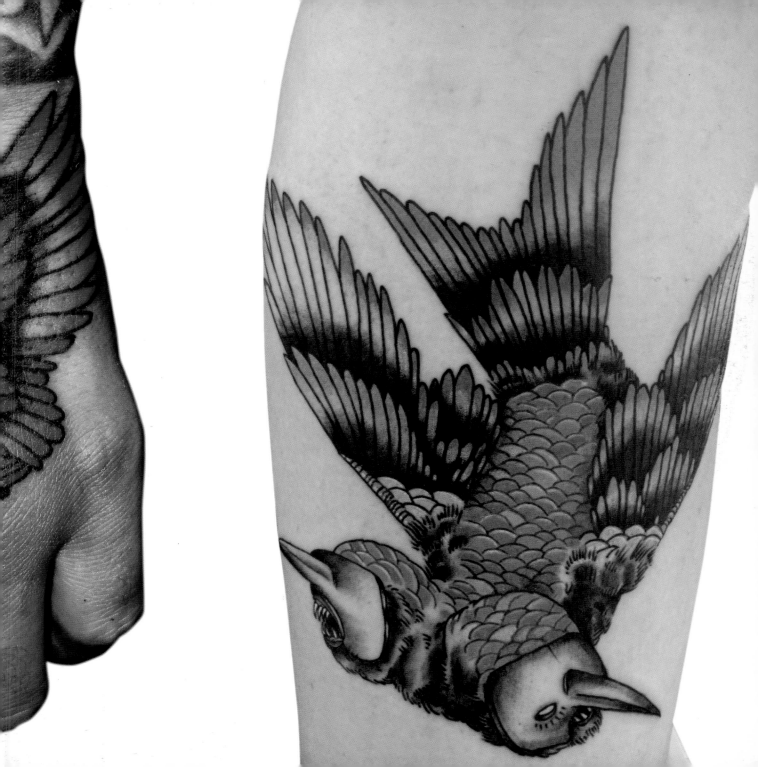

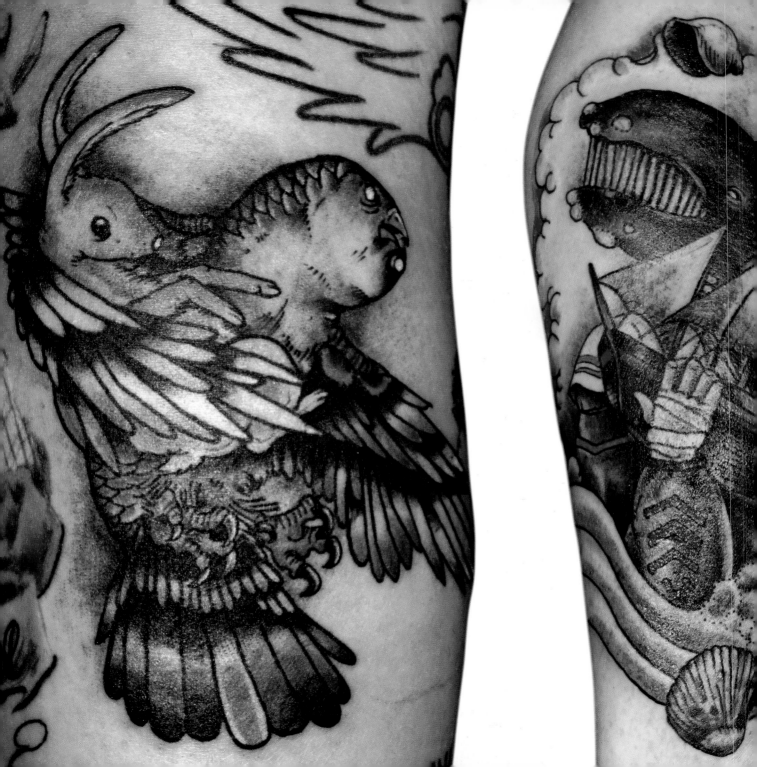

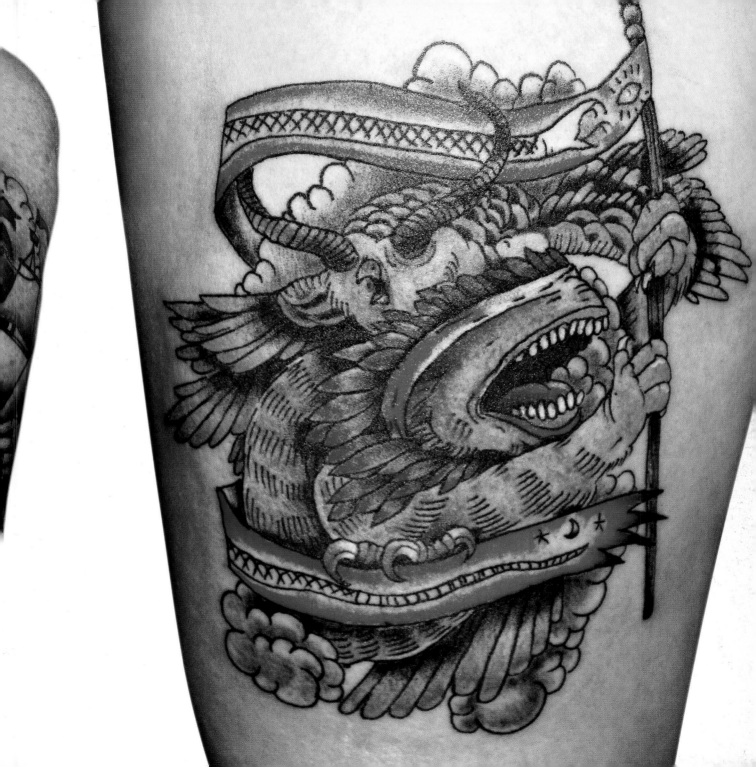

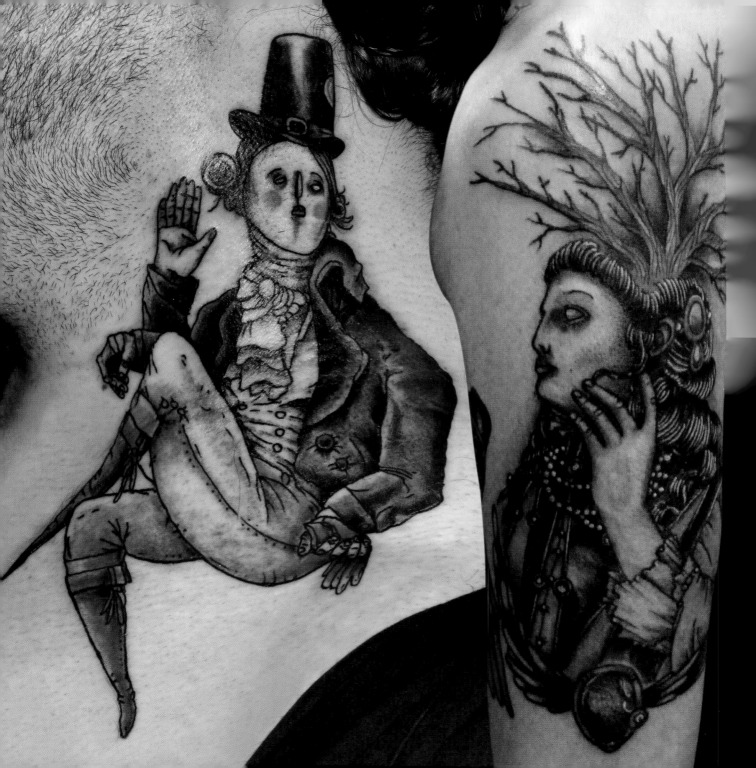

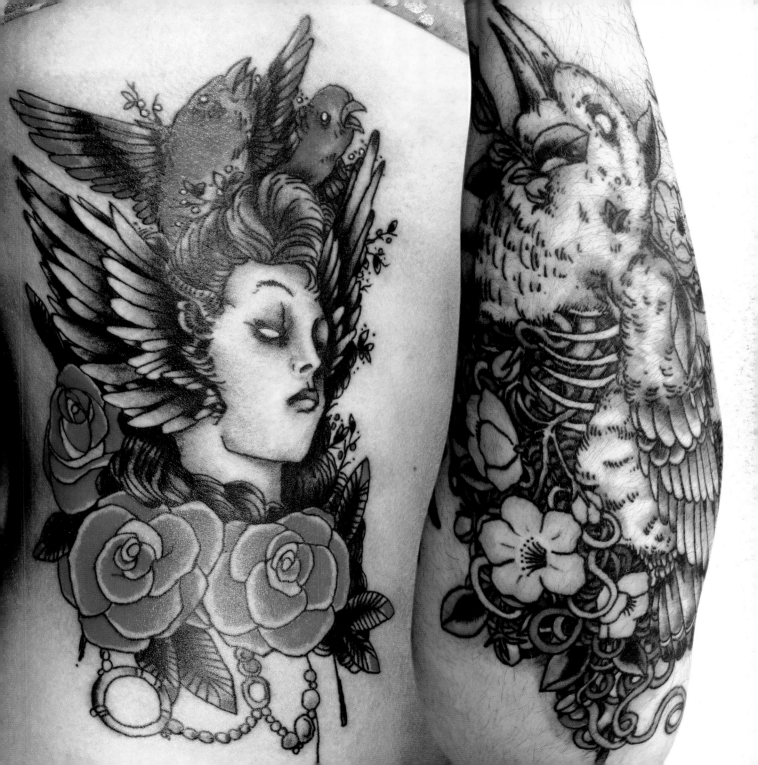

Inspired by tattoo iconography, comic book imagery, and elements of natural history, Myles Karr's artwork is a response to pop culture and media. Contextualized within a mythological framework, and coupled with his signature "whimsical outlook," his designs are inspired by the history of the art of tattooing itself. "I don't think you can be a modern tattooer without existing somewhat within traditional tattoo work," he says.

Karr starts by recording his ideas for tattoos and drawings in his sketchbook, which he maintains daily. "When turning these drawings into tattoos, I redraw the basic ideas over and over until I have five or six different versions of the same image. I'll then combine the best elements of these into a loose stencil, which I'll then redraw on the skin. I don't plan things out very far in advance, choosing to instead work directly with the customer, changing things on the fly, and keeping the drawing fresh right up until the tattooing starts." Rarely drawing a tattoo in advance allows for inspiration to surface spontaneously once he has met the customer.

Karr expresses gratitude toward the clients that he has worked with over the years, saying that, "I have been extremely fortunate to have customers who want to get my artwork tattooed on them." Getting to translate his drawings to skin with a certain amount of artistic freedom has allowed him to push his work in new directions and to build a portfolio, mostly consisting of custom designs. When asked to describe his relationship between the world and his creations, he prefers to let the work speak for itself, saying instead, "I don't know how my work relates to the world. I just know that the world is reflected in my work."

A Volatile Man, 2008
Dual, 2008

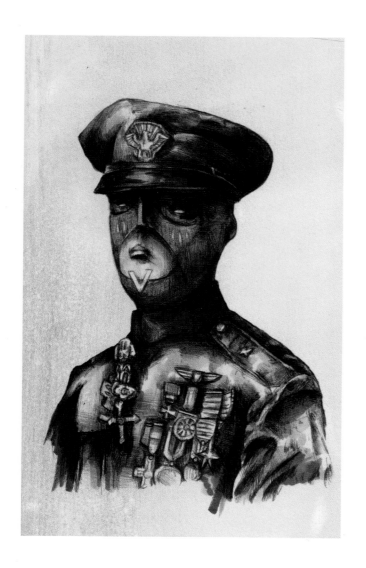

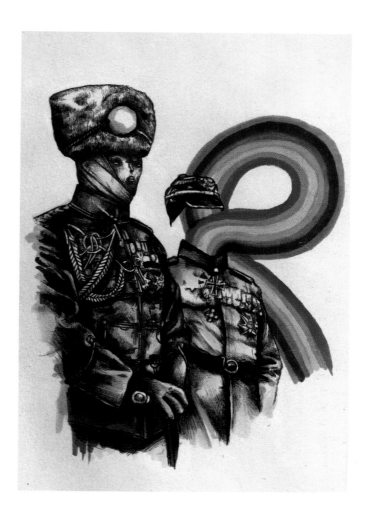

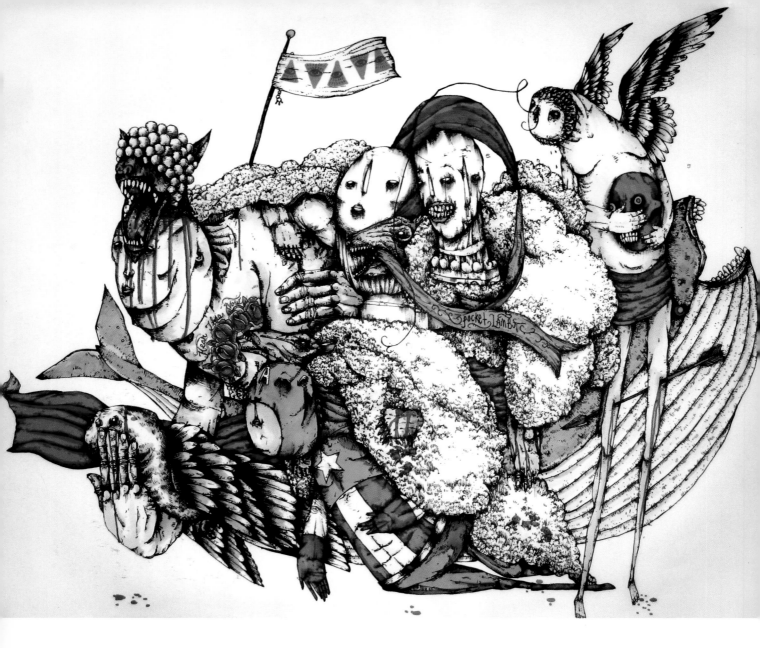

Untitled, 2008

Opposite:
Wooden Whales, 2010
Repenters, 2010

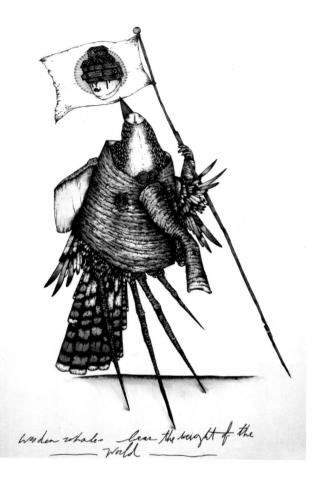

wooden whales bear the weight of the world

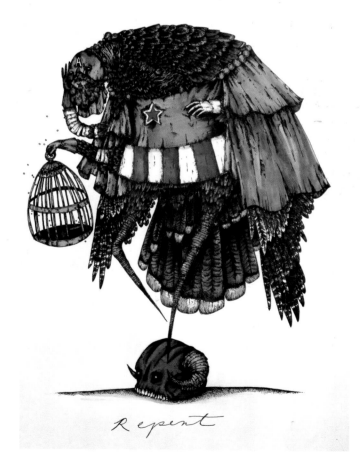

Repent

DIEGO MANNINO

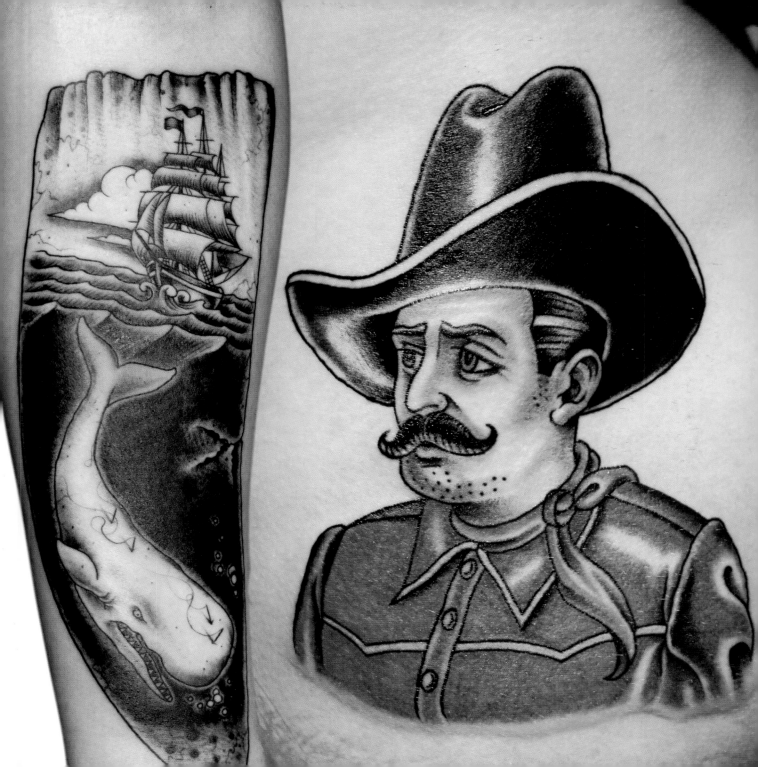

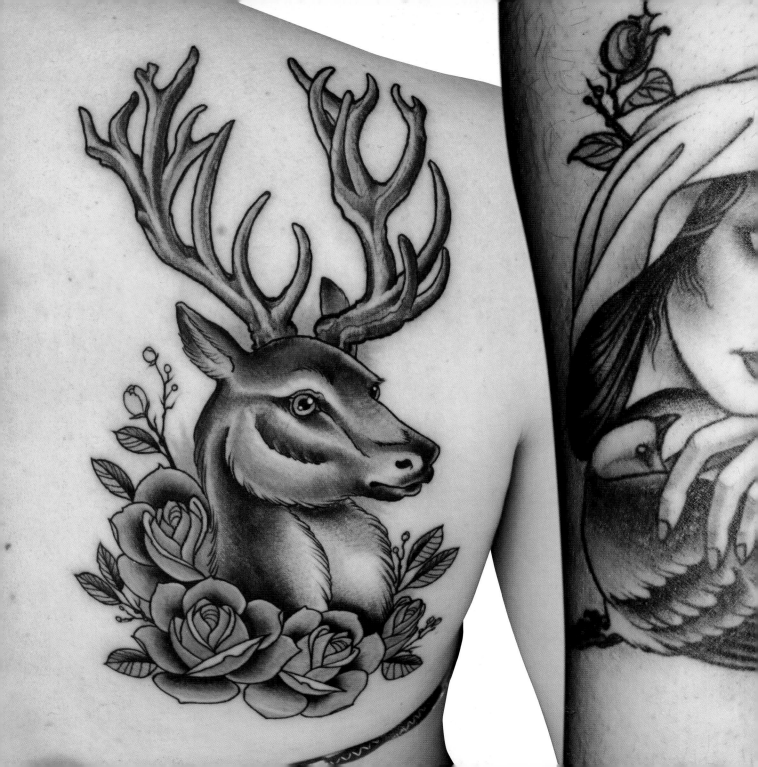

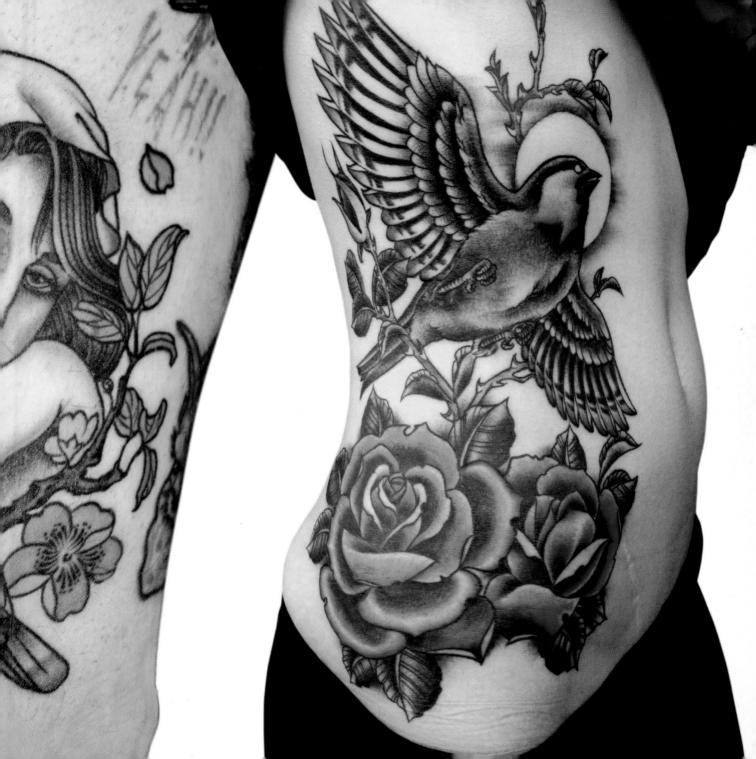

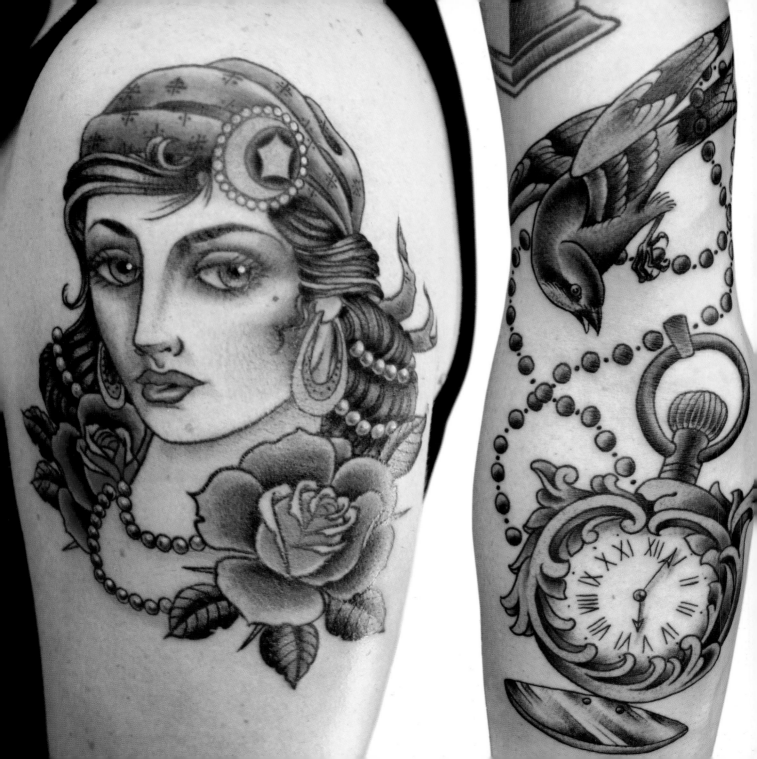

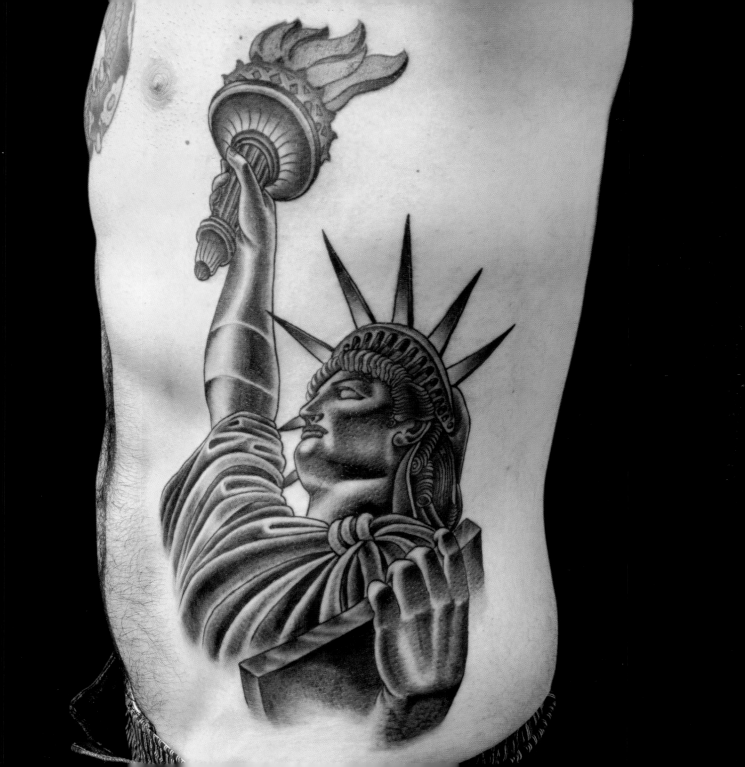

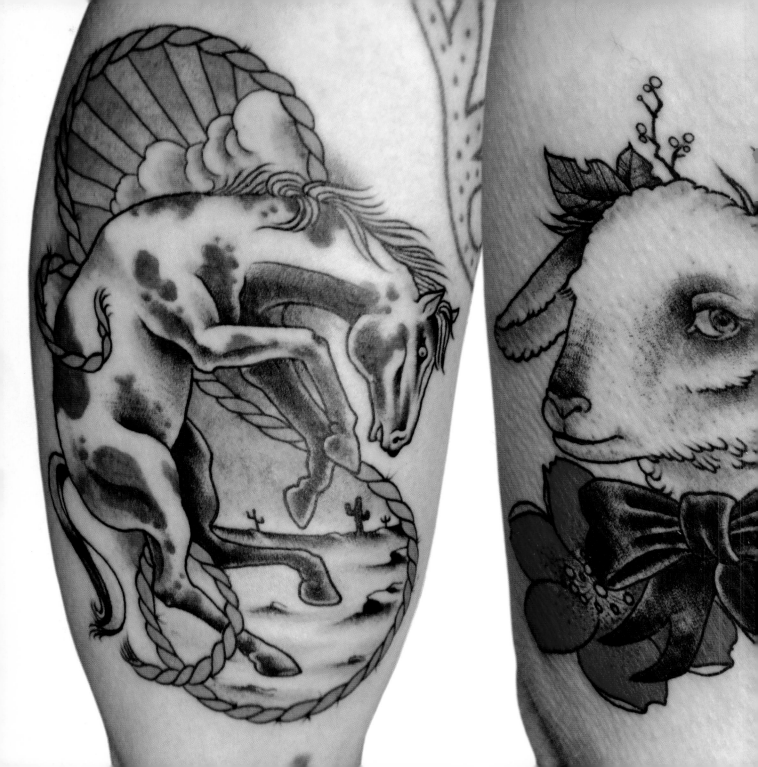

Inspired by painters such as Otto Dix, Odd Nerdrum, Mark Tansey, and Frederic Edwin Church, as well as by surrealism and old children's book illustrations, Diego Mannino's work aims to find a balance between traditional and fine-line tattooing. An avid collector of art books, he has also created his own personal reference library. "The last thing I want to do is rely on the interweb," he says. "Imagination is very important in tattooing, but knowing what something is supposed to look like in reality and where it came from is key." His friends and mentors over the years have also provided him with a wealth of inspiration. As does New York City, which he currently calls home.

He has been focusing lately on bridging the gap between his tattoo work and his personal art, a process that he feels has "been happening naturally and gradually over time." His paintings and drawings have started to sway from the painterly and are becoming more graphic in style, while his tattoo aesthetic has become more illustrative. "I like to mix a little realism and traditional techniques together," he says, "My approach would be to render something like a commercial illustration, and then apply it like a traditional tattoo. One part color, one part black, one part skin."

Mannino finds the constant interaction with lots of different people from all walks of life to be one of his favorite things about tattooing. "I get more inspiration from being at work than I do locked up in my studio," he says. Whether it's a walk-in or a custom piece, he believes that there is a bond between himself and his clients, saying that, "Every person I tattoo carries with them a piece of myself that I've put into their design."

No Times, 2010

Opposite:
Jesus and the Rat, 2009
Mary the Shepherd, 2009
Wild West, 2008

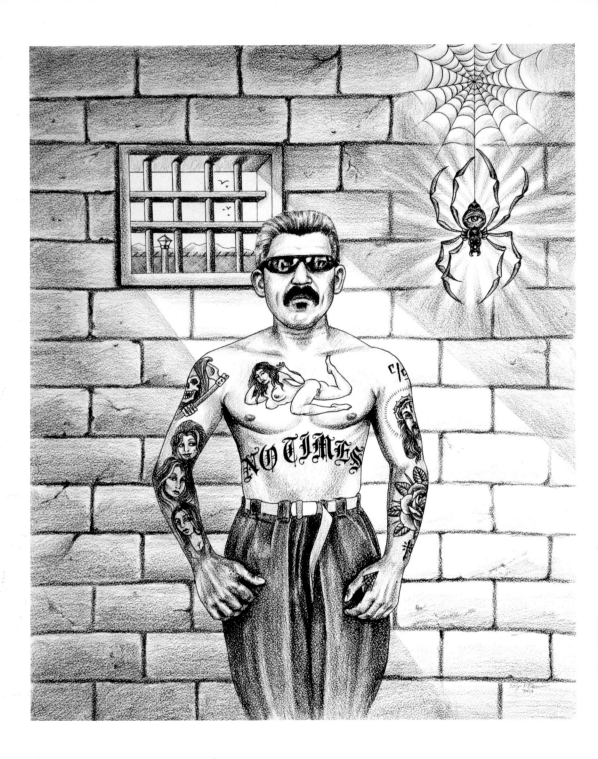

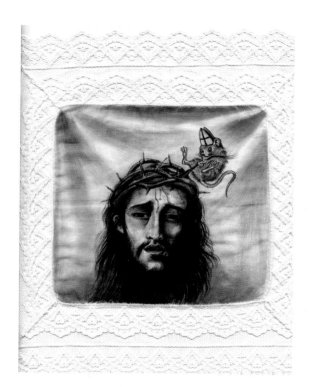

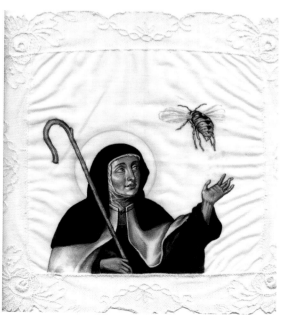

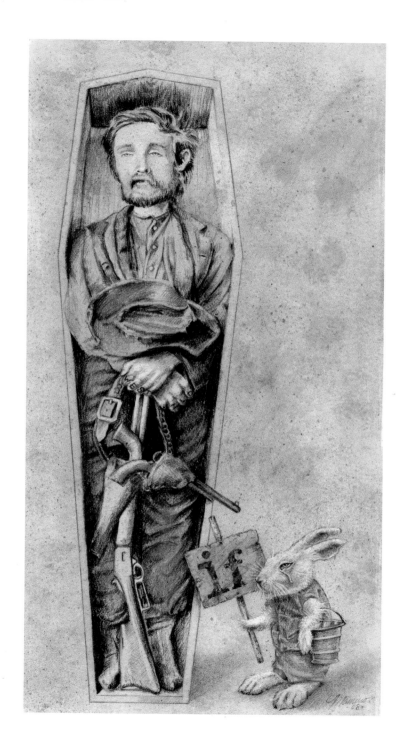

LANGO nator

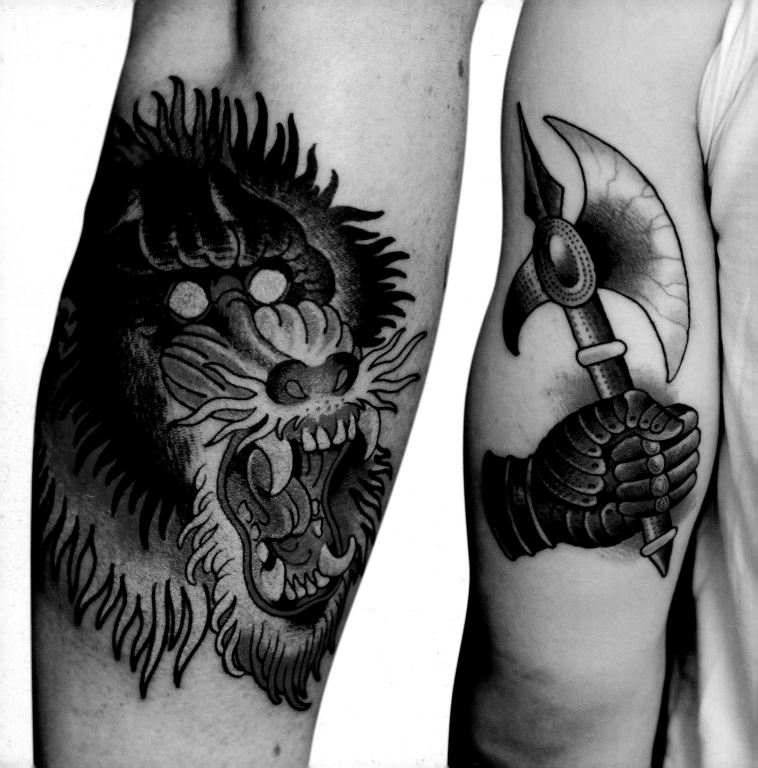

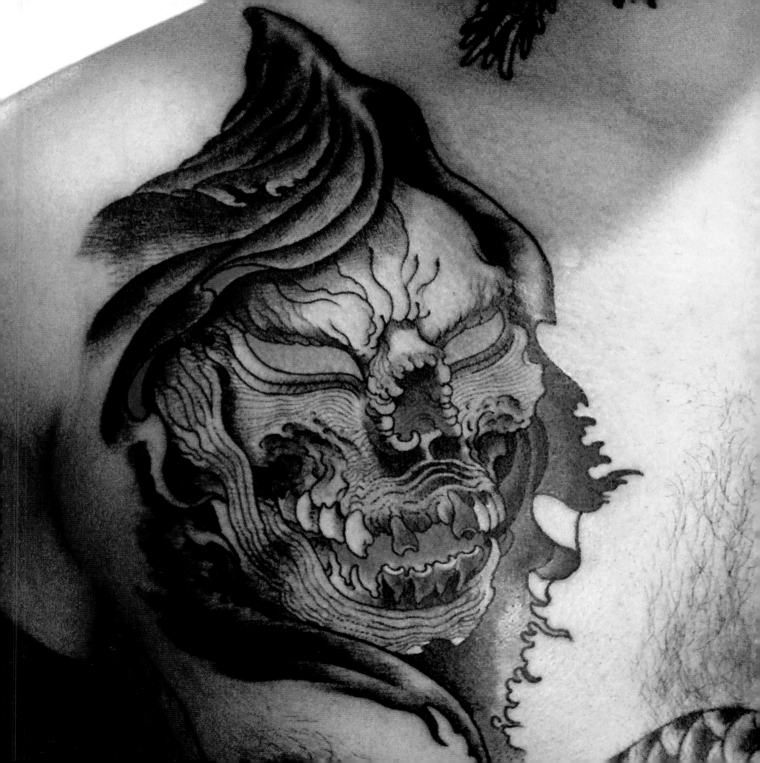

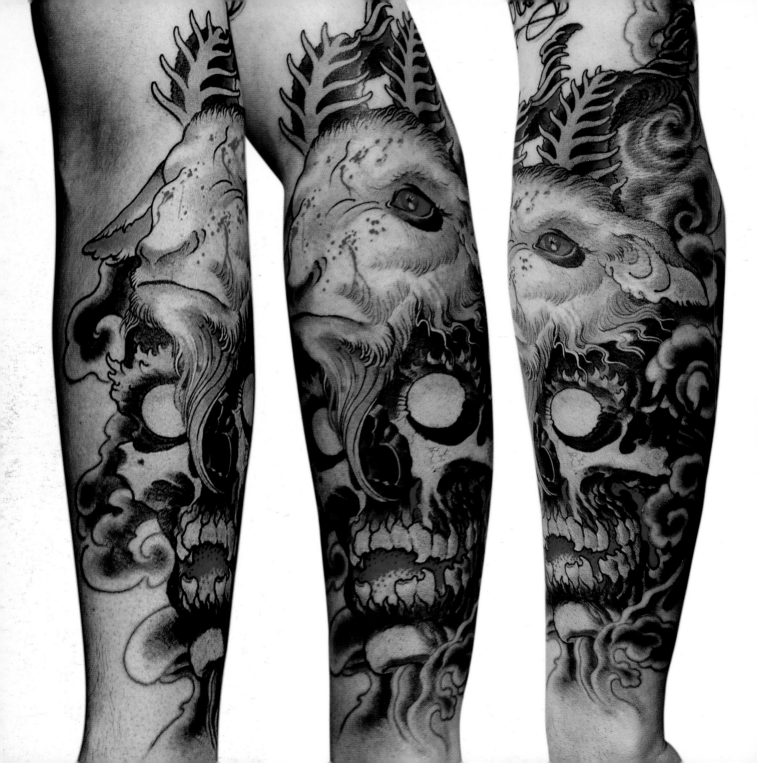

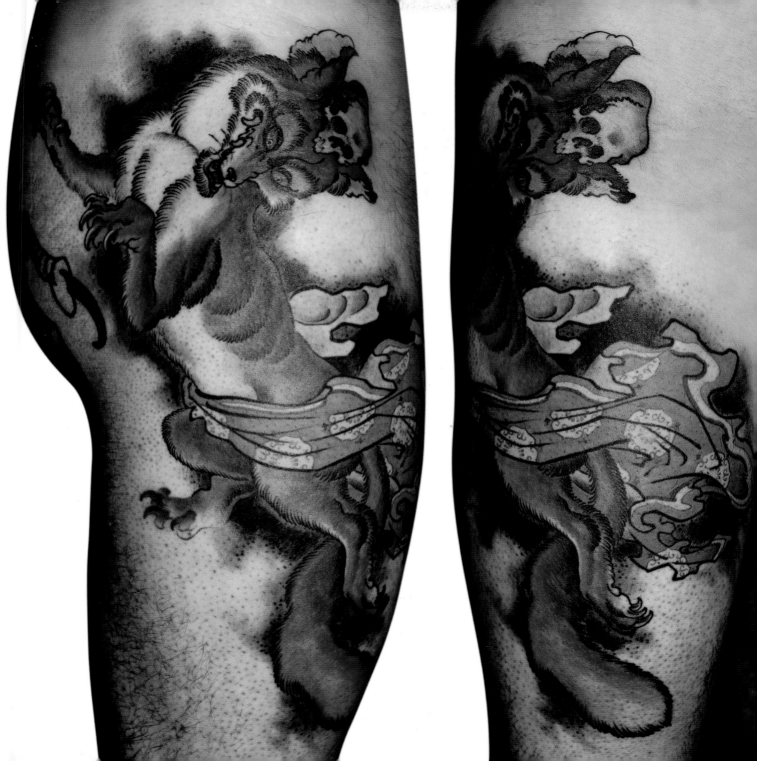

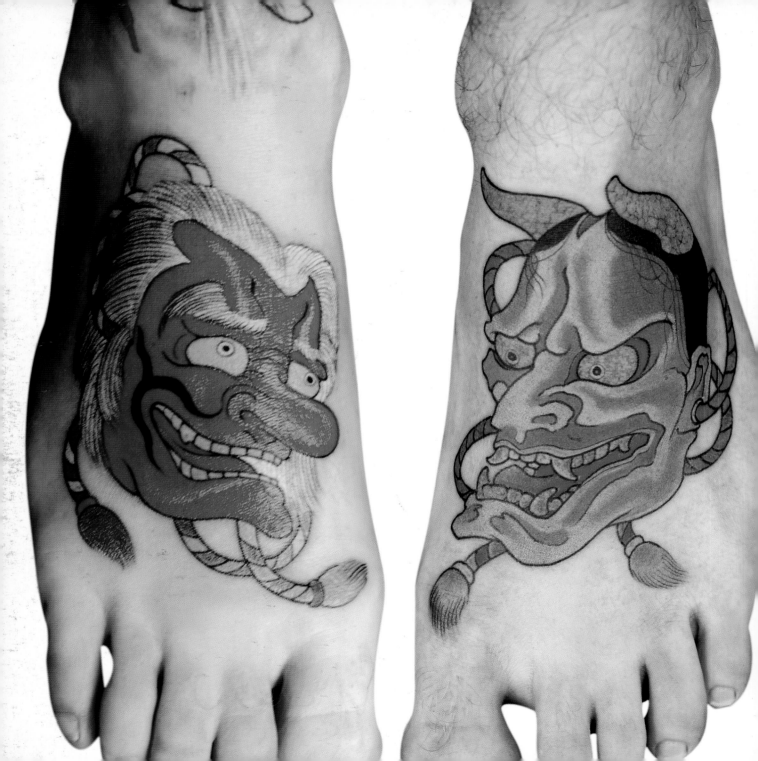

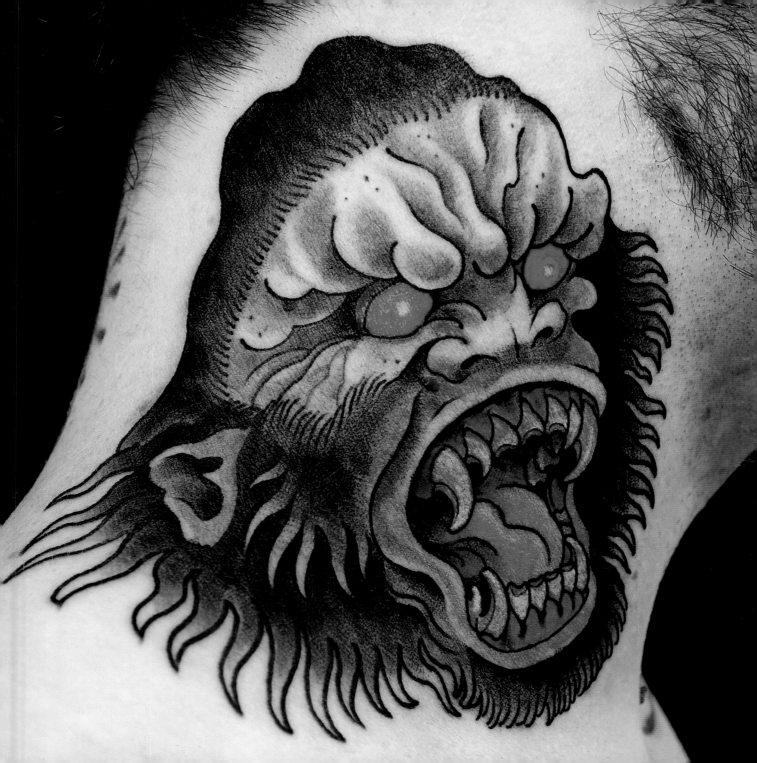

Currently residing in San Francisco, California, Lango Nator states that, "As my tattoo work matures, I strive to achieve timeless tattoos with less incorporation of outside imagery and more focus on my vision of a more traditional subject matter." The artwork and lifestyle of tattoo's old masters inspire him, as do his fellow contemporary tattoo artists who dedicate their lives to the craft. Having witnessed Grime and Marcus Pacheco's revolutionary work firsthand also proved instrumental to his growth as an artist, and his co-workers provide him with constant inspiration, saying that, "Yutaro Sakai and Henry Lewis are also warriors and together at the shop we're like Voltron." Other influences include: Rob Koss, Claus Fuhrmann, Bob Shaw, Ed Hardy, Greg Irons, Percy Waters, Bert Grimm, Jack Tryon, Ralph (Duke) Kaufman, Cap Coleman, Gifu Horihide, Cliff Raven, Guy Aitchison, Aaron Cain, Eddy Deutsche, Timothy Hoyer, Felix and Filip Leu, Horiyoshi I, II, and III, Horisei, Richard Stell, nature, astronomy, graffiti, dreams, and death.

When asked about his craft he says, "I tend to create art that usually has little connection with the contemporary world, but more from a medieval or futuristic time. An image frozen in a lost time, extracted from the abyss of space; or abstract work teeming with indefinable biological matter." Having worked in street shops most of his life, Nator's philosophy is a simple one: "The clients get whatever they want and everybody gets the tattoo that they deserve," he says. "I believe that a good tattoo artist should be able to tattoo anything a client wants—an anchor or a portrait—with the same good results. Style before high-tech tricks is something that seems to be forgotten nowadays."

Opposite: Skull Column Weapons, 2008

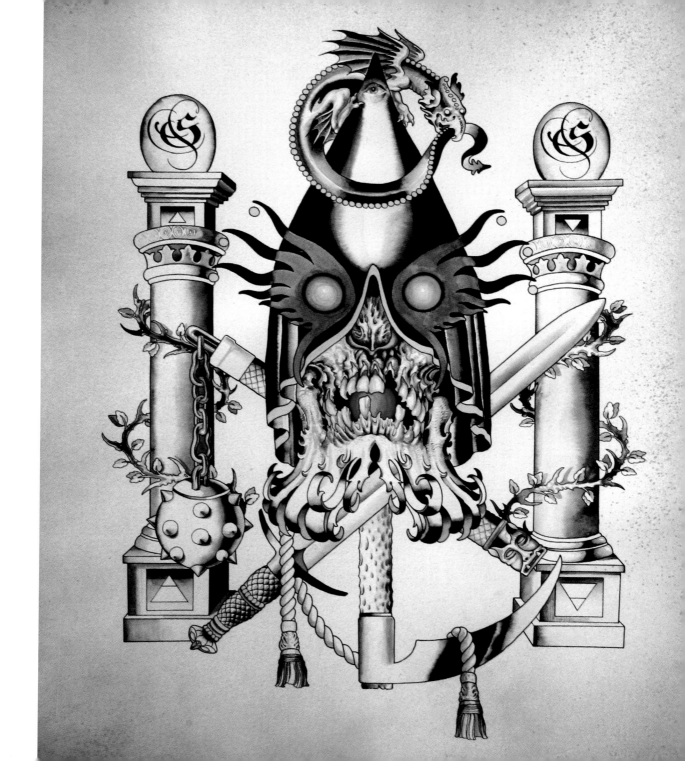

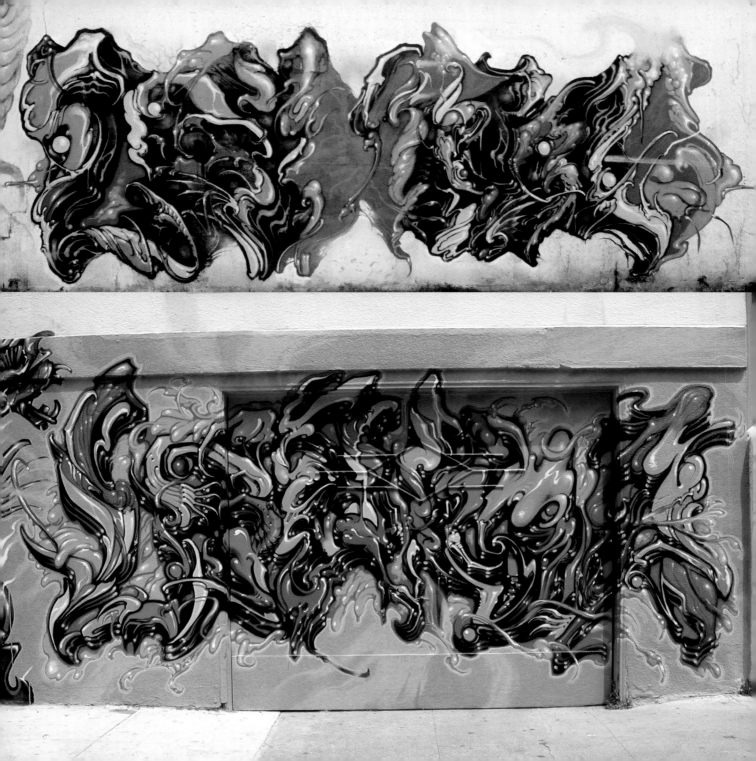

JOHN REARDON

190

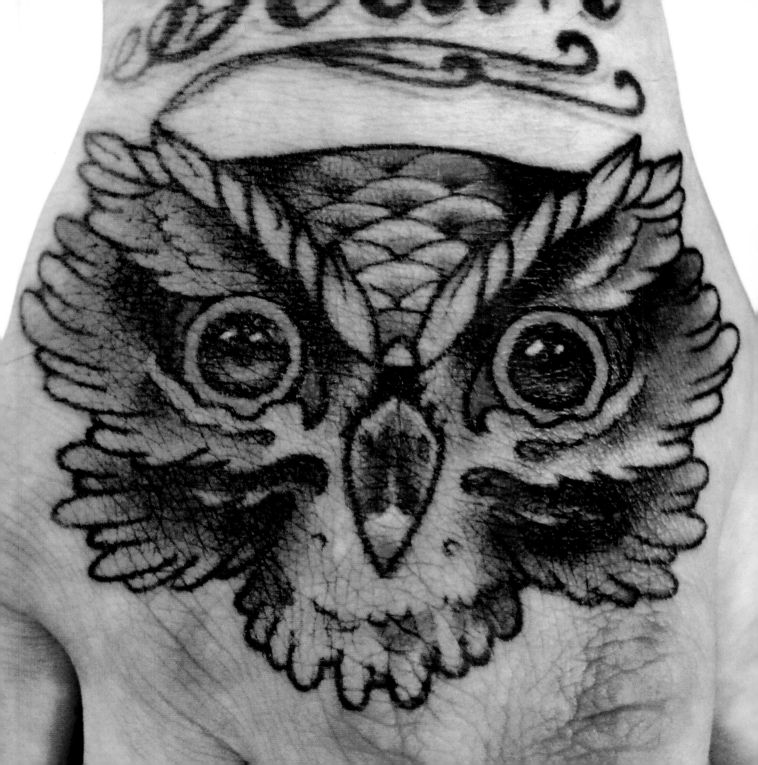

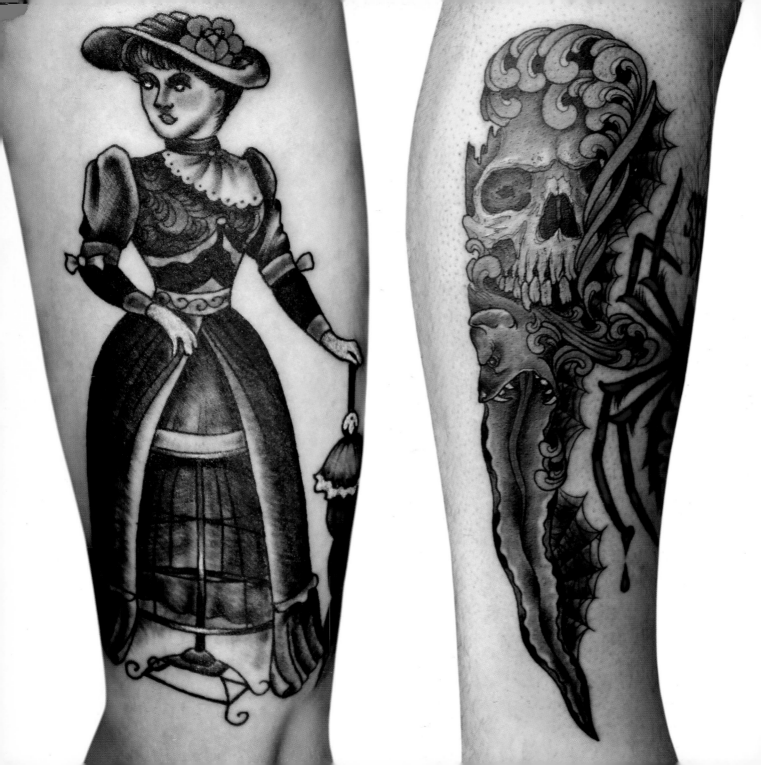

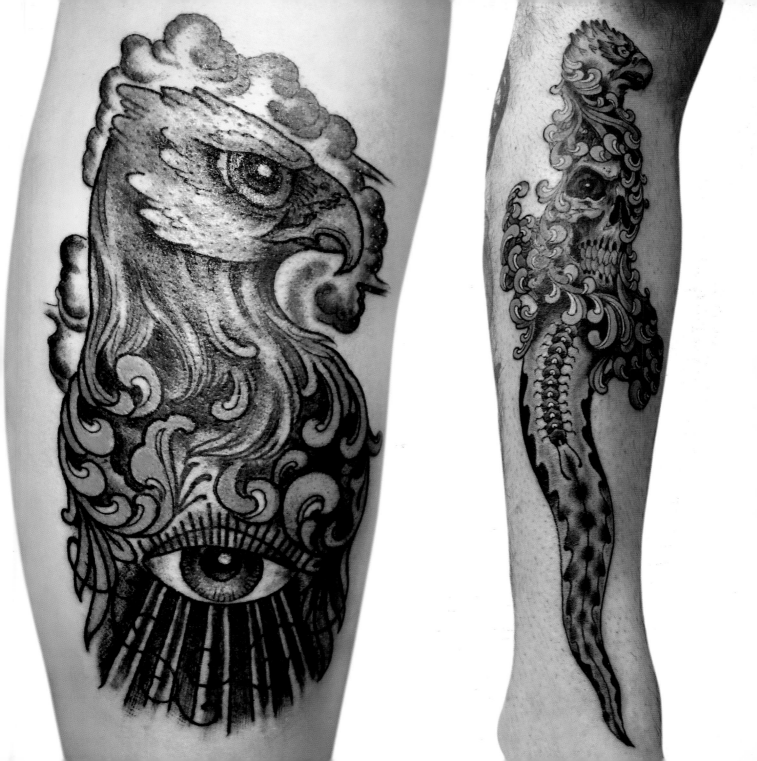

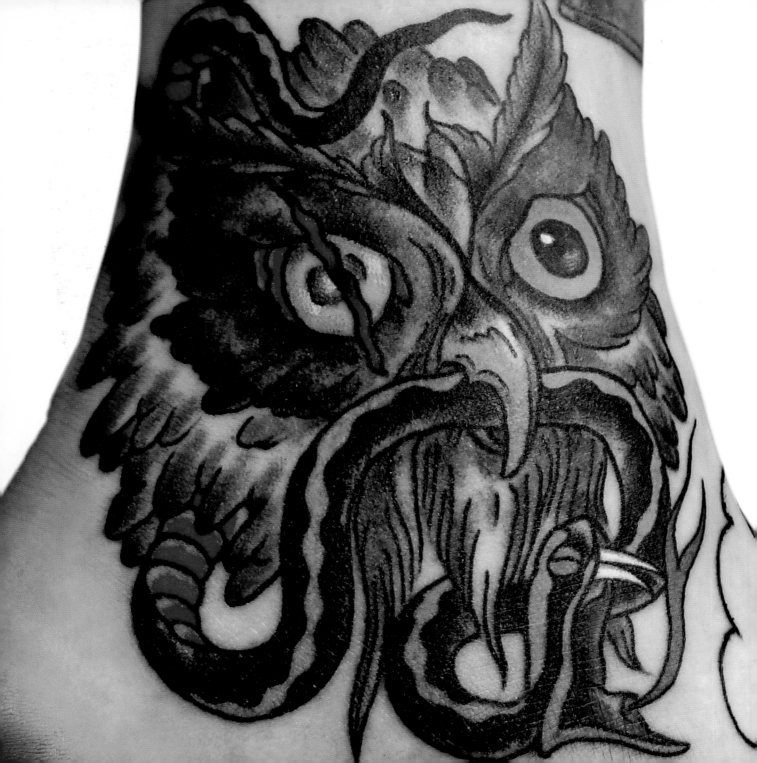

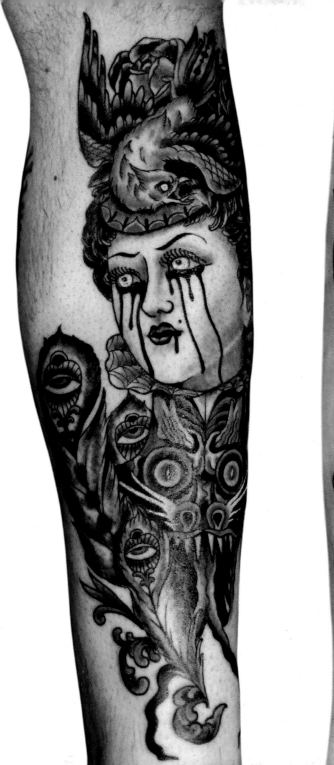
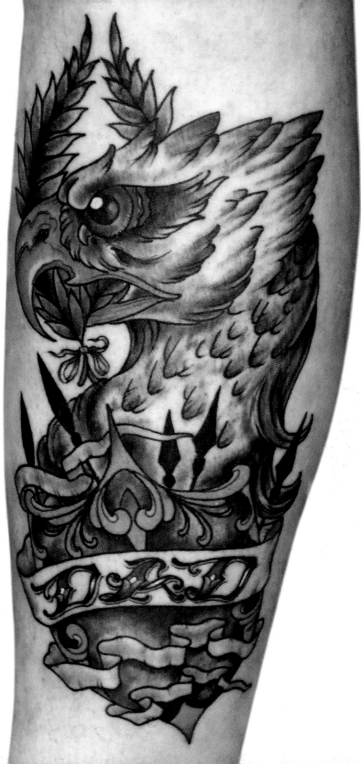

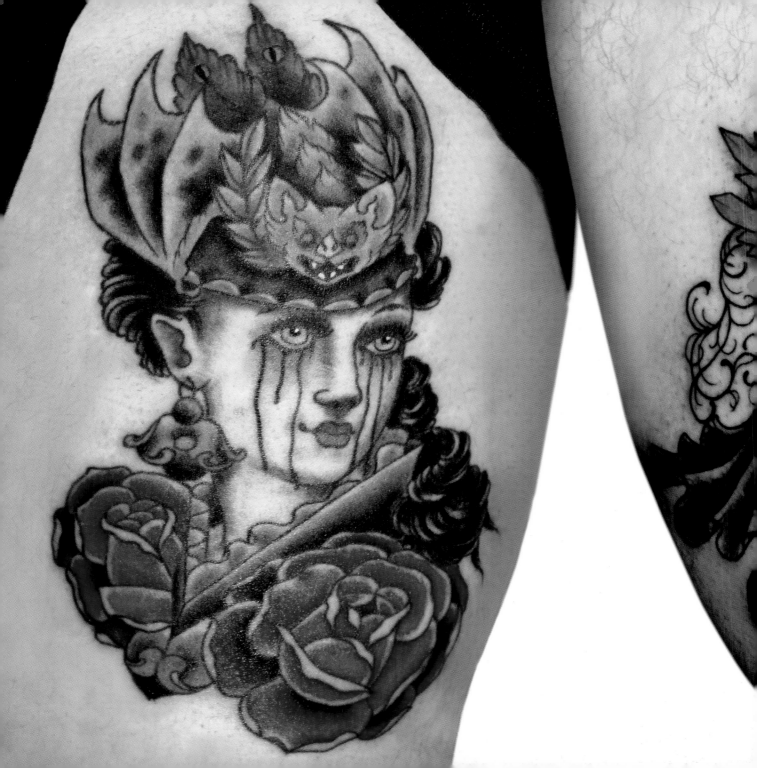

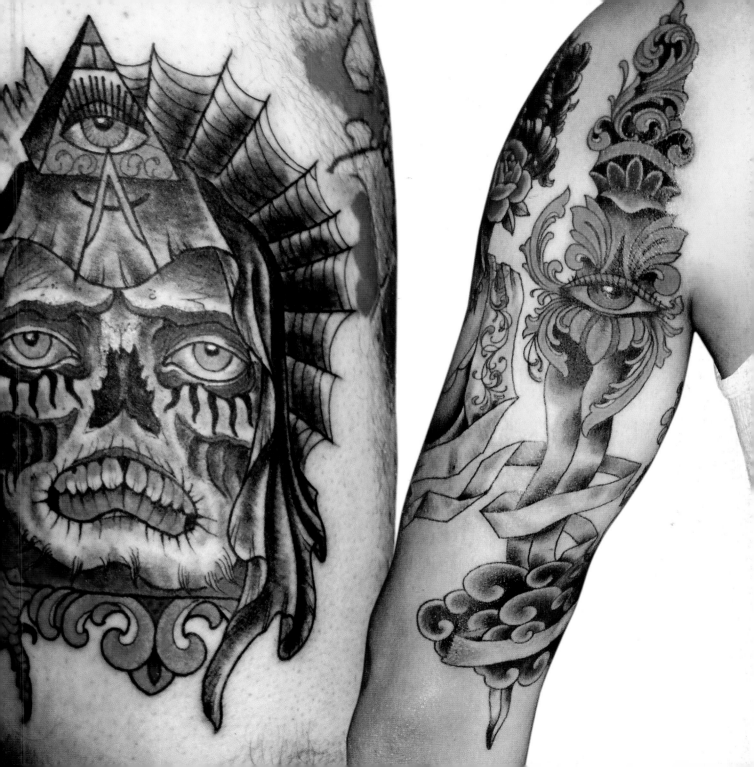

John Reardon's art is heavily influenced by day-to-day life and "whatever is around at that specific time and place." Other sources of inspiration include the tattoo artist Horiyoshi II, Bert Grimm, Miki Foged, and the Metropolitan Museum of Art. And when he really needs inspiration for something new, he just turns to his contemporary, Dan Trocchio. "What's Trocchio doing?" he asks. "I just see what he's up to and then ideas just happen. If he ain't around, just trace some old flash, add a couple of things, and bam! You're a tattooer and probably making some cool shit."

He strives to continue to evolve artistically, and parallels his body's physical changes with his creative development, saying that, "I keep trying to do better. I was really crap, then not so much. I must be evolving aesthetically. I am also growing more hair from various parts of my body where there was no hair before. It's the same thing." Despite being a tattoo artist, his aspirations are not too different from the average urbanite, as he claims that he is "just trying to impress my friends and pay rent, overeat really good food with overpriced cocktails, and maybe a bottle or two of red or white depending on the season or choice of meat."

What is Reardon's advice to novice tattoo artists? "Use a lot of black and do sit-ups or yoga or something like that because my back hurts and so will yours." He dissuades artists from attending traditional art schools, advising them instead to "do what ever you want. A good tattooist is a good tattooist, and if you suck that's cool, too. It's all perspective."

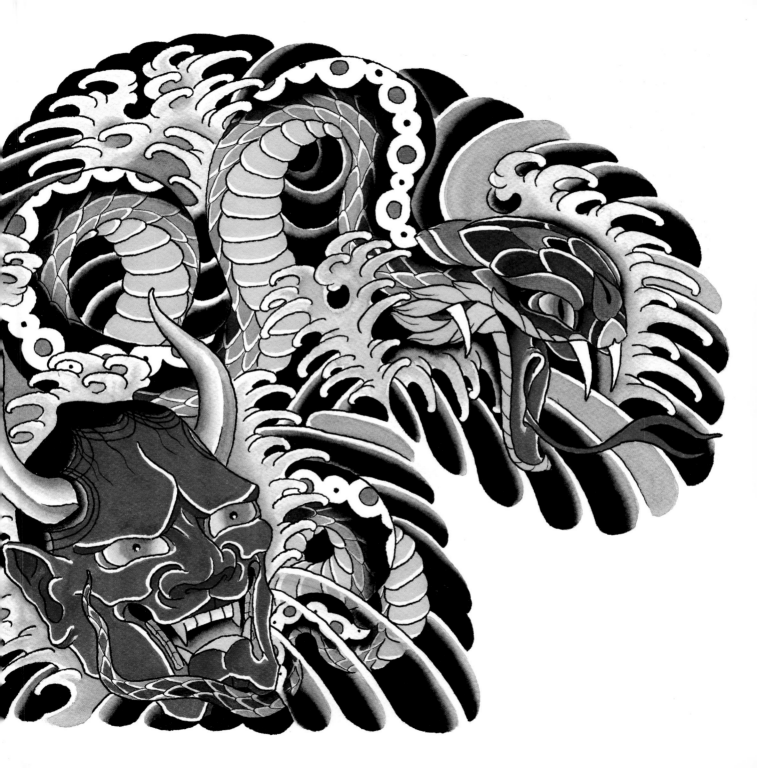

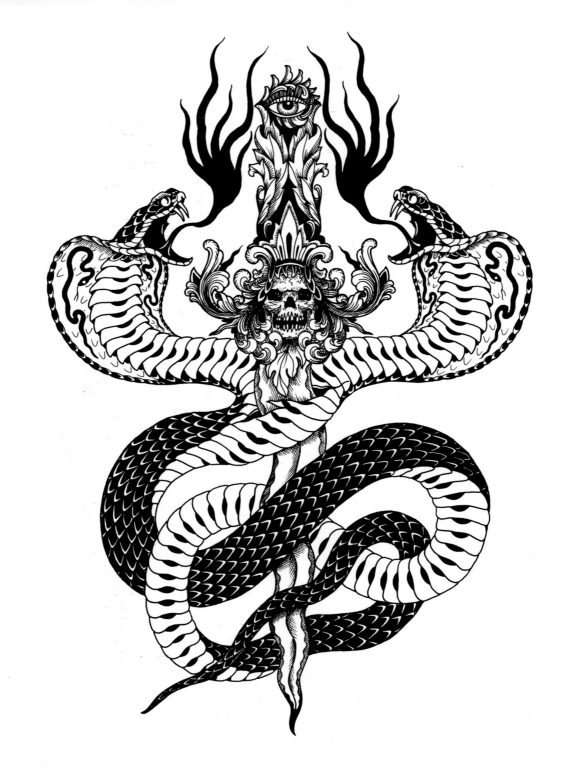

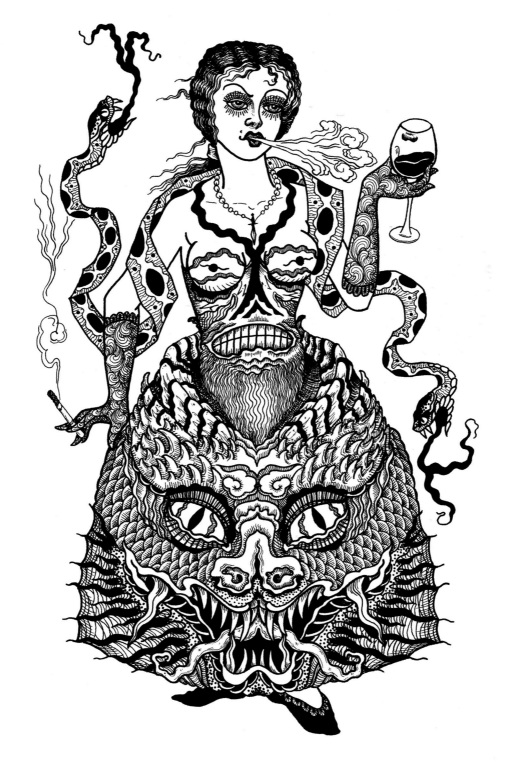

JAVIER RODRIGUEZ

202

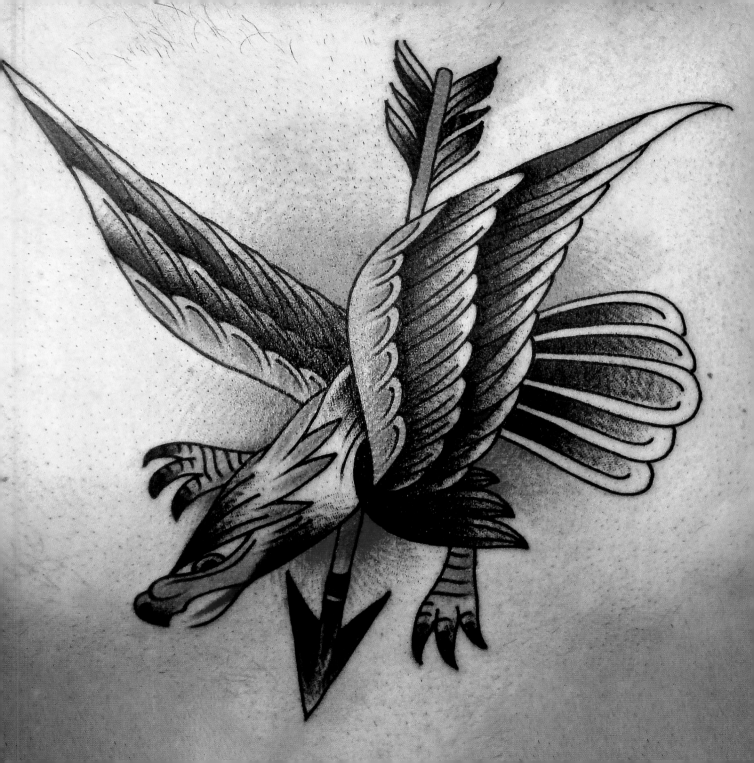

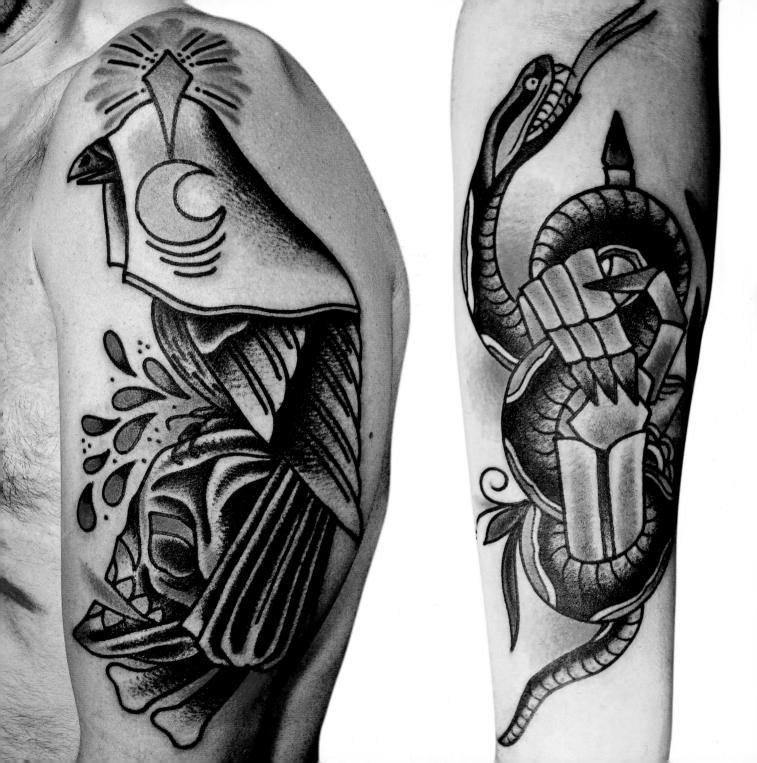

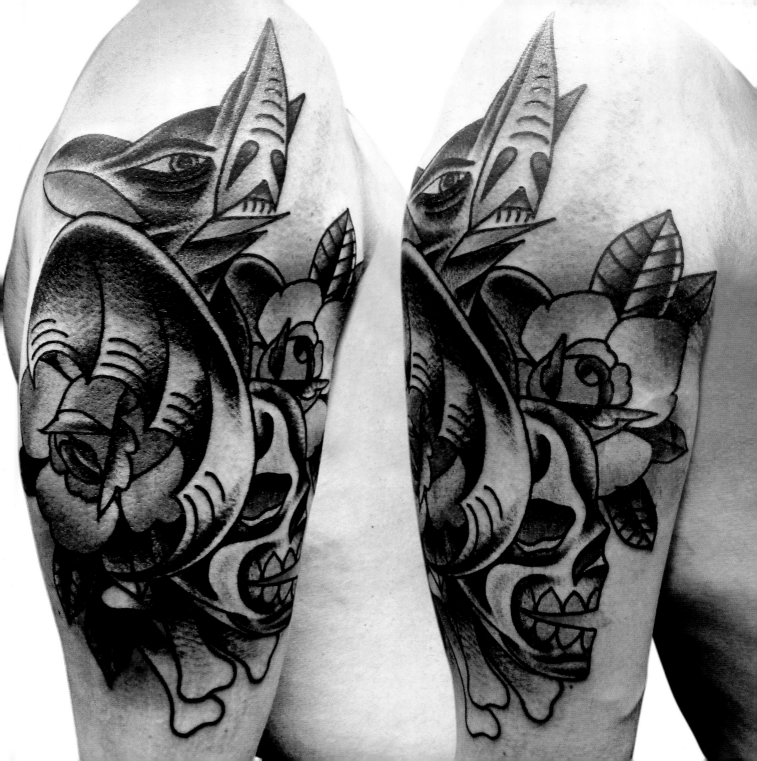

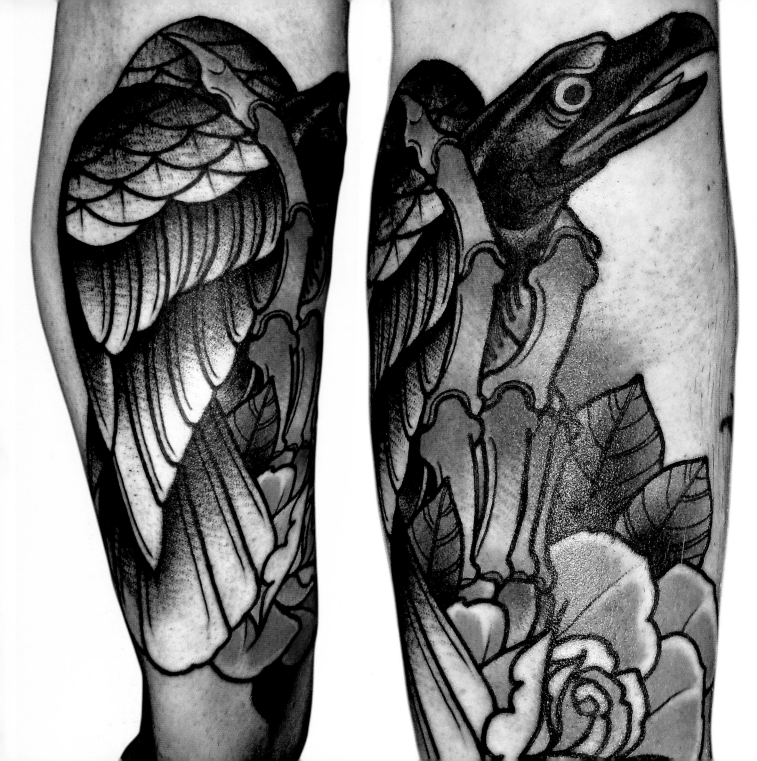

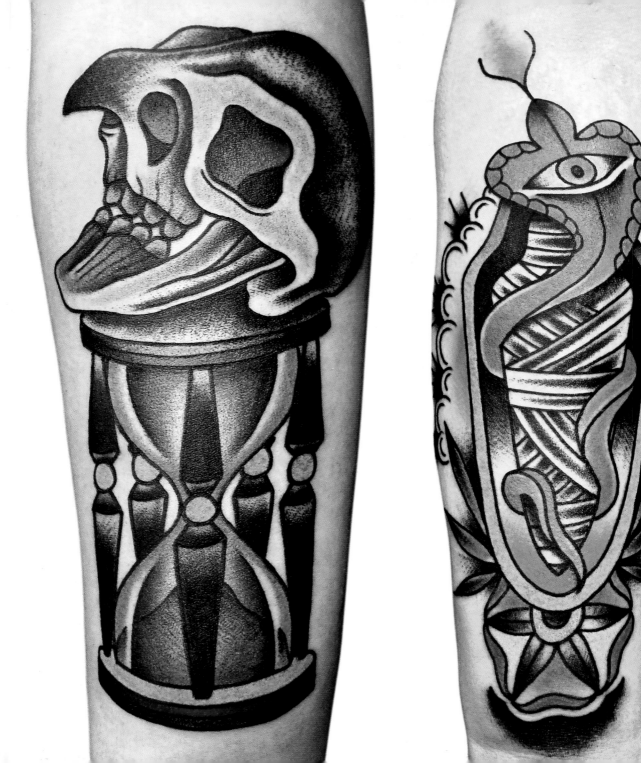

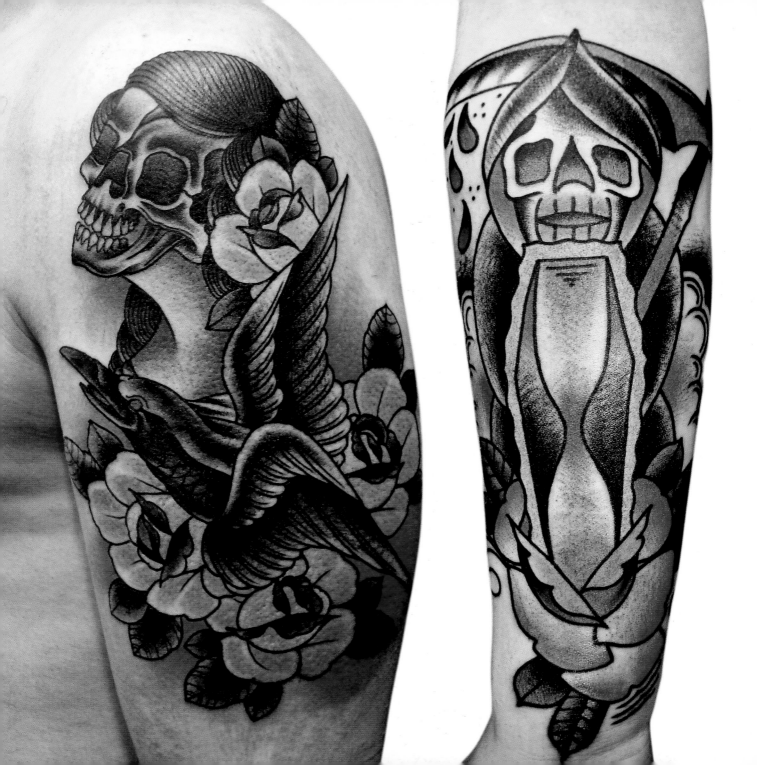

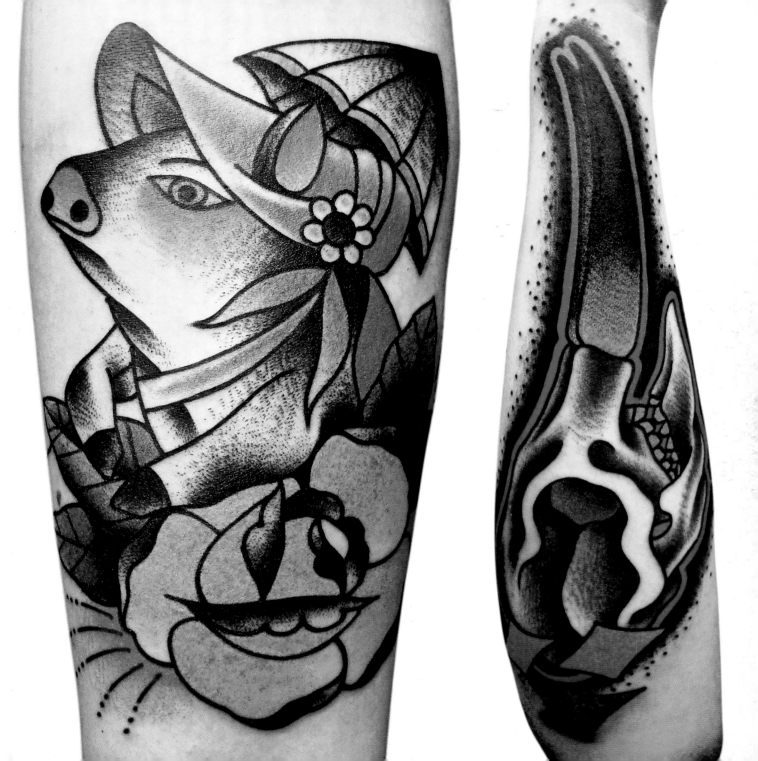

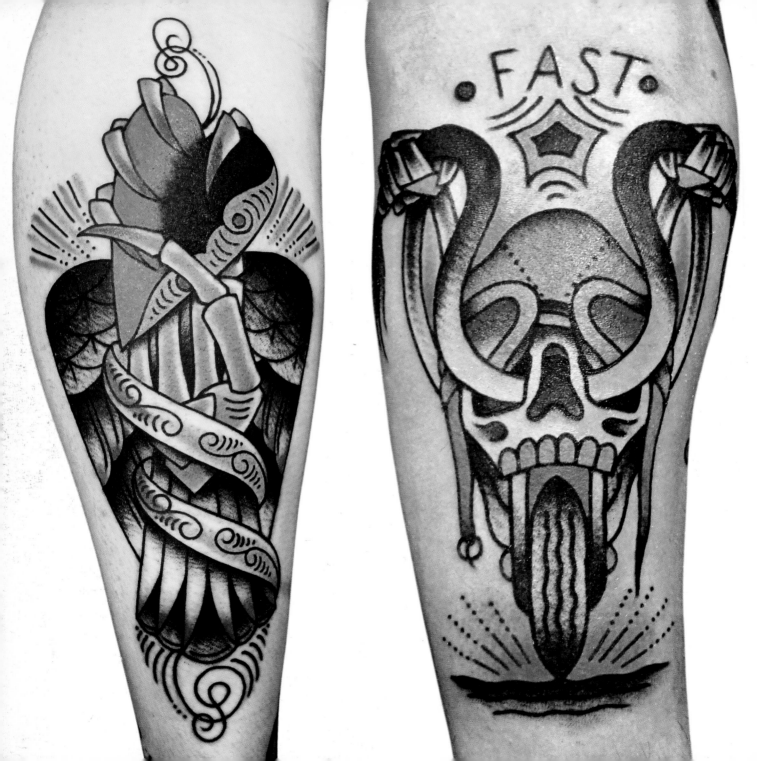

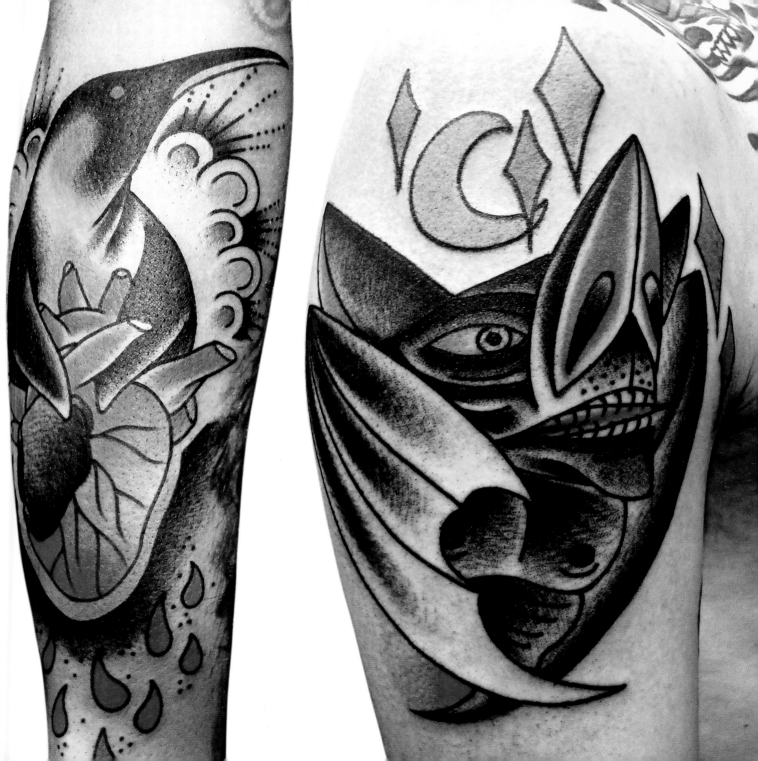

Javier Rodriguez aims for simplicity in both his tattoo and artwork. Early sources of inspiration came from magazines where artists such as Scott Sylvia, Jeff Whitehead, Ed Hardy, and Juan Puente displayed their traditional American-style designs. From there he became more interested in artists from the 1940s and 1950s, which led him to develop his own identity as an artist who "works with a mixture of elements and meanings in a straightforward way, using innovative techniques."

When working on a tattoo design, Rodriguez admits, "The challenge is to accomplish my client's desires and expectation without losing my aesthetic essence." In the future, he looks forward to pushing his customers' imaginations even further, because it is then that great tattoos are born.

212

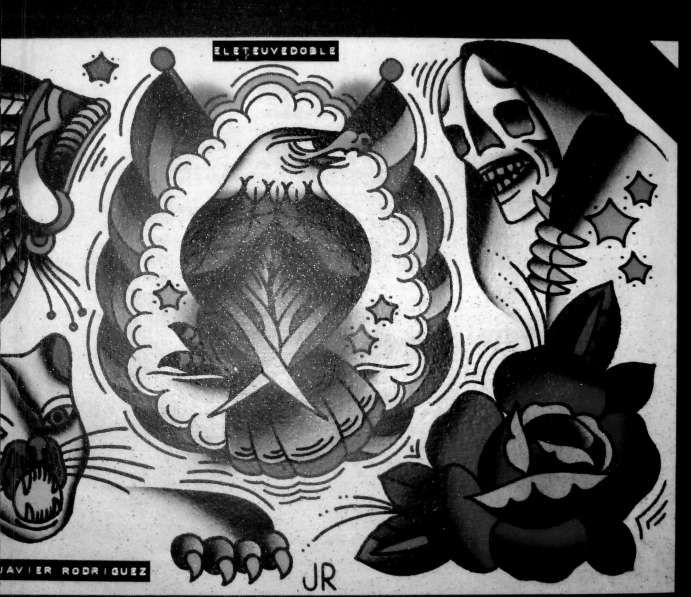

BRAD STEVENS

214

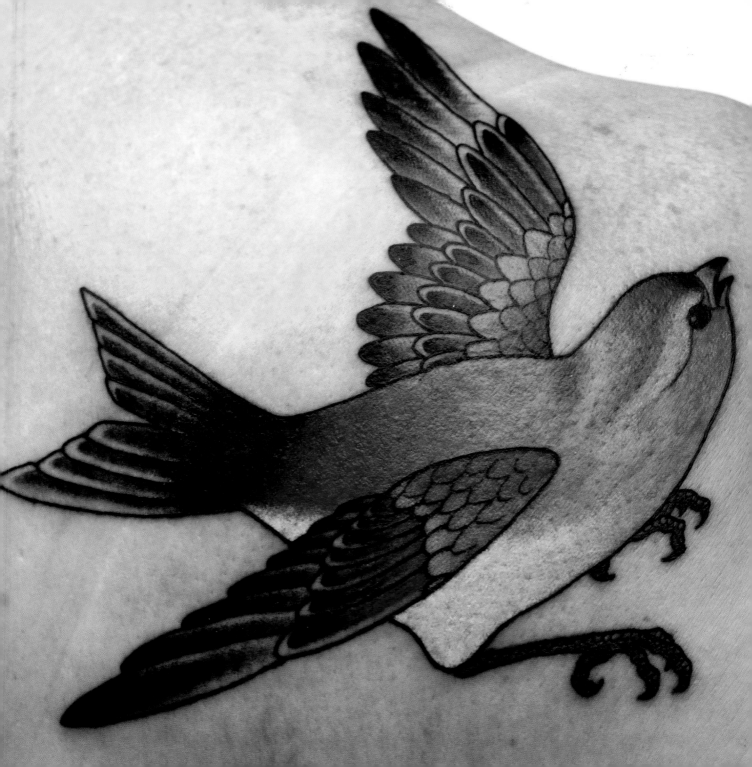

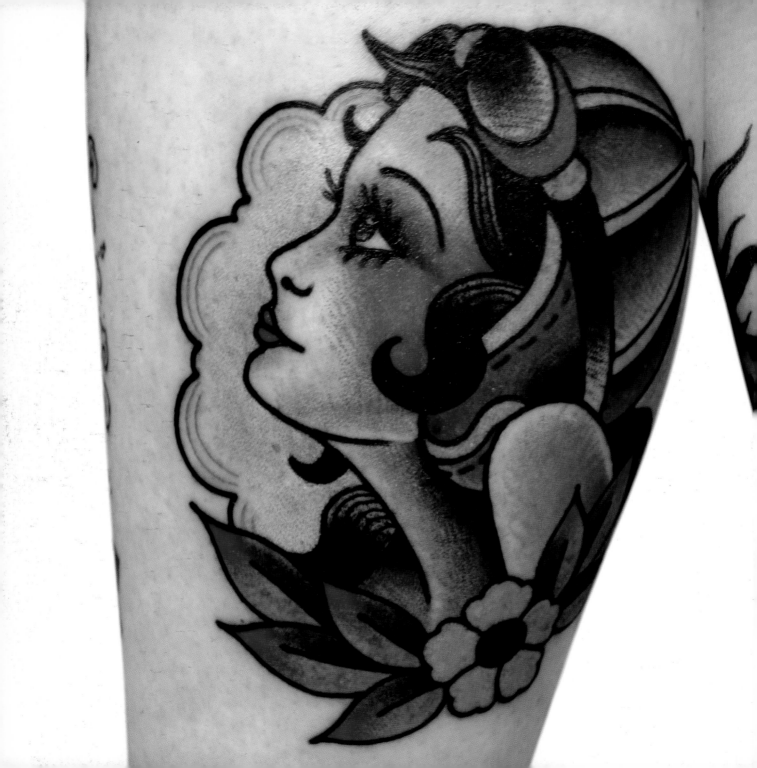

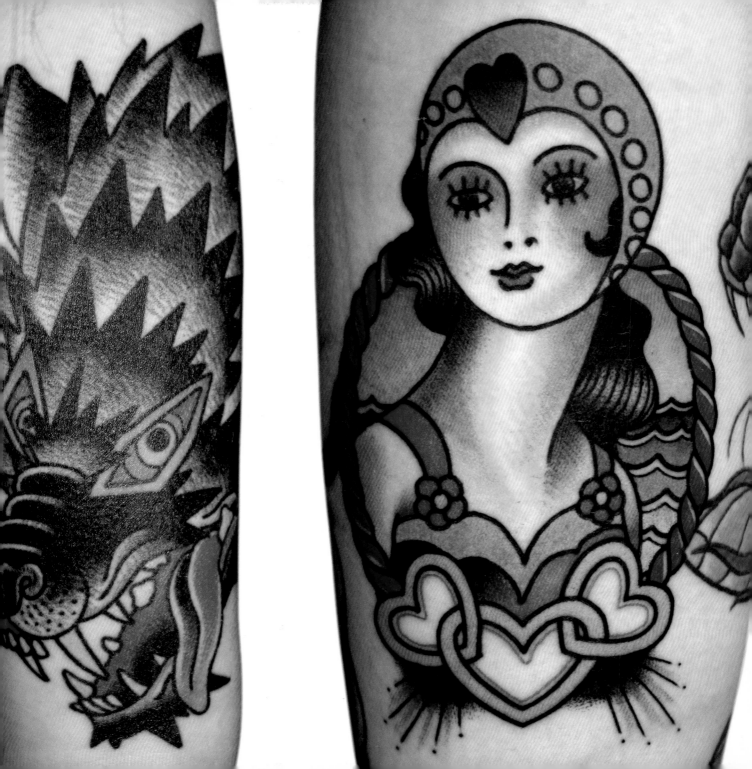

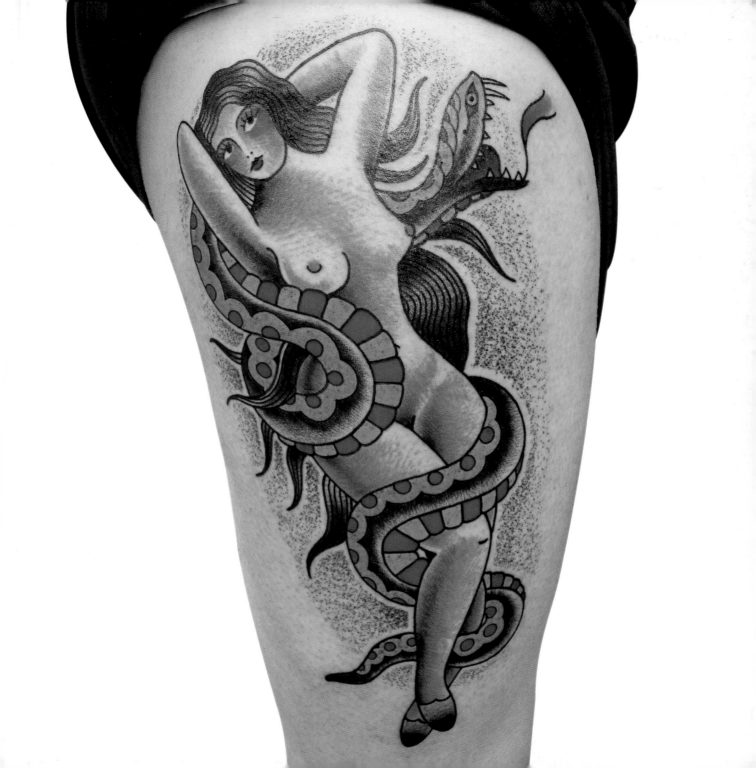

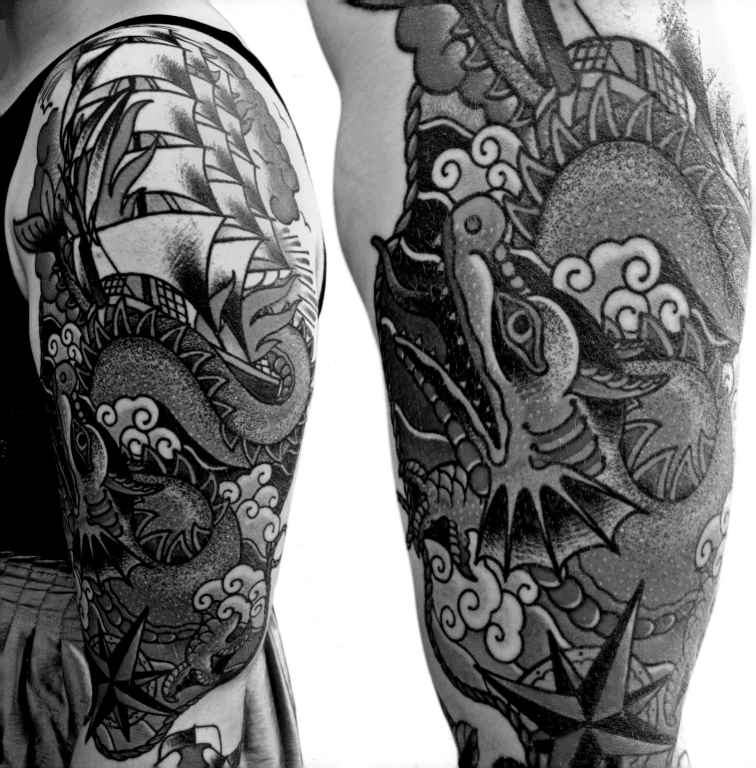

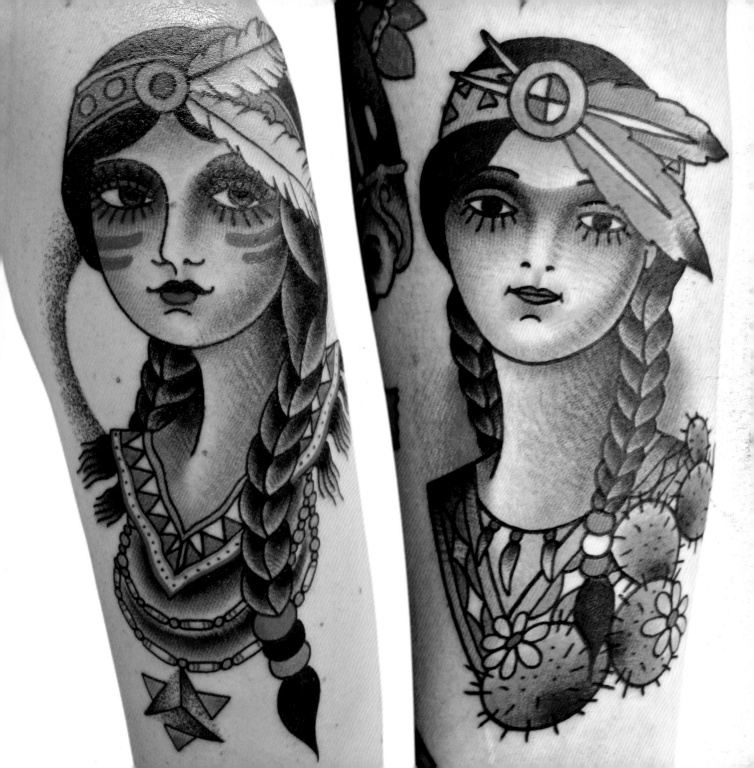

"What really motivates or inspires anyone more than love and hate?" asks Brad Stevens half jokingly, "Usually my inspiration comes from either extreme of [those] emotions, or a combination of the two." Originally from Syracuse, New York, he openly admits that he is still "trying to figure out exactly what [he's] supposed to be doing." When he first started tattooing, he became very interested in the popular American style at the time, which he describes as being "neo-traditional." Now he aims to create a more minimal style that is reflective of his current interest in folksy, Americana, and traditional Japanese tattoos. "I feel like it is better for the longevity of the tattoo," he says. "It doesn't 'date' a piece; everything looks more classic this way."

While he acknowledges that he might be too young to complain about the "kids these days," he does so anyway, going on to say that, "I feel like my generation is doing so much damage to tattooing. Everyone wants to be a tattooer, but nobody wants to put in the time and effort to do anything forward moving or good. My generation's sense of entitlement is absurd, and I don't want to be mistaken for someone who is part of the problem." Currently tattooing in New York City, he describes the secret to his success as a combination of "drawing until it looks OK" and "putting in the time to do things right."

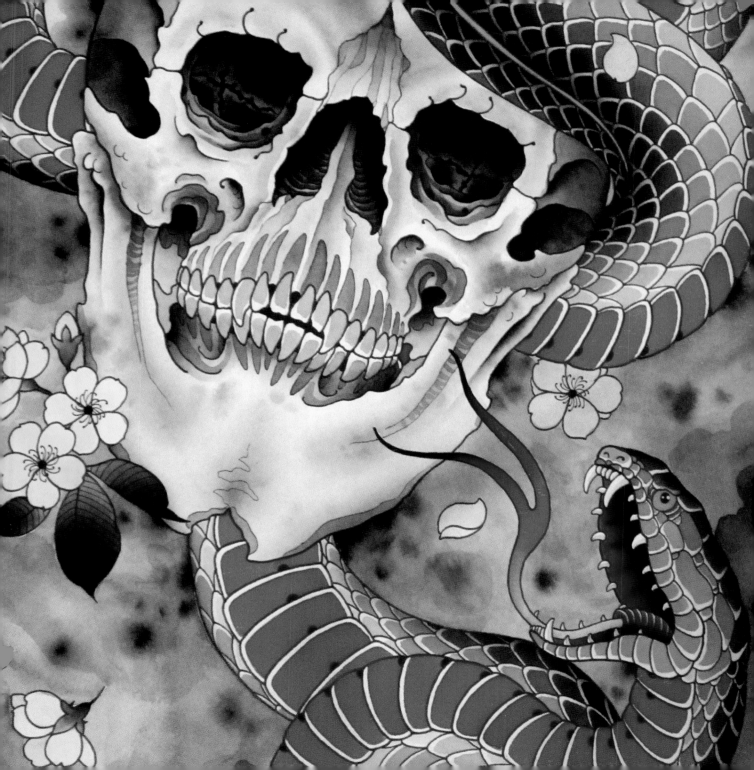

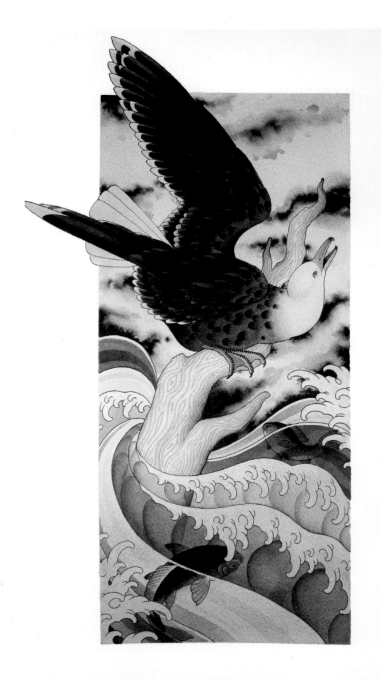

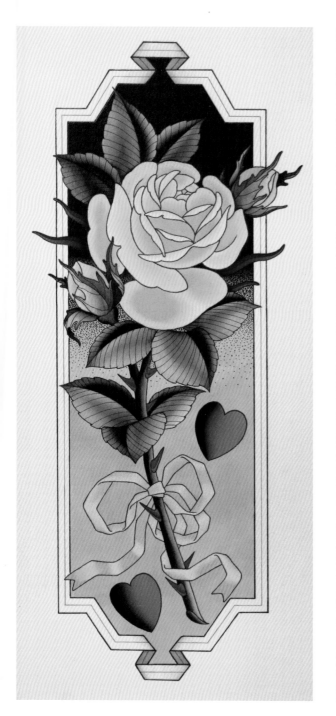
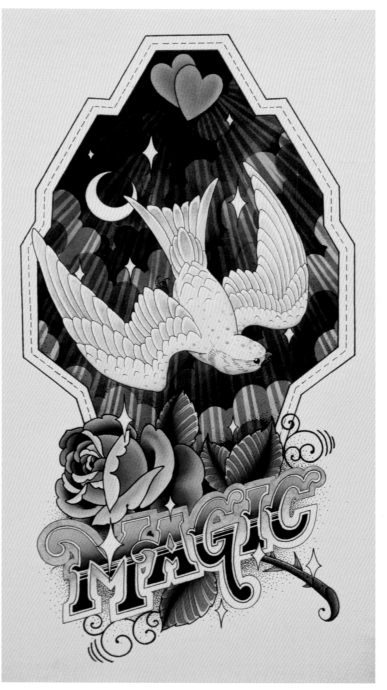

STEPHANIE TAMEZ

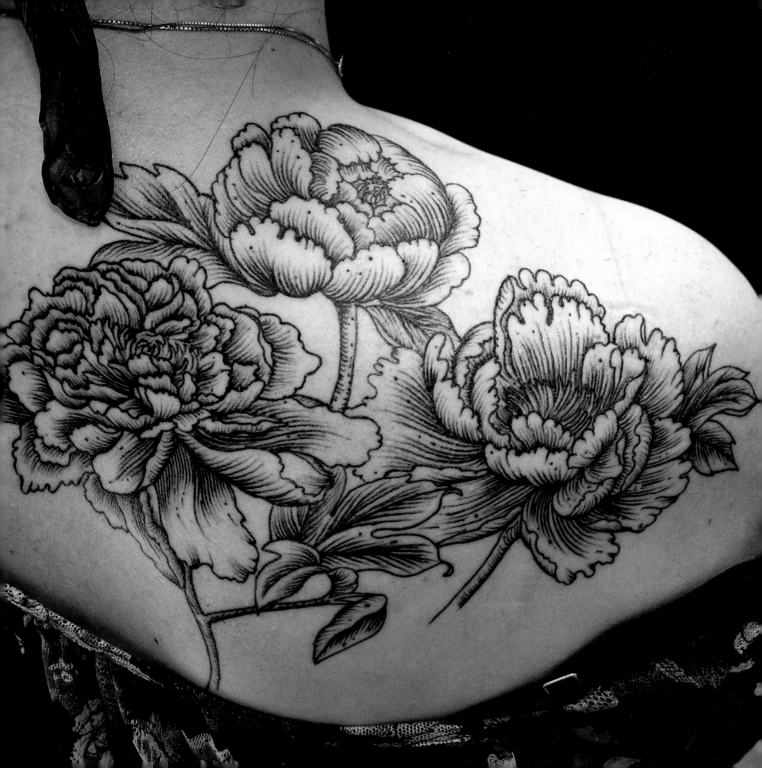

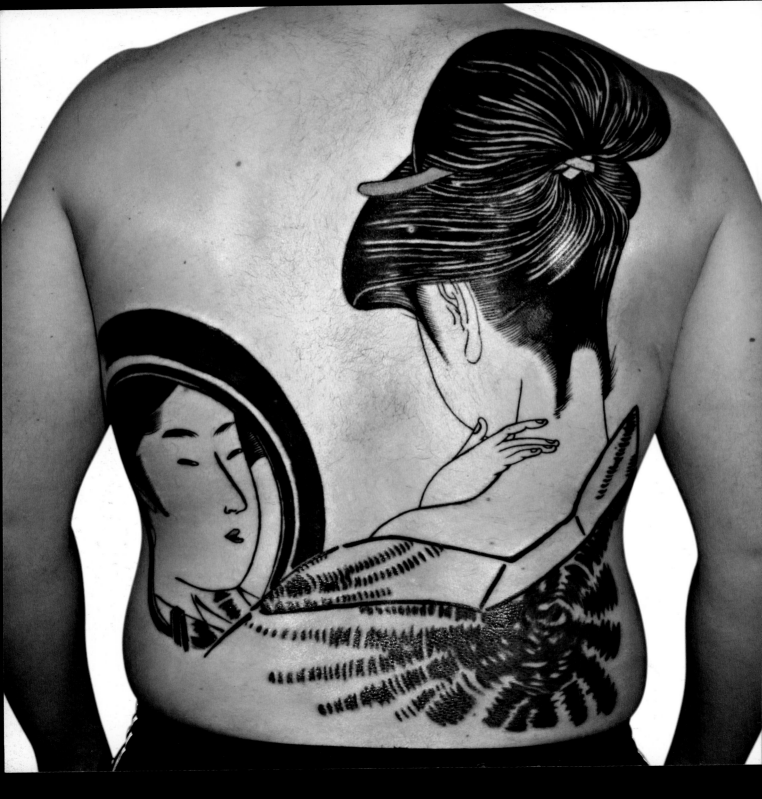

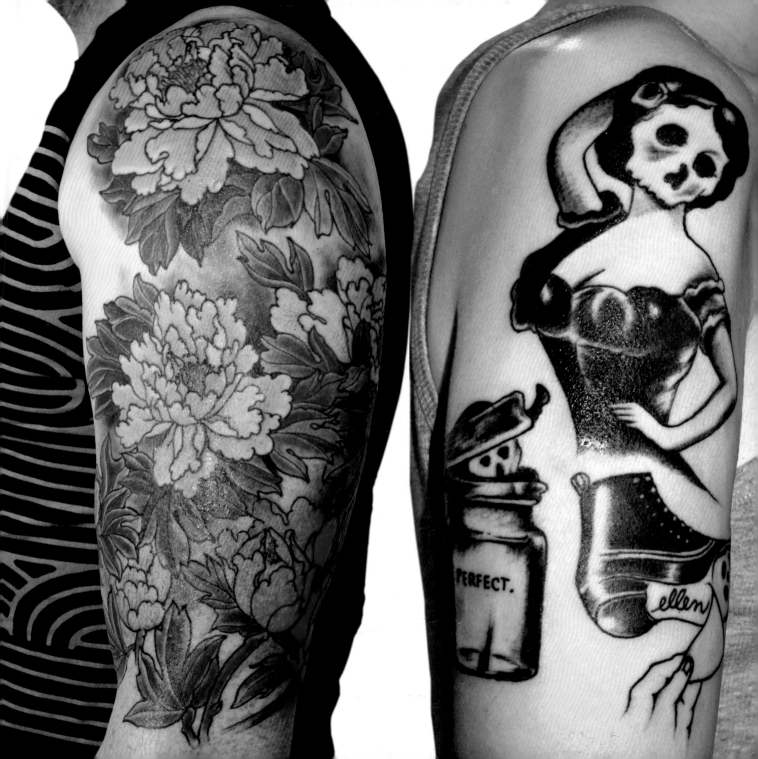

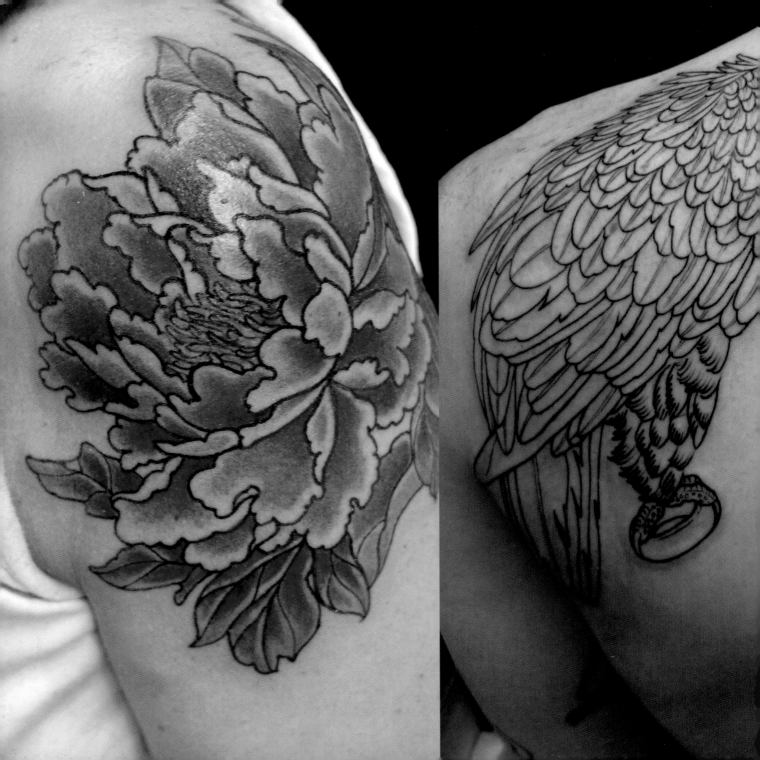

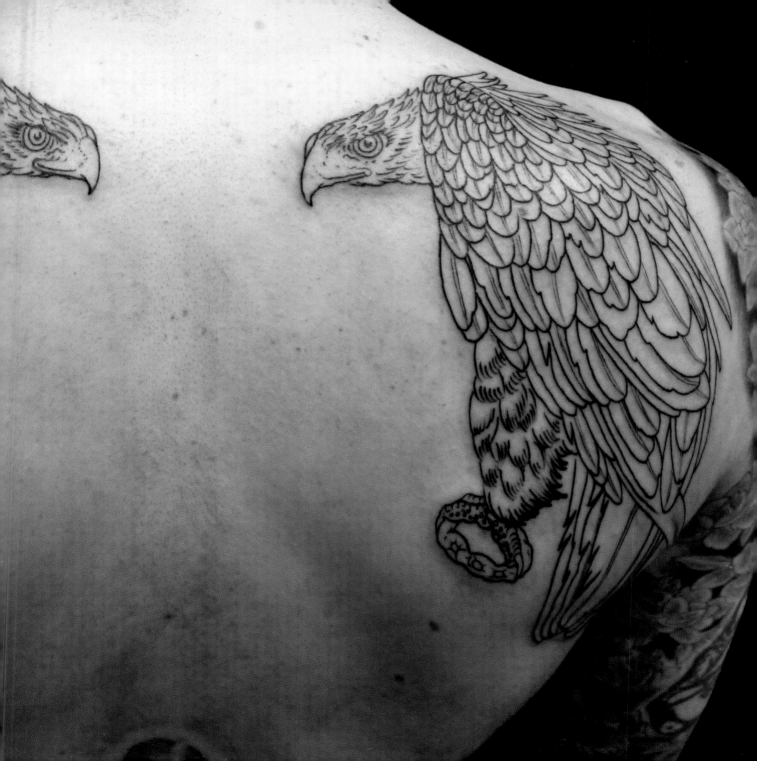

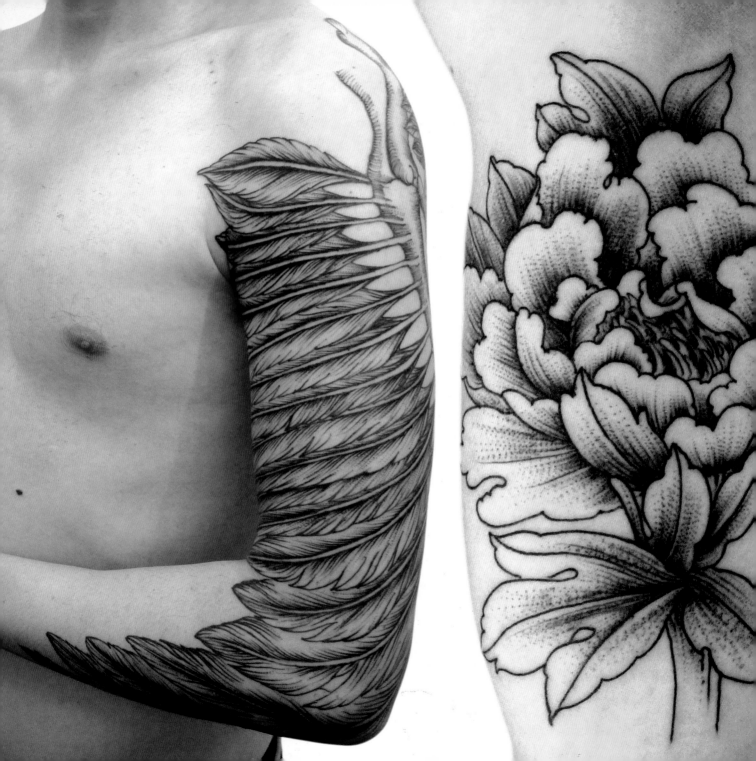

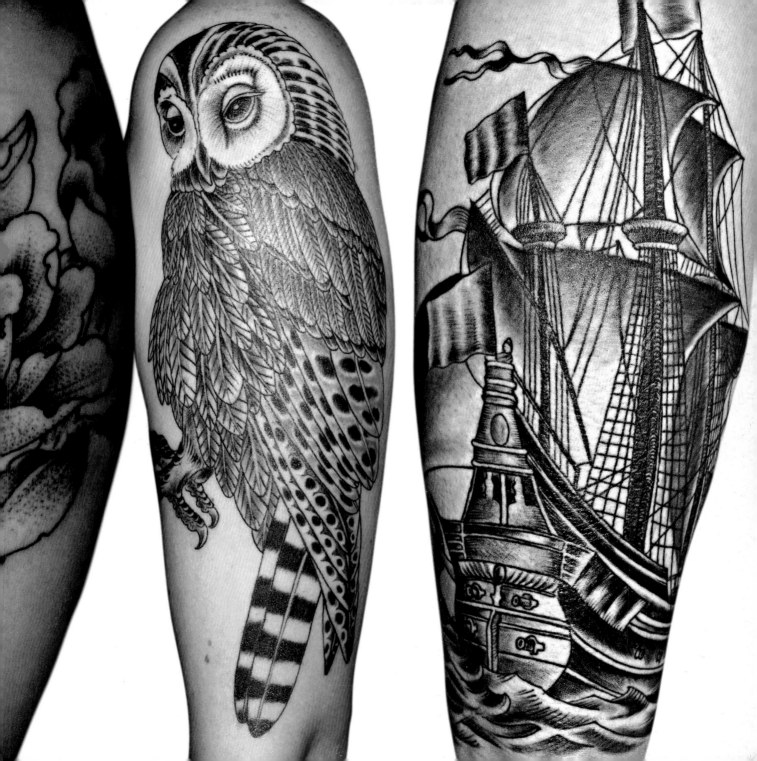

Though her style and technique have shifted over time, at the heart of New York City–based tattoo artist Stephanie Tamez's work is an investigation into notions of faith, sacred symbolism, and mythology. Earthlier influences include artists such as Remedios Varo, Alfaro Siqueiros, José Guadalupe Posada, Julio Ruelas, and Albrecht Dürer; and her fascination with Catholic icons and religious devotion as depicted in traditional Mexican votive paintings called *retablos*, also color her own creations. Having a background in graphic design, she is equally as drawn to "simple straightforward symbols, nothing too mysterious on the surface to figure out," and believes that "it's more about a direct, personal contemplation on a strong image that has multiple layers of ideas built up within it—like a cross, a sacred heart, a pyramid, a nun, or a temple." She elaborates by adding that, "You get to go on your own internal ride about those images. Tattooing tends to involve images we feel a close connection with, which is why symbolism and myths tend to be the philosophy I gravitate towards."

With her work she aspires to create a contemporary aesthetic "that still holds true to the vigor of our past." She also believes that, "Ancient civilization and modern man are still relating. We continue to love, to write about our lives and our thoughts, draw ourselves using tools, interact with the powers of animals, and question our gods and our place in the universe." For Tamez, each connection is a piece of the puzzle leading toward humanity's core.

Demon Head, 2009
Sacred Heart, 2009

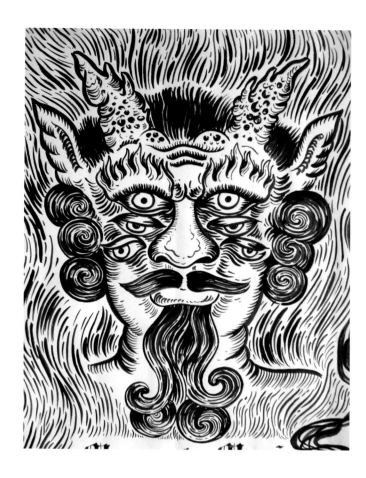

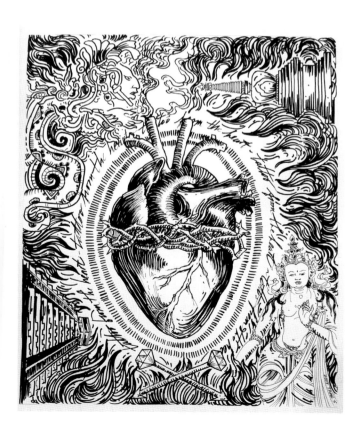

Clockwise:
Cross with Paper Airplanes, 2010
Cross with Eyes, 2010
Cross with Roman Boxheads, 2010
Cross with Eyes and
Red Sun Cycle, 2010

Opposite:
Flying Wolf, 2009

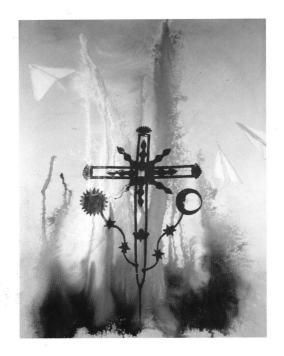
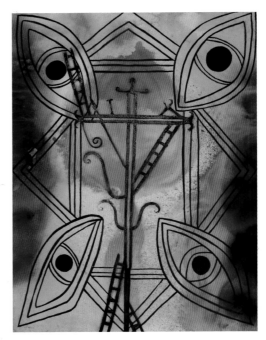
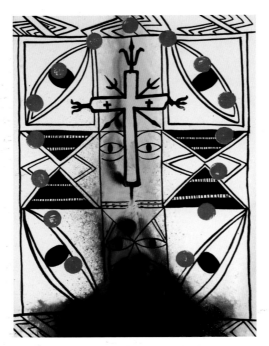
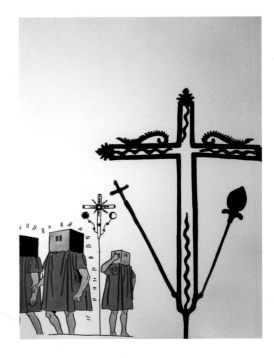

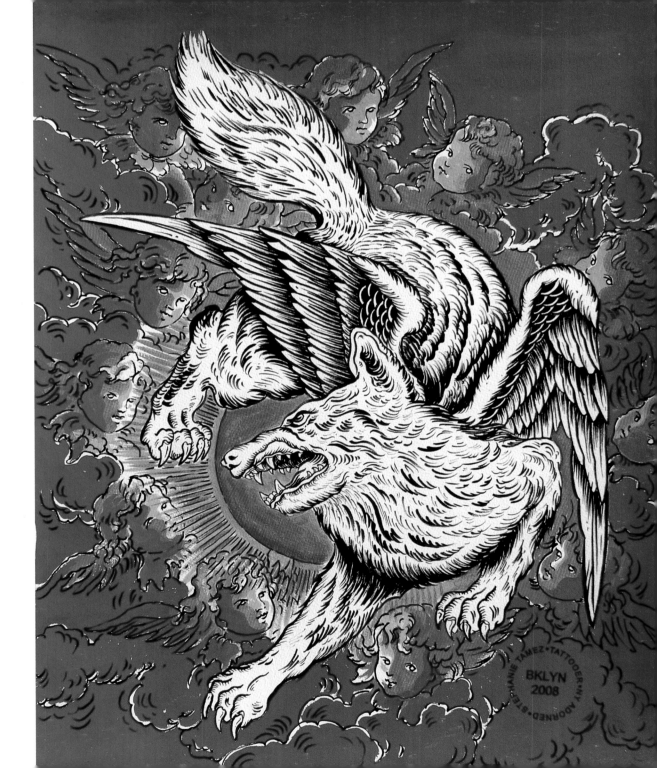

MICHELLE TARANTELLI

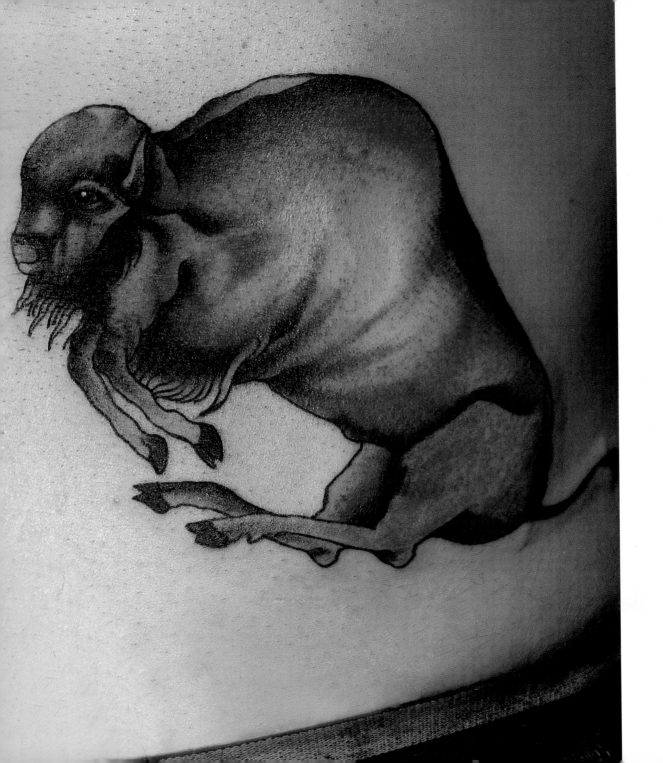

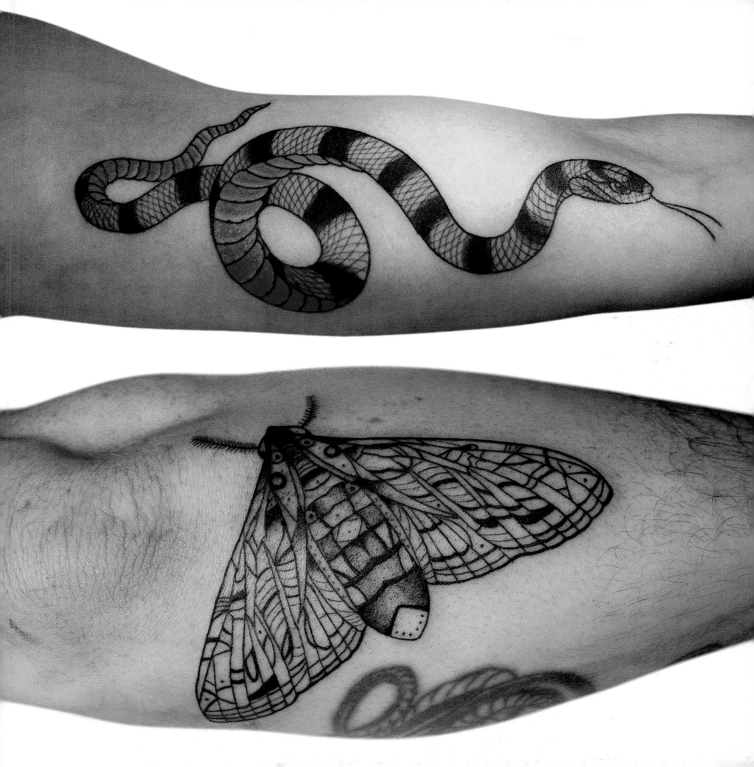

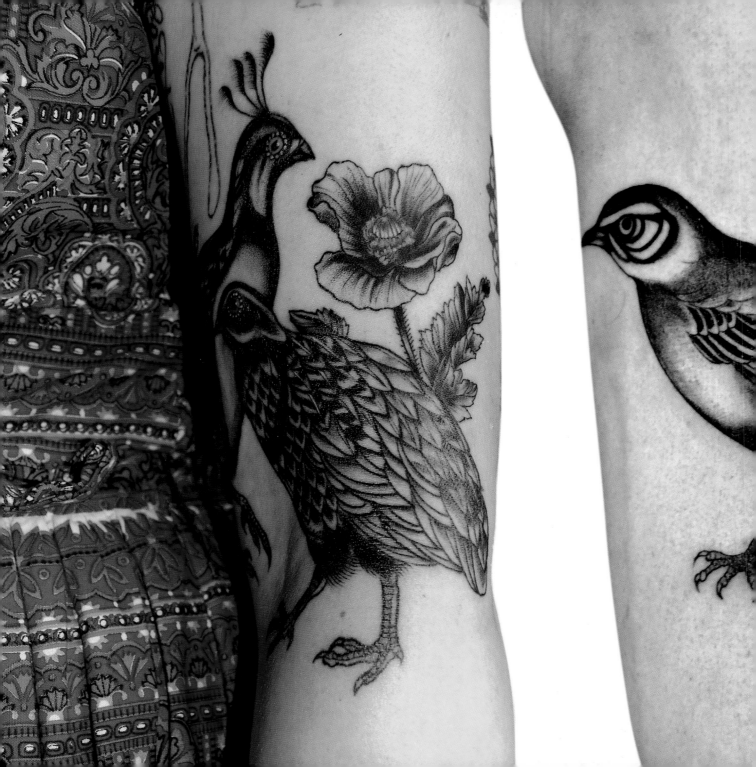

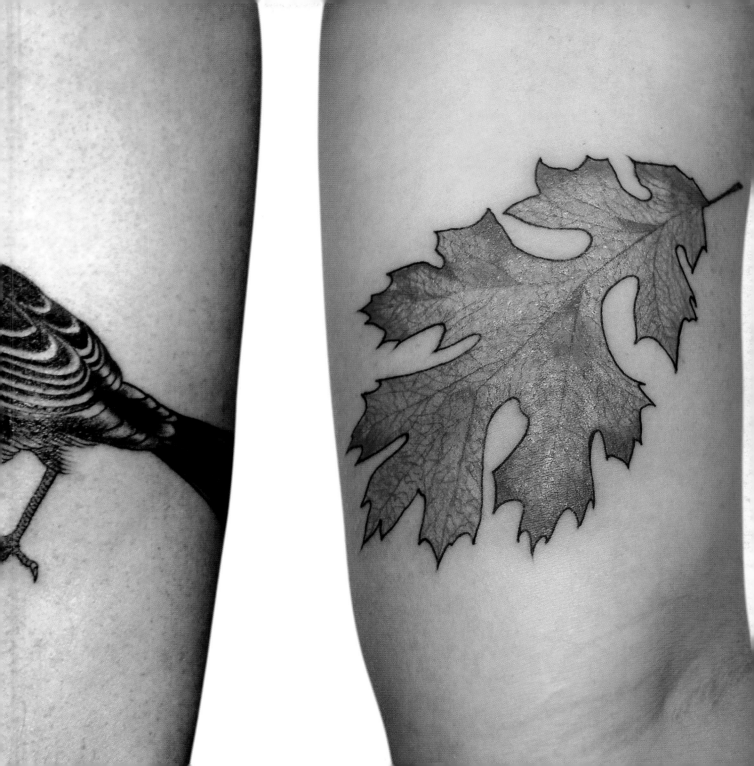

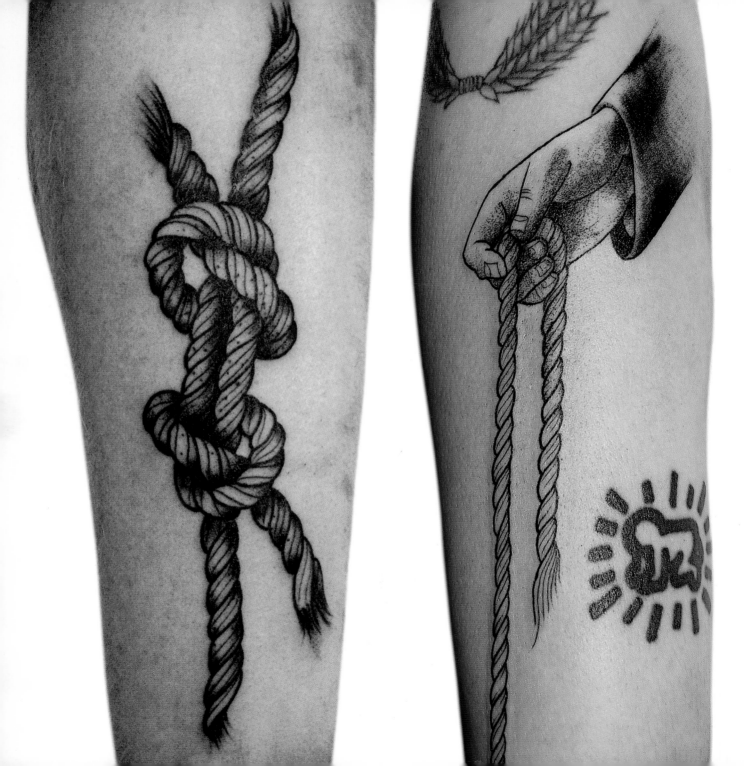

Because she still considers herself a "young" tattooer, Michelle Tarantelli claims that her aesthetic is "purely a result of attempting not to completely blow it." Inspired by her real or imagined memories of childhood, she also adores folk art, tramp art, matchstick crosses, hand-painted religious symbols, and Haitian voodoo alters; as well as the work of painter Alice Neel and photographer and Robert Frank. While music remains her greatest muse, she also finds herself drawn to "collections, memorials, longing, and the human devotion to things that are not tangible." And though she admits that "…just attempting to create without the internal thoughts killing the spirit of what inspired [her] in the first place is a constant battle," she continues to paint, draw, and express herself in many mediums, trying to piece together words and images in a meaningful way.

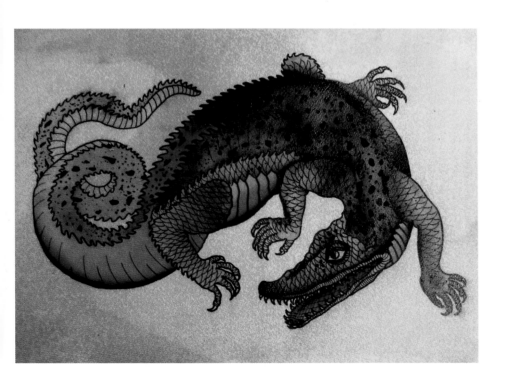

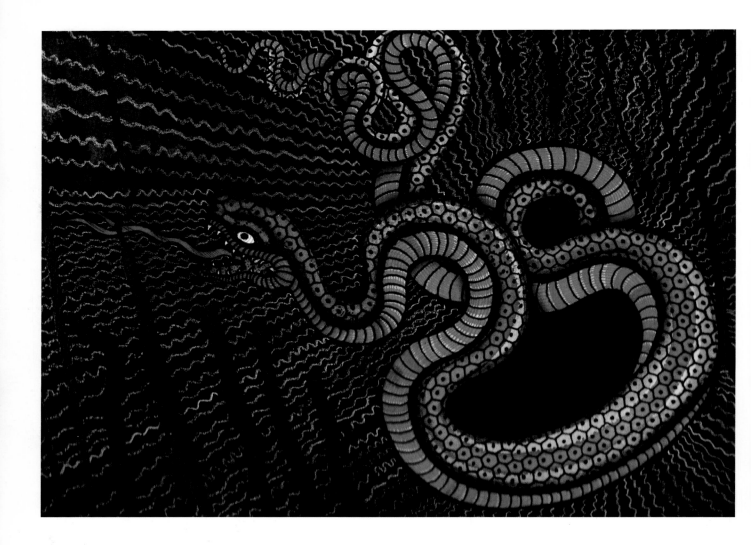

Previous:
Untitled, 2007

This page:
Untitled, 2009

Opposite:
Untitled, 2008

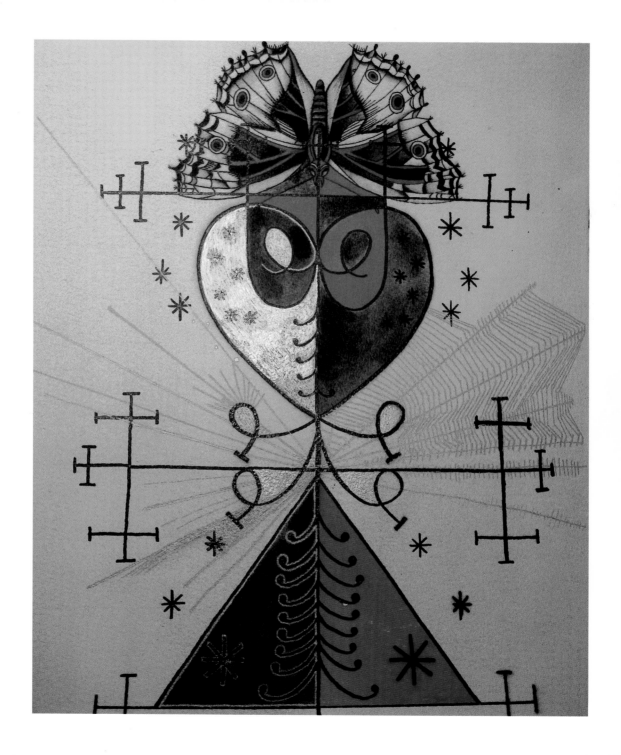

DANIEL
trocchio

250

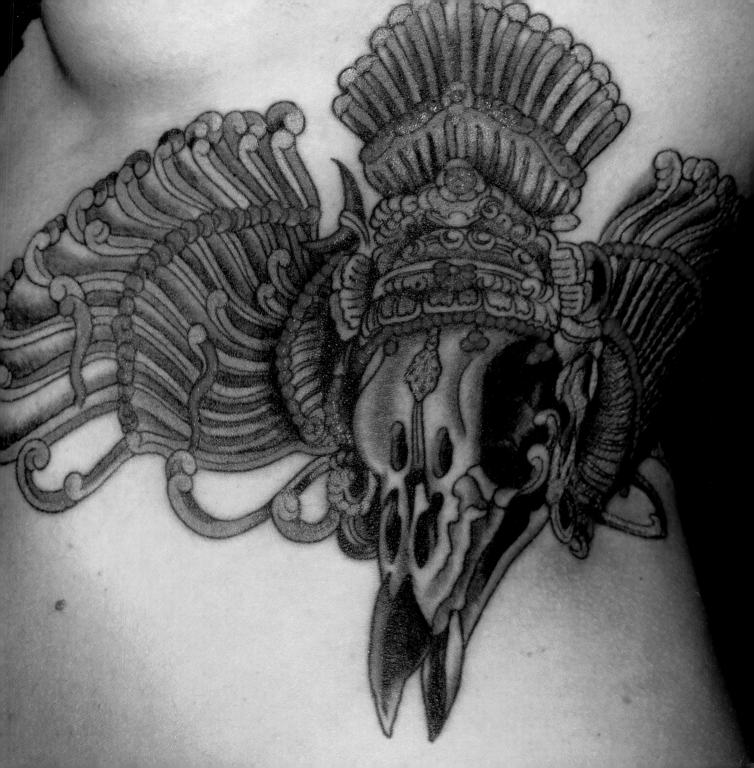

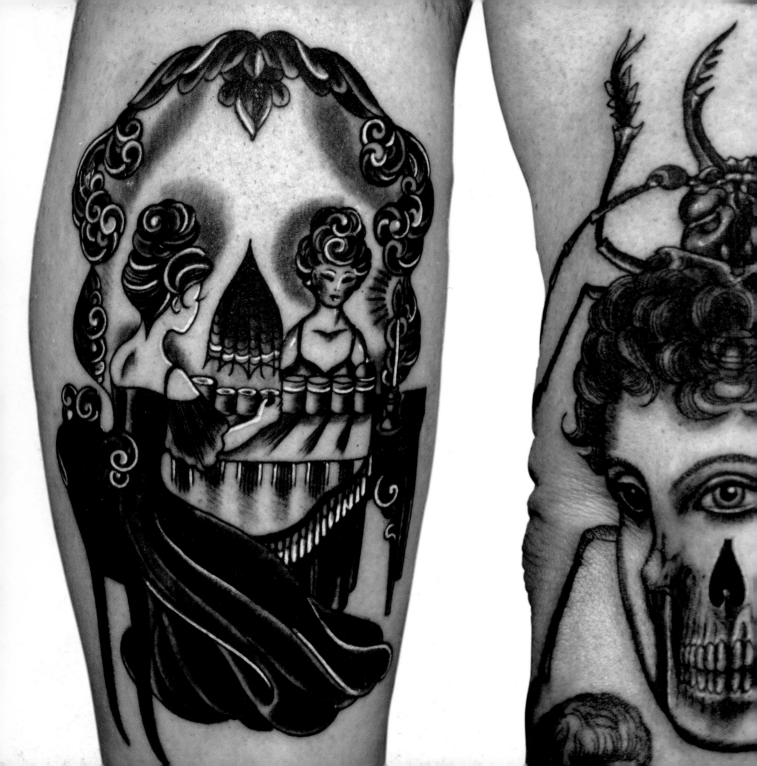

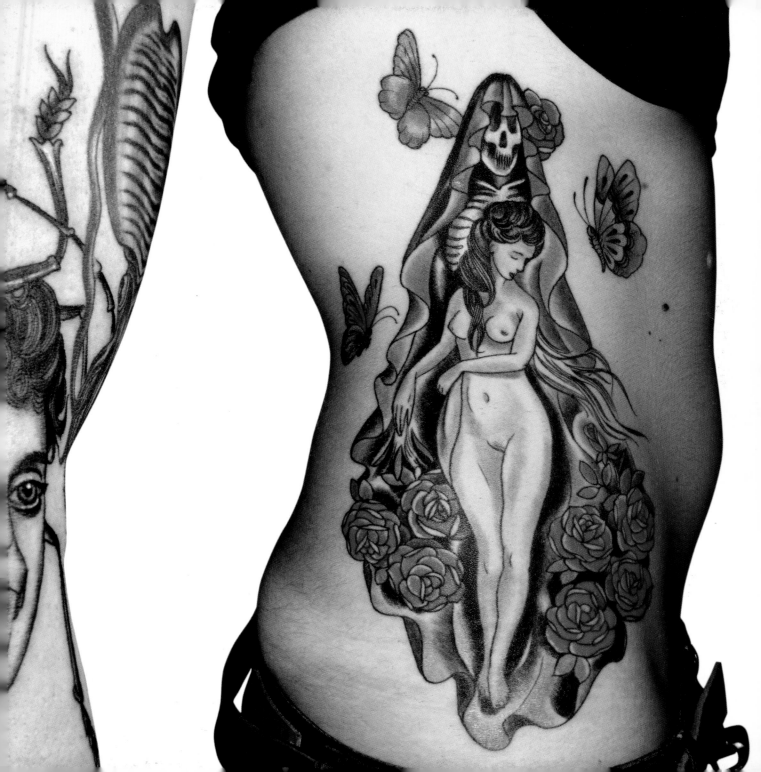

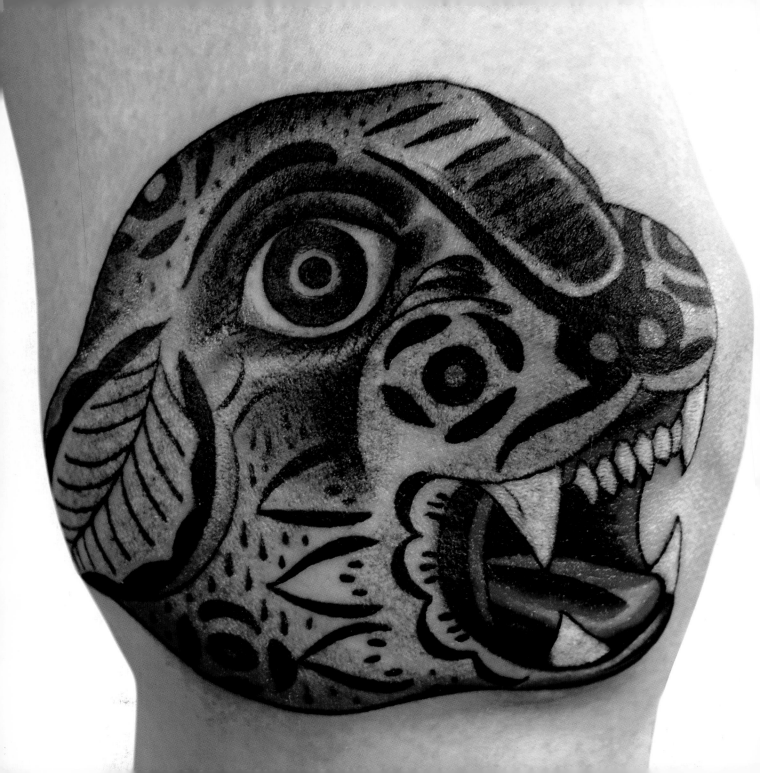

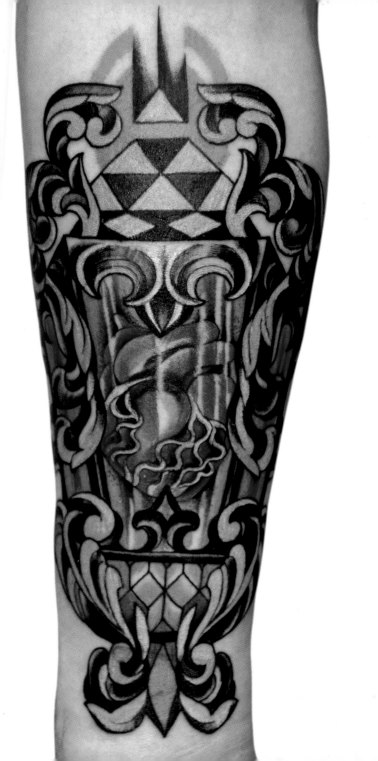
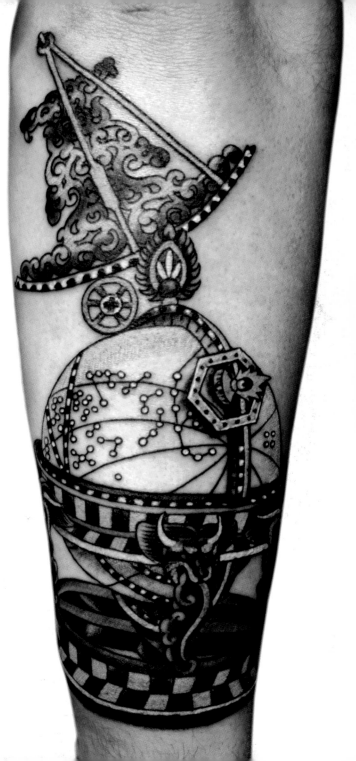

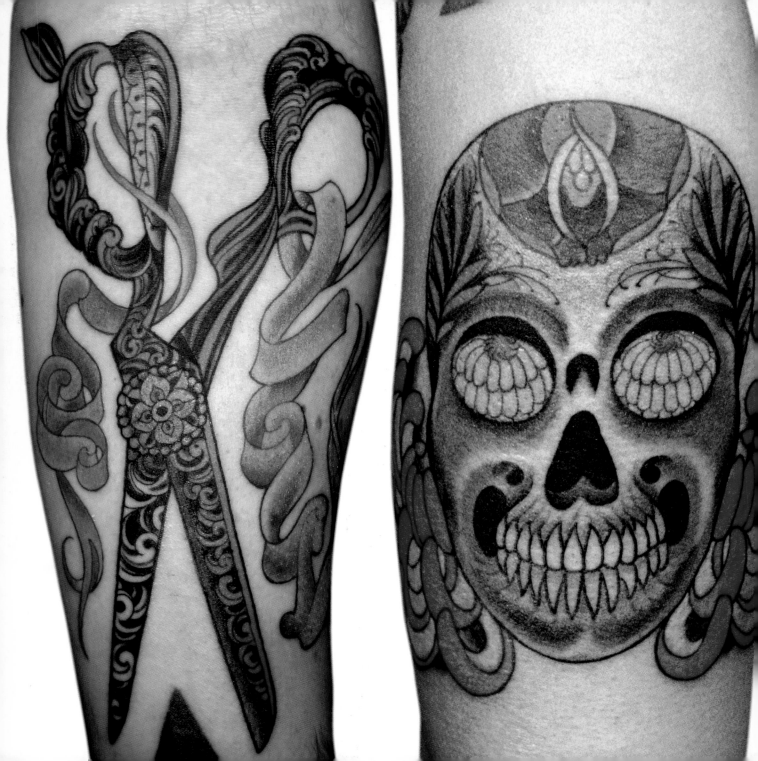

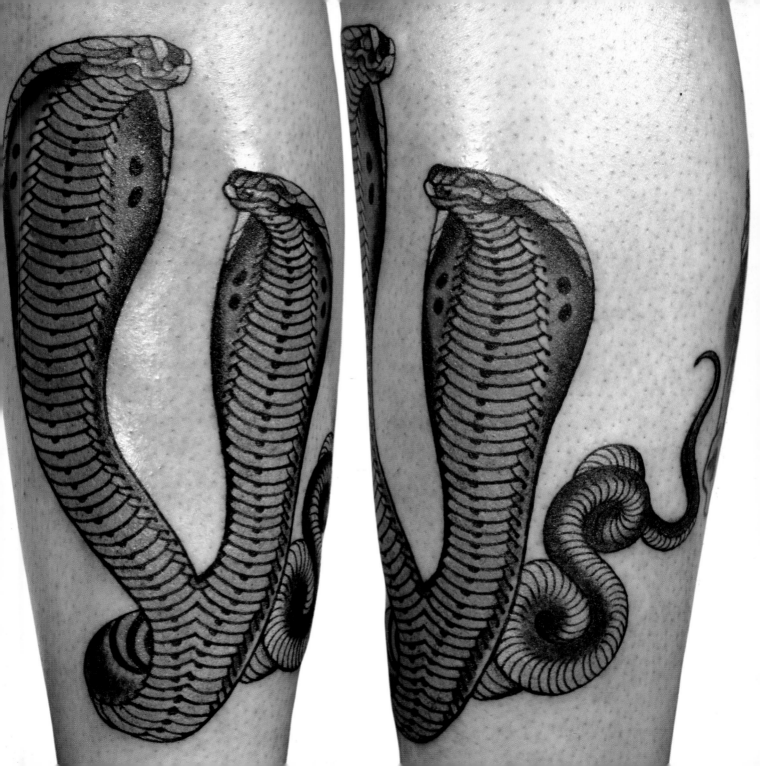

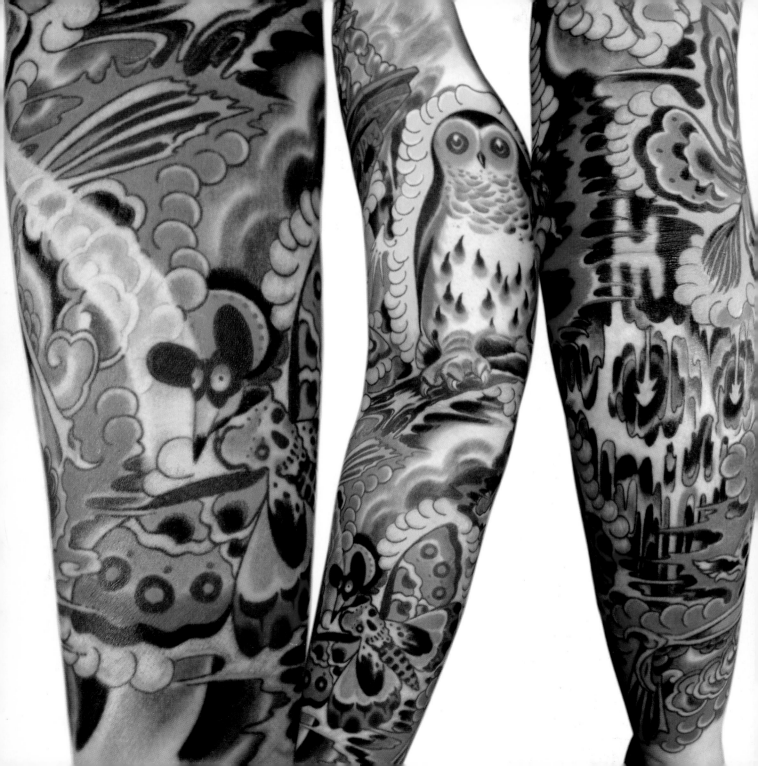

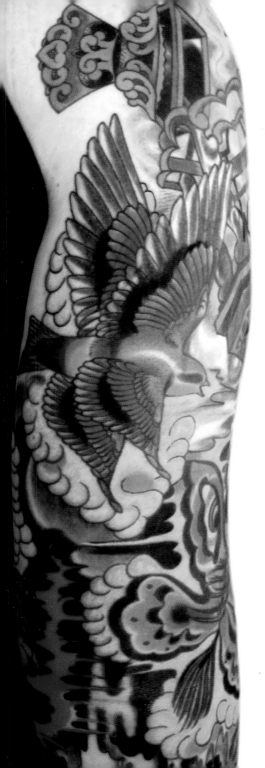

"I like art that creates an environment and is capable of setting the stage to tell a story for the visually astute and verbally impaired," says the New York City–based artist Daniel Trocchio. His list of inspirations include turn-of-the-century advertising cuts, rococo, surrealism, Tibetan narrative illustrations, and existentialism; H. P. Lovecraft, Gustave Doré, Ivan Albright, Utagawa Kuniyoshi, Kawanabe Kyosai; and fellow tattoo artist, Jondix. He also spends a lot of time painting, which he claims keeps him balanced and his work and personal art linked together. But above all else, his most readily available source of inspiration has been working with his friends and fellow artists, which he describes as being "the best experience of my life."

259

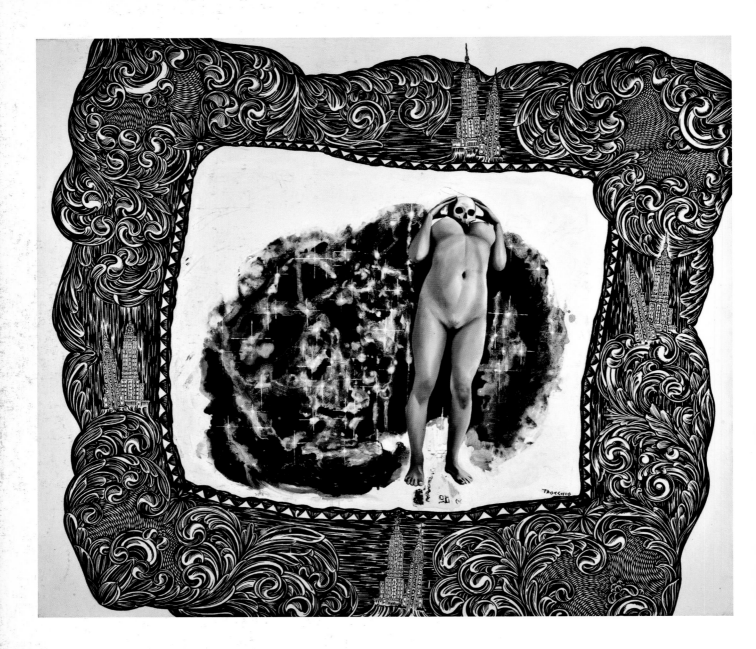

Untitled, 2009

Opposite:
Communication Isn't Working, 2010

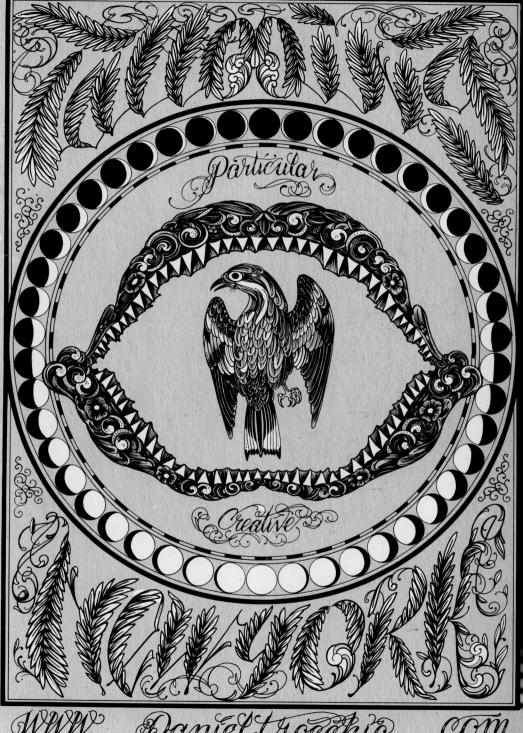

AMANDA WACHOB

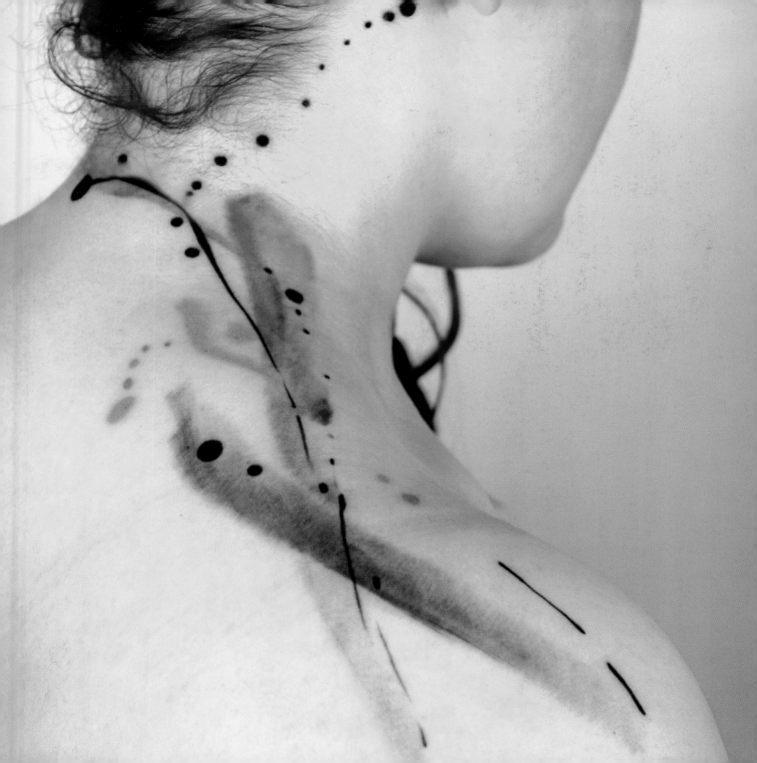

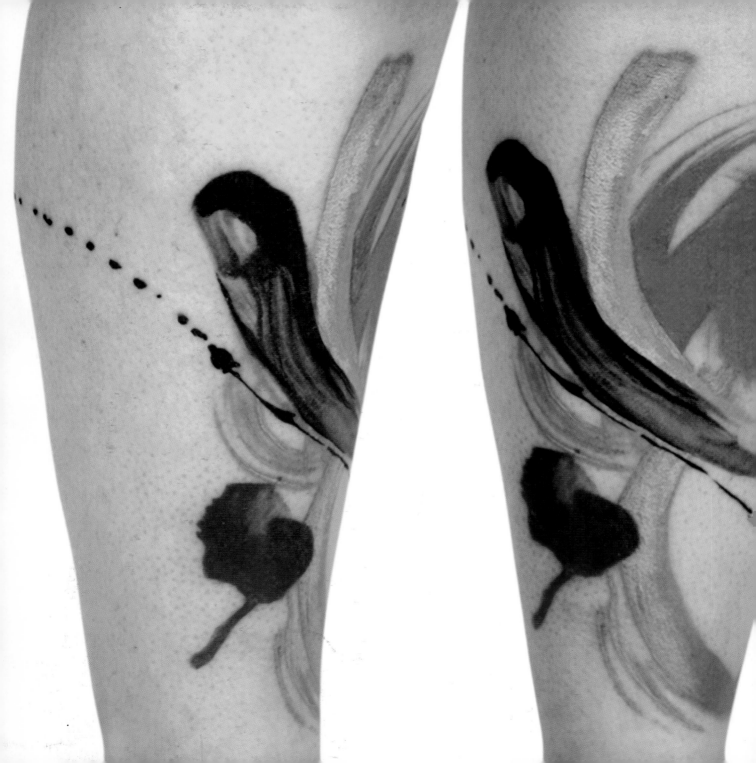

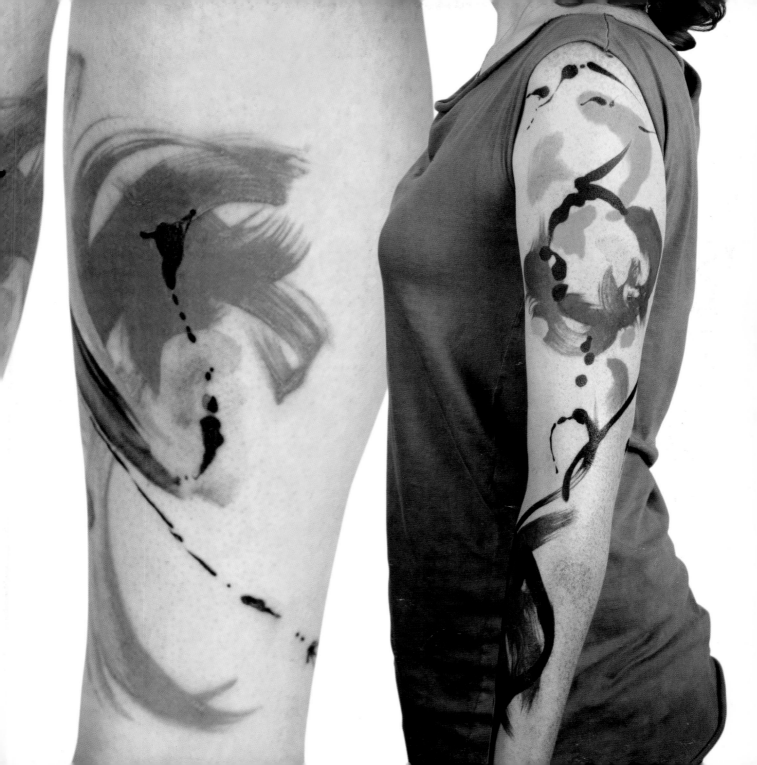

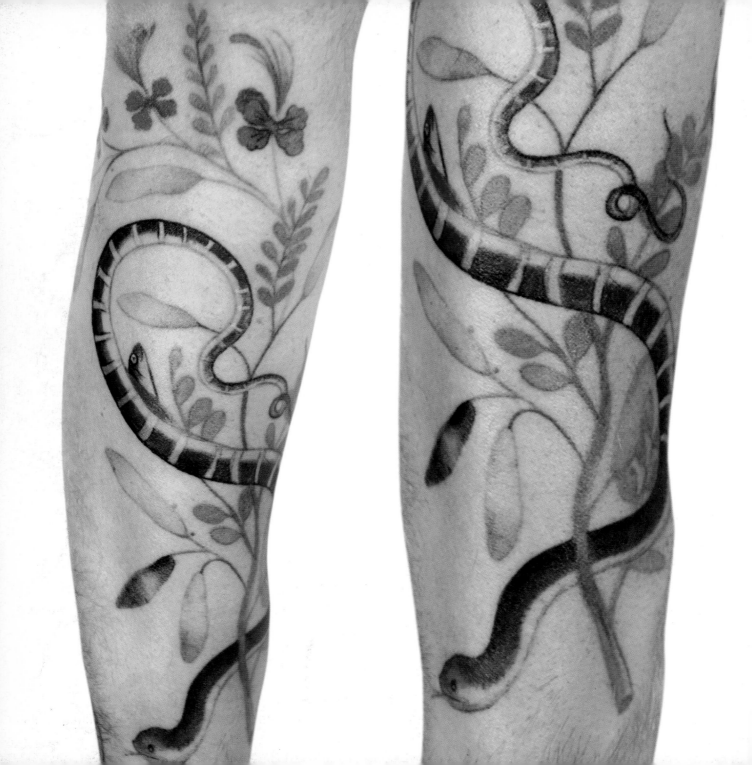

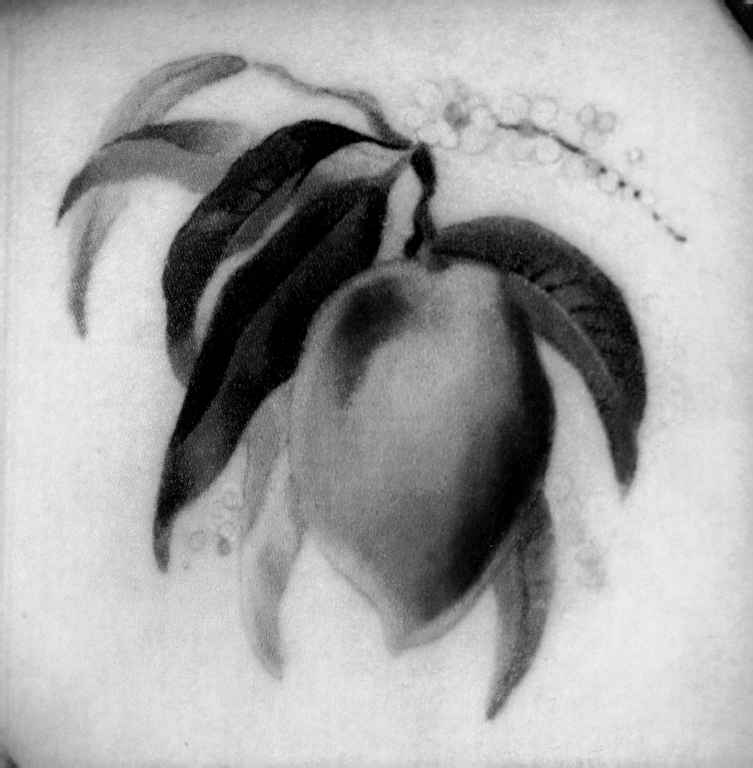

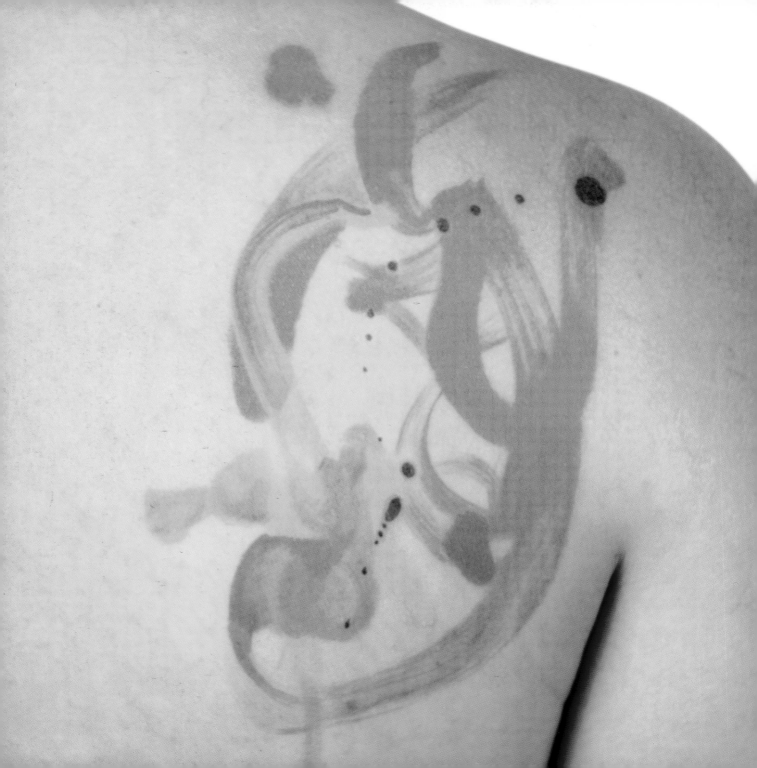

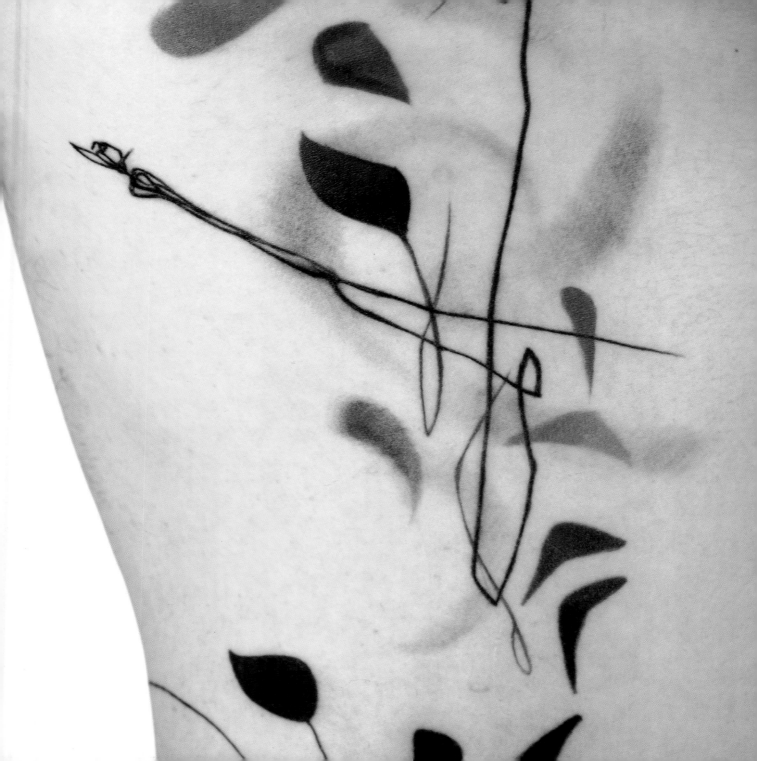

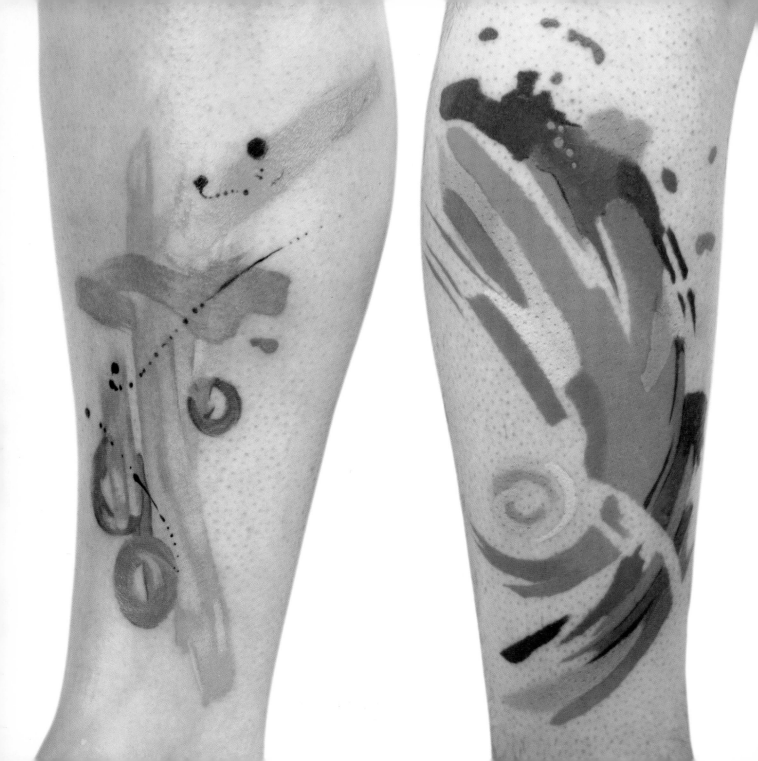

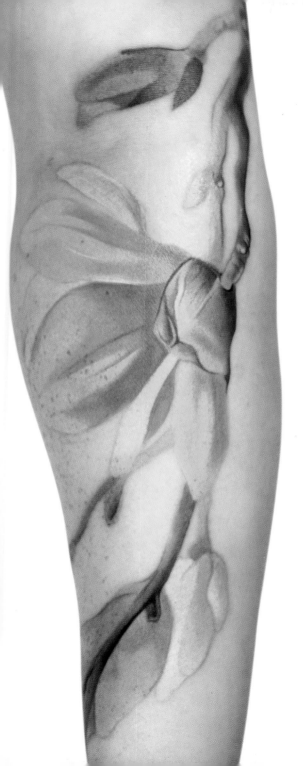

Amanda Wachob has always felt a kinship to artists who approach the creative process intuitively, and recalls coming across the work of Cynthia Witkin in an issue of the Ed Hardy–edited magazine, *Tattootime*, as an early source of inspiration. Witkin's unusual style of creating a design based on the client's personal history resonated with Wachob, and since then she has been interested in pushing the boundaries of what a tattoo can be and mean. In her own work, be it art or tattoo, she has started to gradually shift away from the overt use of color found in some of her earlier pieces, and has heard more than once that her often abstract and conceptual designs don't look like traditional tattoo work. "I don't always intentionally strive for that," she says, "but I like how it makes people view a little differently what a tattoo can be."

271

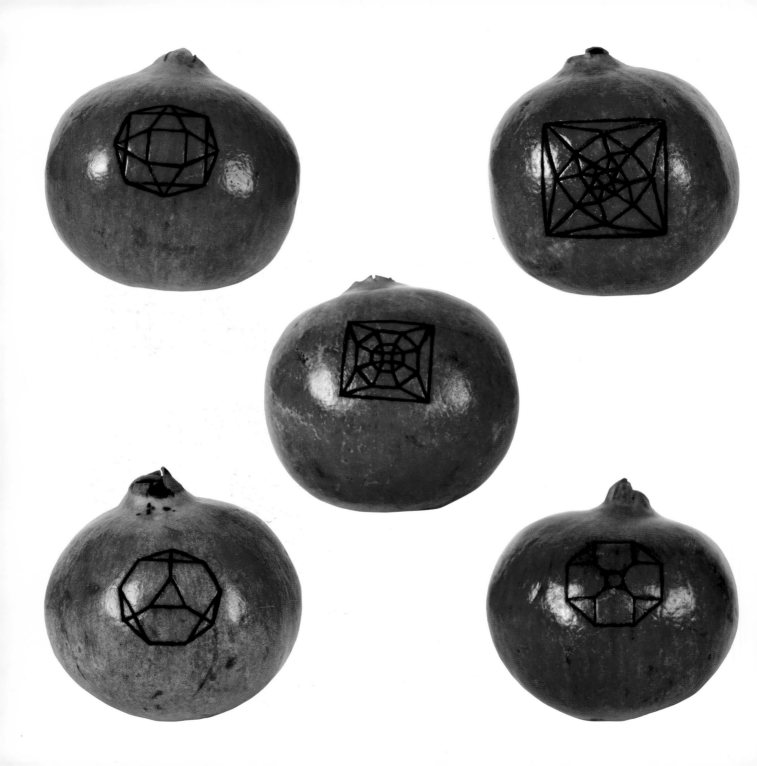

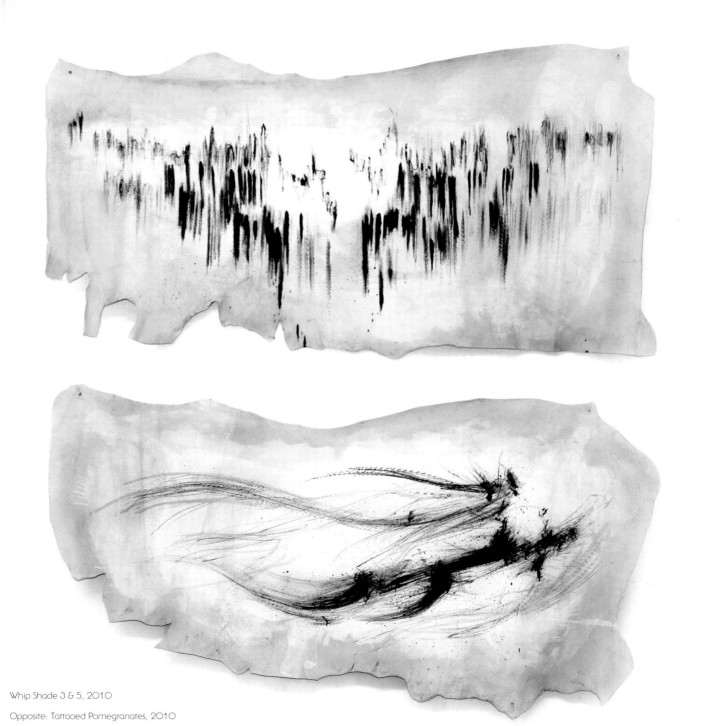

Whip Shade 3 & 5, 2010

Opposite: Tattooed Pomegranates, 2010

SETH
WOOD

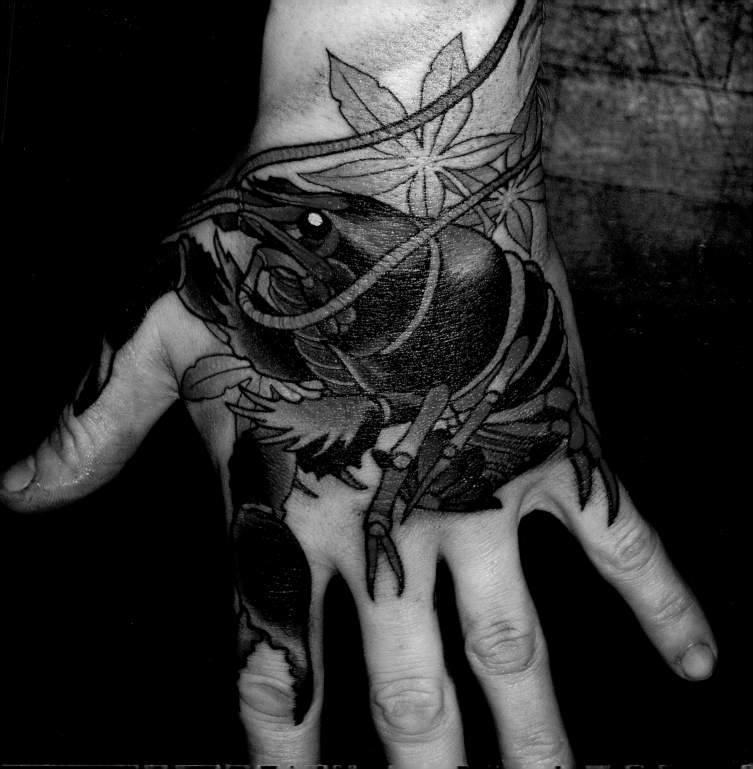

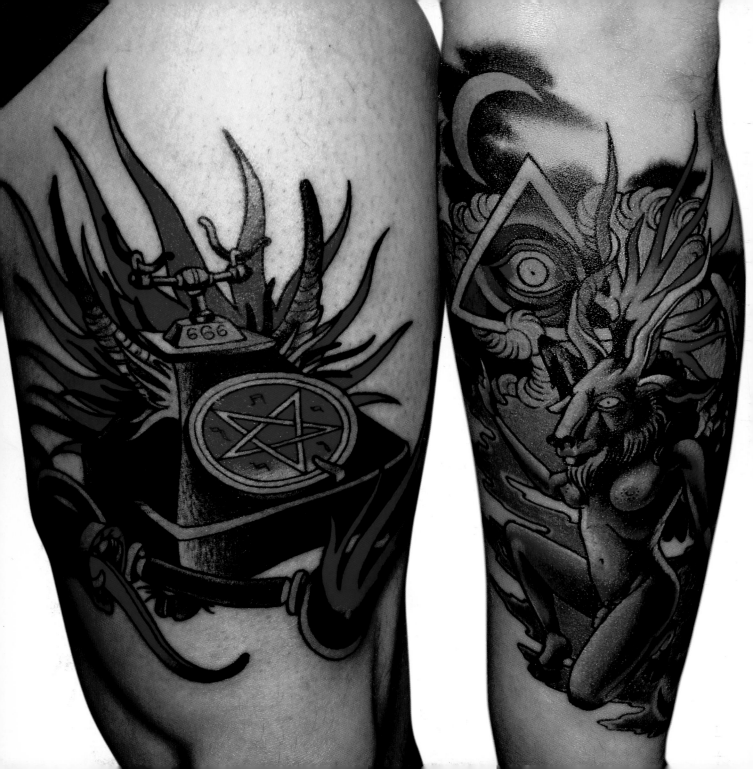

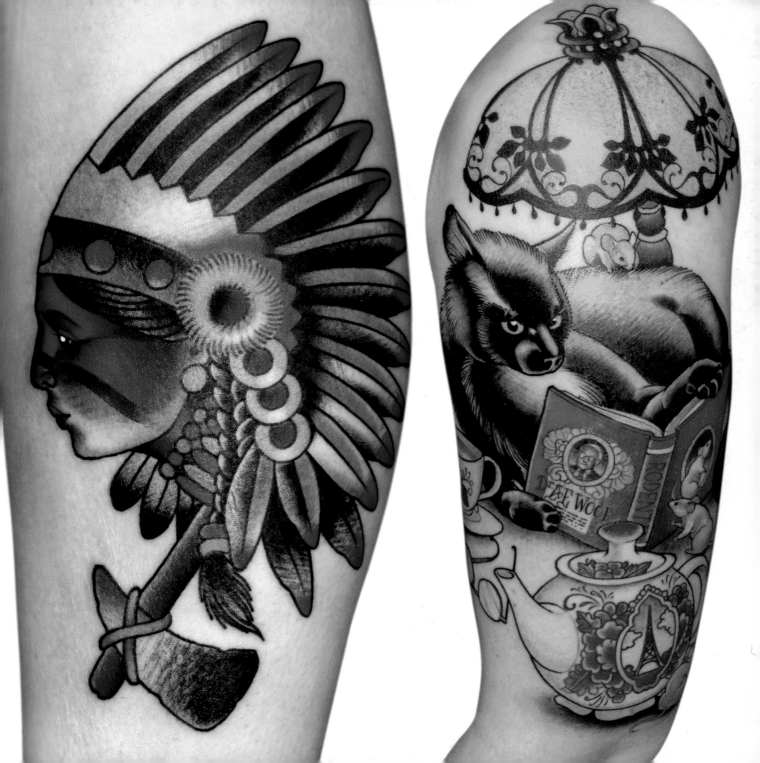

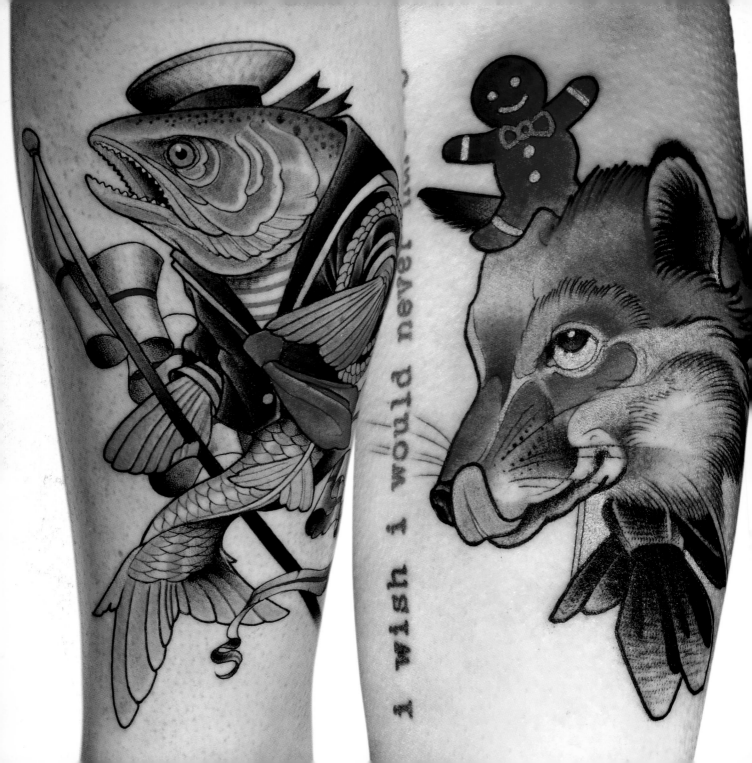

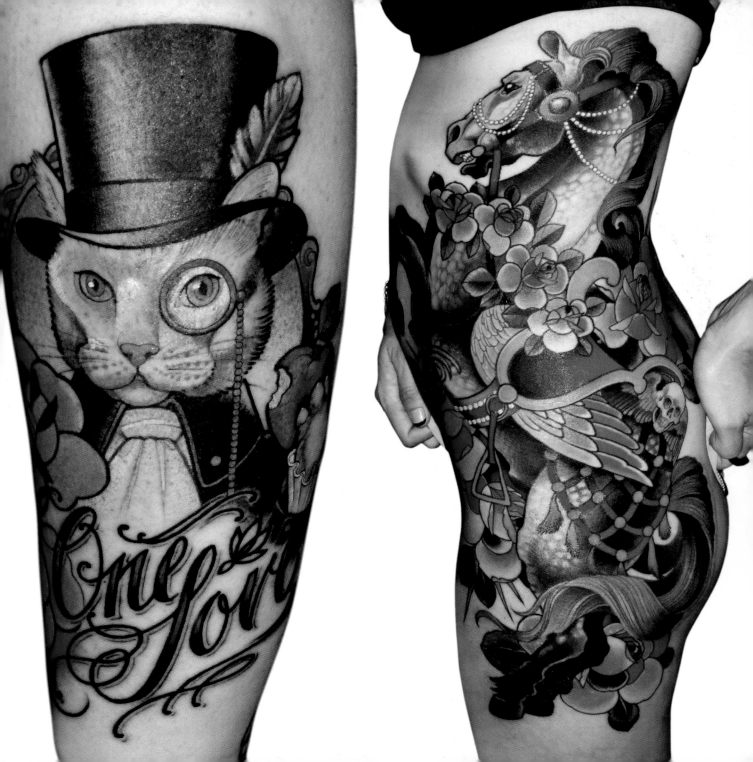

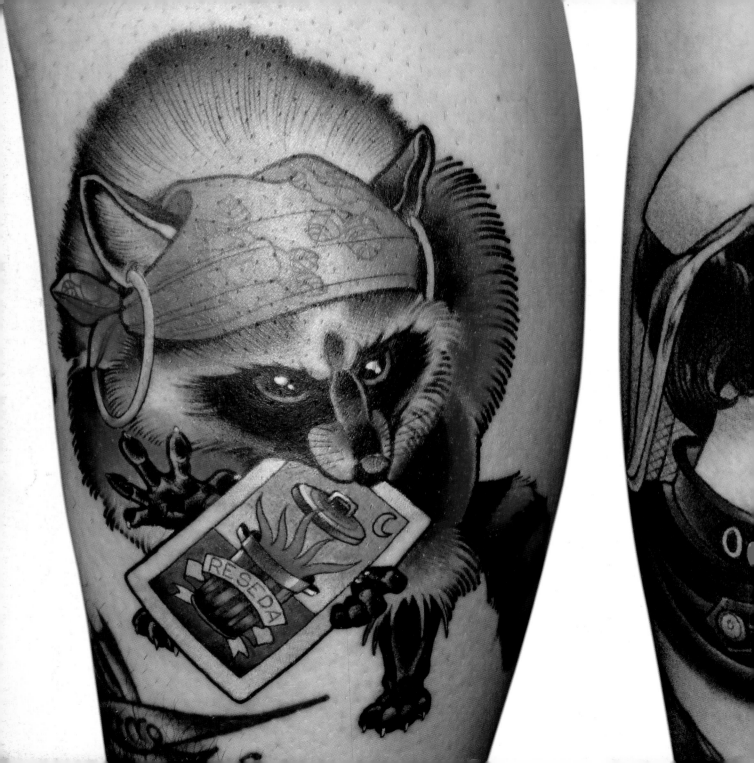

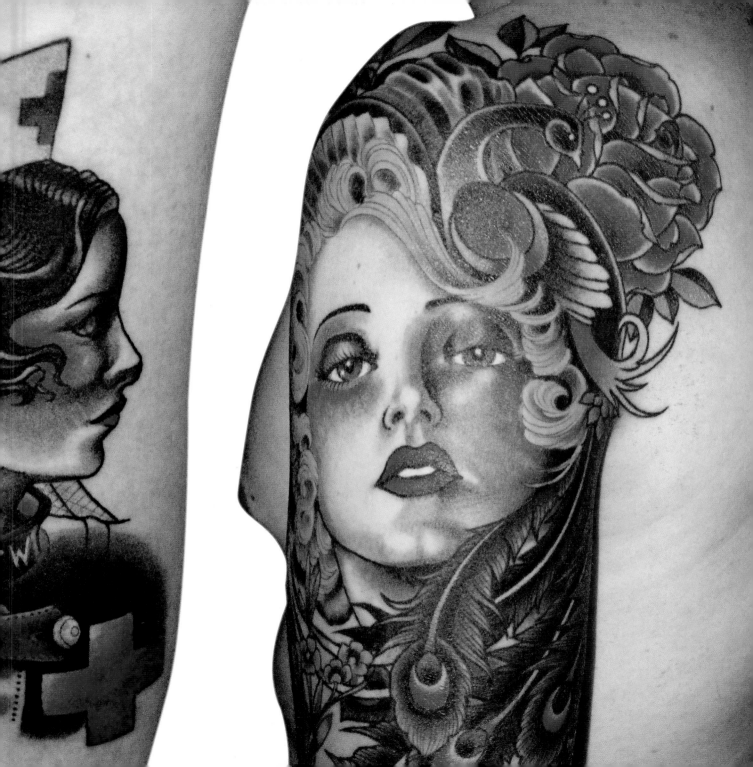

Seth Wood grew up in a home where a dinosaur's skull was considered decoration. His father and grandfather were paleontologists, so it was not unusual to be surrounded by books and artifacts depicting prehistoric life. But rather than the scholarly pursuit of science, he became captivated by the hyper-meticulousness of the renderings, and spent his time redrawing his favorite illustrations. In recent years, he's started collecting antique field guides and prints, drawn to what he describes as "the highly technical, but absurd" quality of the work. "Which I guess is the impression I'm trying to create with a lot of things I'm making," he notes. He has even found ways to infuse some of his designs with his own personal history. He once created a tattoo of a cat reading a book by Dr. A. E. Wood, who was his grandfather, and also the "world's foremost authority on fossil rodent teeth in his time." On sneaking in such tributes, he notes that, "Tattoos are ultimately designs made to the client's specifications, but I like the idea of looking back at this collection of commissioned designs and being able to extract a hidden personal narrative from them."

When he first started tattooing over twelve years ago, artists such as Marcus Pacheco and Timothy Hoyer helped shape his idea of what a tattoo could be. Drawn to "large-scale, bold designs," most of his formative practice was "in nailing down some fine-line wizardry." He admits that it took some time and "a lot of wild stabs at trying to create something that was [his]," but he eventually developed a style all his own, gaining a "much better appreciation for design and source material" along the way. He describes his goal for each tattoo as being "pretty unextraordinary—make something that's clean and readable and that will age well in the skin." Yet he challenges himself to push his work even further, saying that, "Even better than that, is if you can accomplish this without regurgitating the same designs that ten thousand other tattooers are doing with proficiency… That's the crux of the journey for me; finding imagery and ideas that aren't too safe, but applying them in ways that are proven to work over time."

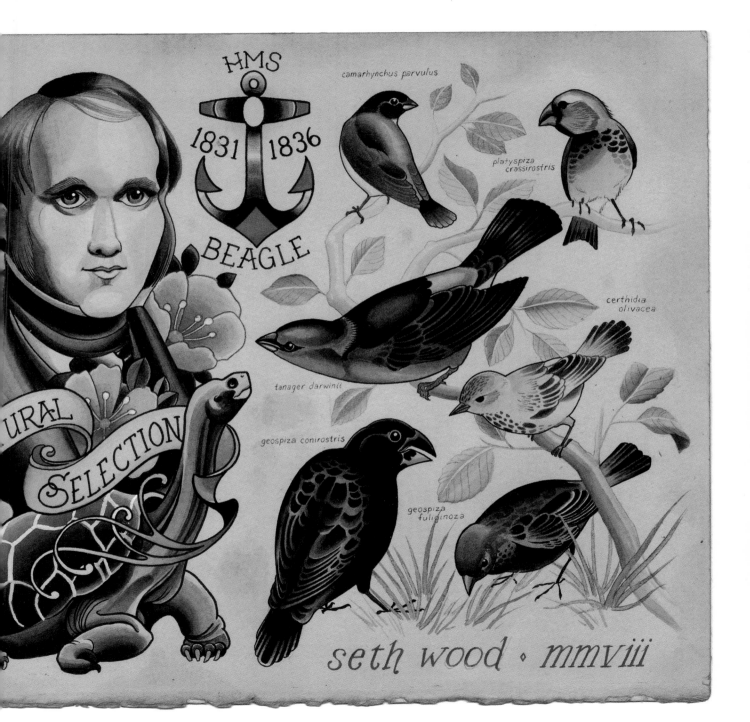

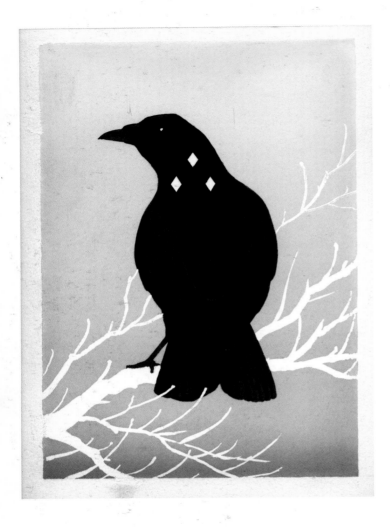

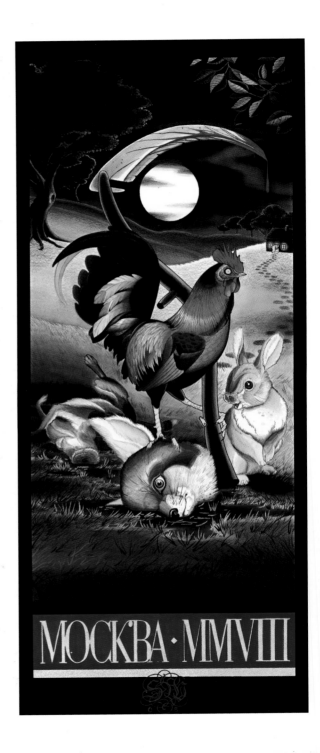

Previous:
Darwin Flash, 2008

This page:
Crow, 2008
Moscow Poster, 2008

Opposite:
London Poster, 2009

МОСКВА · MMVIII

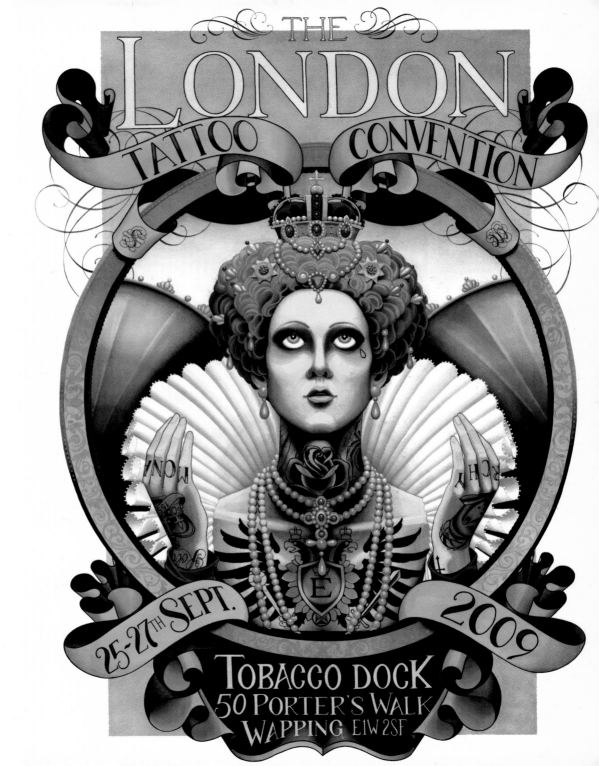

Joseph Ari Aloi would like to thank Jonathan R. Stein, Matthew Clark aka Houston, Julie Schumacher, Ashleigh Allen, Amoreen Armetta, Daniel Melamud, Charles Miers, Carlo McCormick, all the artists for contributing and inspiring, my family, friends, teachers, clients, treasure map providers, unseen forces, cosmic consciousness, my wife Adrienne LaBelle, and daughter Twyla Maggie Snowdrop.

Thanks also to Claudine Aguste, Gloria Ahn, DB Burkeman, Maria Pia Gramaglia, Colin Hough-Trapp, Kayleigh Jankowski, Klaus Kirschbaum, Kaija Markoe, Anthony Petrillose, Lynn Scrabis, Elizabeth Smith, and Stephen Zadrozny.